THE GRASS OF THE PEOPLE

WALTER MACKEN
(1915–1967)

Walter Macken, novelist, short story writer, playwright and actor, was born in Galway on 3 May 1915, the youngest of three children. His father, also named Walter, was a qualified carpenter who also worked as an actor in an old theatre in Middle Street called the Rackets Court; in March 1916 he was killed in the trenches at St Eloi, France.

The young writer spent all his childhood in Galway, growing up in St Joseph's Terrace and Henry Street. He first began to write at the age of eight and acted while still at school at the "Bish"; on leaving in the 1930s he became a member of the company at the Taibhdhearc, the Irish language theatre in Middle Street. It was there he met his wife, Peggy Kenny, daughter of the founder of the *Connacht Tribune*. They worked together in the theatre until their marriage in 1937, after which they lived in London for a while.

Returning to Galway in 1939, Walter Macken took up the post of theatre manager with the Taibhdhearc, where in nine years he staged over seventy different productions. At this time he also began to write for publication both in Irish and English; in 1946 his first play in English, *Mungo's Mansion*, was successfully staged at the Abbey Theatre in Dublin and his first novel, *Quench the Moon*, was accepted for publication, while he was already working on the short stories which would constitute *City of the Tribes*.

He joined the Abbey for three years in 1948; a year later his second novel, *I Am Alone*, was published, and in 1950 his third novel, *Rain on the Wind*, brought him international recognition with the Book of the Month Club in the UK and the Literary Guild in the USA. His successful US theatre tour with the M.J. Molloy play, *The King of Friday's Men*, gave him the impetus to return home to Galway to establish a career for himself as a full-time writer.

In 1957 he embarked on his most ambitious writing project: the three historical novels, *Seek the Fair Land*, *The Silent People* and *The Scorching Wind*. He did extensive historical research for this trilogy, setting out to show in them how the ordinary people survived the battles and tribulations of those troubled times. In 1964 he turned his hand for the first time to writing for children, and his first children's novel, *Island of the Great Yellow Ox*, proved to be one of his most popular books. In all, he produced a body of work which finally came to ten novels, seven plays, three books of short stories and two children's books; most of his novels have been translated into many languages. His last novel, *Brown Lord of the Mountain*, was published just a month before his death on 22 April 1967.

THE GRASS
OF THE
PEOPLE

Walter Macken

BRANDON

First published in 1998 by
Brandon
an imprint of Mount Eagle Publications Ltd.,
Dingle, Co. Kerry, Ireland

Copyright © Ultan Macken and Fr Walter Macken 1998

ISBN 0 86322 248 X

Cover illustration and design: Steven Hope
Typesetting by Red Barn Publishing, Skeagh, Skibbereen
Printed by ColourBooks, Baldoyle, Dublin.

Contents

Publisher's note

In late 1996 we received typescripts of over thirty unpublished stories by the late Walter Macken, many of which he had intended should be published as a collection cohering around the character of the city of Galway, under the title of *City of the Tribes*.

In addition to the stories published in that volume, there were a further twelve unpublished stories, and these we have combined with eight stories which were originally published in *The Coll Doll* (1969) and which are not currently available in either of Walter Macken's other collections, *The Green Hills* and *God Made Sunday*.

The Grass of the People

O NCE YOU TURN off the main road out there you are on a winding, twisting, up-and-down road that bisects the peninsula.

It is a lonely place. In your eyes, maybe, but you will be surprised to learn that tucked away in the folds of the rocky fields and the sheltered places near the sea-wracked shore, there are enough houses to cover the heads of about two thousand people. They don't think it's a lonely place. They think it's fine. They feel very sorry for you if you have the misfortune to live like a rat in a city. They till their small fields and they fish the double bay outside and they catch a few brown trout in one of the two lakes, and when the bailiff is not looking they take a salmon or two from the river. They have to export the major share of their children because the long winter nights lead to prolific breeding and everyone can't stay there. Not that they want to. They are a very adventurous type, and they send home nice cheques and money orders at the proper time, so that tears shed for the poor emigrants are mainly crocodile, partly Irish and temperamental, with ten per cent (mothers') genuine and heart scalding.

About half way along the peninsula road there is a large rectangular field with decently built stone walls around it, and in here the people bury their dead. They speak about the death being tragic if the corpse is under eighty years of age (a man in the prime of life)

because they are a long-lived lot unless they are swiped out of the world by storms at sea, but in those cases the bodies are rarely recovered. Everyone loves a funeral. Nobody works. They drink quite a lot and when they plant the person in the graveyard they talk about what a grand place it is to lie, and how they will like to be buried here when their time comes, what a great view they will have of the enclosed bay and the mountains behind, forgetting that they are looking at the view standing on their legs, but that if they are reclining six feet under the earth it's not easy to see the view. To this they will reply, because they are a sincerely religious people, that the eyes of the dead are the hawks of God.

Graveyards have to have caretakers and the caretaker of Cloonbwee was paid five pounds a year and tips. It wasn't a great sum, but then he had very little to do, about ten funerals a year, ten graves to be dug and refilled, and afterwards he could fill his belly with porter for the few days that the wake lasted. Everybody thought that he was doing all right, except himself, and he sat down and with great effort he wrote a letter to the County Council complaining about his wages, talked about the cost of living, his rheumatism, the decline in the price of farmers' produce, and Big Bartley said he was told by a councillor that the caretaker also mentioned the two Great Wars, the Franco-Prussian War and the Great Wall of China.

The caretaker was known as Gorgeous. He was really very ugly. One good look at him would stop an average-priced clock, but he was a soft man and never did anything to hurt his neighbour until the graveyard business came up. All the people of Cloonbwee talked Irish. They only threw in odd words of English, and it was a young fellow who had spent some time in America who came back and was throwing around the word "gorgeous" every five minutes until it became a cant and landed on the caretaker.

They say that there was a lot of fun at the meeting of the Council that considered his letter. First it was in Irish and had to be trans-

lated and some of the translation was unfortunate, but anyhow the upshot of the thing was that they granted the caretaker an increase of two pounds a year and also gave him permission to sell the grass of the graveyard.

That's what started it. The grass of the graveyard, which as you know grows very high and luscious. The whole of Cloonbwee, as a Midland farmer once remarked, wouldn't make a decent-sized field. Near the sea it is rocky and the bits of salvaged land have to be intensely cultivated, but God's acre in there grew great grass, with hardly any effort at all.

There was uproar among the people.

Afterwards of course, when they came to talk it over, they decided, but were not quite sure, that they didn't give a damn one way or the other about the grass of the graveyard until Big Bartley, Bartley Tom that is, stirred them to the depths of their souls about the horror of it. If it wasn't for Bartley Tom, in other words, they wouldn't have realised the enormity of the crime that Gorgeous was intent on committing. Bartley was a nice, tall, twinkling-eyed, clear-skinned man who fished as well as farmed and owned a lovely black pookaun boat and was the father of ten children, and since a man of such rectitude took this matter to heart so badly then, everybody thought, he must be right and they became protesters too.

"Letters," shouted Bartley, "must be answered by letters, and we the people of Cloonbwee will write a letter that will never be forgotten."

It was arranged that the meeting be held in the local pub. They could have asked the priest for the loan of the parish hall, but the consumption of strong drink was banned there, so they had no option in a way.

Every able-bodied man in the place was crowded into the pub, much to the delight of the owner (who naturally enough was on the side of the people). Bartley stood in front of the great open fire

3

with his legs spread and a pint glass in his hand, and Tom Tony, a young man who was on the point of going to college to become an agricultural scientist, sat on a form and drafted the letter on top of a Guinness barrel. Away below in the corner, bending over the counter, was Gorgeous. He might as well have had a disease, so little notice was taken of him. He wasn't invited to the meeting, but the place was a public tavern and how could any man keep him away from it?

"So we are agreed, men," Bartley said.

"We are agreed," they shouted.

"Write down, Tony," said Bartley, with a gesture, "'*To the Councillors of the County Council, O Friends*'."

"That's a good start, Bartley, right enough," they encouraged him.

"'*The people of Cloonbwee have lived and died in Cloonbwee before the Firbolgs were ever even heard of.*' Have you got that, Tony?"

"I have that," said Tony, blowing the top off a pint.

"That's sound talking, Bartley," they said.

"Now attack," said Bartley, "like this: '*What are ye trying to do to us? Aren't ye the elected representatives of the people? What has come over ye? Have ye entirely lost yeer respect for the dead?*'"

"Oh ho," they encouraged him, "that's great talk, Bartley. That will rock the devils sure enough. To the foundations," they added.

"Right," said Bartley, thinking, his eyes dropping on the miserable Gorgeous who was listening closely.

"'*Ye appoint over the bones of the dead a man who was one time an honest person who was content with his lot, until he became possessed by the devil.*'"

"Ho-ho," they said, looking over their shoulders at him.

"That's not true," Gorgeous suddenly shouted in his own defence, but being greeted by cold looks he subsided.

"'*Possessed by the devil,*'" Bartley repeated. "'*What else can we the people think when he asks ye to do this horrible thing, the greatest desecration in the history of the world.*'"

"Oh, man!" they praised him.

"Hold on a minute now, Bartley," Tony said, writing furiously.

"It makes me blood boil in me veins, dammit," Bartley said and cooled his blood with a great emptying of the glass in his hand. "Fill it up again, Joe," he said. "Now! *'Ye give to yeer miserable henchman the right to cut and sell the grass in our graveyard. Have ye thought what this means?'*"

"*'What this means,'*" said Tony.

"*'We'll tell ye here and now,'*" Bartley shouted.

"Coming up, Bartley," said Joe, sliding the pint.

"Thanks, Joe," said Bartley and took it.

"I'm only a poor hardworking man, trying to make ends meet, that's all," Gorgeous suddenly shouted, but for all the attention he got he might as well have been a curlew over the Atlantic.

"*'Yeer miserable scavenger cuts the tall grass fertilised by the bones of our grandmothers,'*" Bartley dictated. "*'He sells it back to the children of the dead. They feed their cattle with this holy grass and what happens? Tell us that, let ye.'*"

"By gob, Bartley, that's powerful business," they tell him.

"Are you right, Tony?" Bartley asks.

"Coming up, Bartley," Tony said. "Right, now."

"*'We'll tell ye,'*" Bartley shouted. "*'We kill our cattle fed on the flesh of our beloved and we eat the meat, and what will we be known as from all time henceforward. I'll tell ye! We will be known as the Cannibals of Cloonbwee.'* Am I right, men?"

"You're as right as rain, Bartley," they shouted at him.

"Is it anything else?" Bartley asked them. "Did anybody since the beginning of the world hear of anything worse than that, that we should be eating our own grandmothers. Tell me that? What kind of a man is it, one of our own, that would even dream of such a proposition? What kind of a man is it that would be sitting down at his own table before a feed of stew and for all he know be eating his own Uncle Daragh that died and was buried in that same graveyard

only two years ago. I say shame on him, that's what I say. Shame on him!"

"Ooh, shame on the bastard indeed, Bartley!" they shouted.

Gorgeous was nearly crying.

"But it wasn't like that at all. I didn't mean that at all," Gorgeous shouted. "I don't want to be eating me Uncle Daragh."

"I'm right now, Bartley," said Tony.

"'*Beware!*'" Bartley dictated. "'*Beware! If ye won't be haunted by the outraged flesh of the dead, then ye might be haunted by the living fists of the living! And what might happen to the miserable slave of the grave, if he tries to sell the grass no man knows, but he won't be long a living ghoul.*'"

"Hasn't he lived too long already?" somebody asked.

"Maybe something ought to happen to him right now?" asked somebody else.

"But listen, can't ye listen, men?" Gorgeous asked them, but he had no chance of a hearing. He began to sweat a little.

"Finish the letter — '*It is we the people of Cloonbwee of high opinion of ye, in defence of the grass of the people*' — and then we'll all sign it and I'll post it in the morning with my own two hands," Bartley finished up.

Gorgeous had come out a bit from his corner. He tried to take the middle of the floor.

"I can tell ye," he said. "Ye don't understand. Are ye going to hang a man without listening to his side of the question?"

"Isn't our patience exhausted?" Bartley asked. "Did anybody invite that fella to the meeting? If he isn't out of that door in five seconds, what's going to happen to him?"

"He's going to be fired into the cold sea," they roared.

"Now listen," said Gorgeous, but he started backing to the door.

"One, two, three, four," Bartley started counting.

"But if ye'd only listen...," said Gorgeous.

"Five," said Bartley, and Gorgeous was gone into the night.

"There's never been a more powerful letter written since Daniel

O'Connell," they told Bartley as they filed up to append their names to the letter. Then Bartley folded it and put it in an envelope, let Tony address it, and then put it in his pocket, and they drank and sang and had a few steps of a dance there until closing time, and they all made for home very pleased with themselves and indignant at Gorgeous, and Bartley went home humming, and near the graveyard he turned up towards his own house. (The plot of land for the graveyard had been bought from Bartley's father twenty years ago for a round sum. In fact Bartley's holding surrounded the graveyard; that's why his house was near by.)

As he expected, when he got near his house Gorgeous came out of the shadows.

"Bartley," he said.

"What do you want?" Bartley asked him very gruffly.

"Are you really going to post that letter?" Gorgeous asked.

"As sure as the sun comes up in the morning, I am," Bartley assured him.

Gorgeous sighed.

"You're a hard man, Bartley," he said. "All right. Don't post the letter and we'll go on as before. I'll cut the grass and throw it over the wall to your beasts. We'll let it go at that, Bartley, but you're a hard man, a hard man."

"H'm," said Bartley. "As long as you have seen what a shameful thing you were about to do and are truly sorry for it, I'll not send the letter." And there and then he took it from his pocket and tore it up and let it go on the breeze.

"Goodnight, man," he said then and went home whistling, and if the people wondered why there was never anything more about the famous letter and the grass of the people, they know now.

What'll We Do with the Yanks?

THE POSTMAN BROUGHT the letter at the end of February. Joe sat in to read it while the postman regaled Mary Ann with a description of a wedding party the evening before.

"It was a fierce drunk, Mrs Coleman," he said. "I have a head on me this morning like a tupenny turnip." Mary Ann suggested a mug of tea. "A life saver," he said. "My mouth is like a rasp. It was a terrible do, powerful pugnacious drinking."

Joe recognised the handwriting.

"It's from Jack, Mary Ann," he said surprised. Jack was his brother. Usually he only wrote at Christmas.

"You should have seen old Bartley," said the postman. "Like a goat. A remarkable man for his years. Over eighty, and he pinching the young girls every time one got near the dresser. Wouldn't you think desire would be dead on him at that age?"

"He's a dirty old man," said Mary Ann. The postman laughed.

"You have to admire his stamina all the same," he said.

"Jack is coming home," said Joe, in great dismay.

"What?" asked Mary Ann, halting in the pouring of the tea.

"And he's bringing his girl with him," said Joe.

"No!" said Mary Ann.

"He is!" said Joe.

"Yanks is it?" the postman asked.

"My brother and his daughter," said Joe.

"What'll ye do with them at all?" the postman asked. "When was he home last?"

"Not since he left," said Joe, counting in his mind. "He was about twenty then. Thirty-five years ago."

"Oh man," said the postman, "I wouldn't be ye! We had an oul aunt home five years ago. She was a penance. Fussy as a pickin' chicken." He supped the hot tea loudly. "That's great stuff. It's better than the hard tack when it's all added up."

"When are they coming?" asked Mary Ann.

Joe consulted the letter again. "Fifteenth of March," he said.

"Two weeks!" Mary Ann ejaculated. "What are we going to do?"

"It's like the bad weather," said the postman, "it has to pass sometime. Did I know Jack?"

"You were in your cradle," said Joe. He walked to the door, looked out. He was a lean man with blue eyes.

"Don't worry, Joe," said Mary Ann.

He turned and smiled at her. The frown left his forehead. He noticed that her brown hair had very few strands of grey in it. They had no children. It made them sad, but close too, in a way.

"No worry," he said. "It's not a tragedy. It's a brave thing to see your only brother again after that long time." He went into the room off the kitchen, the rarely used sitting room with the polished table and the soft chairs. The framed pictures were on the mantelpiece. He took up the picture of his brother. He could hear the postman making Mary Ann laugh again about the wedding. She had a deep laugh.

This well-dressed man with the silvery hair. He didn't know him at all. He was a stranger. Dimly he remembered a well-built young man with fair hair and piercing blue eyes. He was a success. He had gone to college, by hook and by crook, and made a law man out of himself. Yes, he was a success all right.

"Goodbye, Joe," he heard the postman calling. He went down.

"Thanks, thanks," he said.

"There's a lot of rain due," the postman said looking at the sky.

"Let if fall," said Joe, joining him to view the lowering sky and the muddy coloured sea. "Get it over."

"It never rains," said the postman laughing, "until you have someone coming. God bless ye." Then he was gone. Joe went in again.

"Why are we afraid of their coming?" he asked.

"We are afraid of them making us ashamed of what we have," she said.

"What we have is nice and good," he said.

"It is," she said. "But as soon as you start looking at it through the eyes of other people, you begin to fault it."

"They are used to such rich things," said Joe. "I'll have to buy paint."

"You painted for the Station," she said. "There's no place left to paint."

"All the same," he said, "I better buy some paint."

When you are in trouble you can depend on your neighbours.

Mrs Concannon called, barely fifteen minutes after the postman had left. There was no subterfuge about her call. "Ye'er having Yanks, I hear, God help ye," she said, sitting and breathing deeply. She was a heavy woman.

"Isn't it fast ye heard it," said Joe, but she rightly ignored him.

"We had one at home for a while a few year ago," she said. "God forgive her. She had bugs on the brain." She twitched at her shawl.

"Bugs?" asked Mary Ann.

"Everything is bugs with them," Mrs Concannon explained: "house flies, horse flies, daddy-long-legs, midges, moths and beetles. You'd want to have killed all the flies in the world for them. If God didn't want bugs, would they be in it at all?"

Like the good neighbour she was, she gave them a lot more advice too. So did Pension Foran, in five minutes after Mrs C departed.

"Red meat, bad luck to it," he said, thumping his stick on the floor and missing the fire with a tobacco spit. Mary Ann winced. "Home they brought a lump of steak from the town. Cook that.

11

Half of a bloody bullock near. So then? Ye burned the bowels out of it, they say. They want it with blood coming out of it, like you'd see in a slaughter house. Hardly kissed by the pan, bejaney! Like the cannibals, bless the mark, with raw blood running out the side of their mouths." He gave further advice.

So did Jenny McGrath, when Pension had departed, and Mary Ann was sweeping his miss-spits with the twig.

"Oh, cold," she said. "They do be as cold as winter water. Balmy days that you could do without a drawers, and they wrapped in fur coats shivering over a turf fire that'd burn a hole in a granite rock. Put fire everywhere, everywhere," she advised. "Let yeer chimneys be smoking like powerhouses or they'll die dead. And pray that it doesn't rain. They don't want it to rain. I'll do a novena for ye that they won't stay long and that God'll send July weather in March." She left then.

Joe and Mary Ann looked at one another. They were worried. But they worked and got rid of their worries. Joe painted everything again except the inside of the wide chimneys, and he would have done that, too, if they had invented a paint that would go on over soot.

Sarah watched her father John D. They were in the airport restaurant. He was only toying with his breakfast.

"Why are you so nervous?" she asked him. "You haven't committed a crime. I have never seen you like this before."

He threw down the fork.

"I'm worried about you," he said. "I don't want you to get the wrong impression. I don't want you going down there with green stars in your eyes. That's all."

"How could I?" she asked. "You have me indoctrinated. We travel about eighty miles from here to a small scruffy village near the sea. We will sleep in a little insanitary thatched cottage, with tiny windows making you feel suffocated. Possibly we will have to share

our beds with ducks or hens or a cow. I don't know which. It will rain like hell all the time. Outside nothing to see but wild water and rocks and rocks and rocks. Are you happy now?"

He was a bit angry.

"I didn't make it out that bad," he said. "Dammit, it's not that bad."

"Well, that's your picture," she said.

"It's thirty-four years," he almost shouted at her. "Things may have changed a bit."

"Oh, no," said Sarah. "That's what you impressed most on me. Things never change. Never! That's why you had to get away."

He calmed down.

"As long as you don't expect too much," he said. "You have seen some of them come back after being over. For years they built up a romantic picture of their old homes, like misty places in a never-never land. No place could live up to their dreams. They were sad. I don't want you to be like that."

"You mean you don't want yourself to be like that," Sarah said. "Listen, father, I don't give a damn what it's like. I'm going to enjoy myself. I just want to see the place we came from. You can go ahead and nurse your own complexes." She started to eat her sausage with determination.

She was about to convey the sausage to her mouth when she was stopped by the sight of a huge man in bulky clothes and a cap on the back of his head approaching them with shining eyes and she winced in anticipation as a great red hand was raised and fell on her father's back with a sound like thunder. A flood of words in a strange tongue was pouring out of him, and to her surprise her father rose and returned the blow and gave back as good as he got in the same language. They laughed and clapped their thighs and shouted and drew a lot of attention until her father came to his senses.

"Hey, Sarah," he said. "Did you see that? He knew me! After all those years he knew me!"

"Why wouldn't I know you," the man said, "where you are as ugly as ever, just that you're a bit stout?"

"Did you hear the way I hadn't forgotten?" her father asked. "Did you hear the Irish come flooding back to me, after all those years?"

"Why would you forget it?" the man asked. "Do you forget your mother?"

"Will you introduce me to your friend?" Sarah asked, acidly.

He laughed.

"This is my daughter, Sarah. Tom Tuttle."

Tom held out his hand. "You're welcome, Sarah," he said. She gave him her hand expecting his grip to powder her bones, but his clasp was gentle. "You are not a bit like your father," he said. "You have the good looks of his mother's people. Well, it's great to see ye. Joe sent me for ye. Fill yeer bellies fast and we'll be on our way. Joe is in a fever."

"We are ready now," Jack said. "Off with us?"

"What about my sausage?" Sarah asked.

"You can eat live pig if you like when we get below," said Tom.

"We better go, Sarah," her father said. She rose, resignedly.

She had never seen her father like this. He was laughing, talking loudly. They threw her into the back of the car with the suitcases and set off, talking to one another again in Irish, laughing and chuckling (at times, obscenely, Sarah thought).

Tom threw some words back to her once over his shoulder just as he was going around a hairpin bend on his wrong side at fifty miles an hour. "We had fierce rain," he said, "but ye brought the fine weather."

The sun was shining. The very green fields looked freshly washed. She hadn't much time to look about her. Tom seemed to own the rules of the road, because he broke all of them. She was all the time keeping the pile of luggage from falling on her. But her father was happy. She could see that. So she didn't mind.

After some time Tom addressed another few words back to her.

"We're nearly there now, Sarah," he said, "but I hope the flood is off the road."

At that moment the car was enveloped in forests of spray shot up by the wheels. The car quivered and sputtered and stopped dead.

"The curse of hell on the County Council," Tom said. 'We'll have to get out and push.

Her father laughed aloud. "By the Lord, I'm home all right," he said.

"You can take off your shoes and roll up your pants," said Tom. "We'll need all the manpower we can get for this." Sarah laughed. "You too, Sarah," he said. "Off with the stockings."

"I will not," said Sarah. She was indignant. "After all, I am a lady."

"There was no sex in the Flood," said Tom, busy undressing his lower limbs, "and we can't afford it here."

"Can't I guide while you push?" she asked.

Tom was kind with her. "The car weighs nearly two ton," he pointed out. "There's two foot of water. Not a soul on the road and it'll take the combustion of the three of us to free her. Why am I wasting my breath?"

Sarah started to undo her stockings.

Her father was laughing. His pants were rolled. He got out of the car. "Wow!" he shouted, "the water is cold, Sarah." She tucked her skirt. She put a white foot into the water. It was cold. It made her catch her breath. She let herself into it painfully. The water was above her knees. She could feel small pebbles under her feet.

They pushed at the car. What in the name of God am I doing here? Sarah was wondering. "Hup!" Tom would shout as if he was encouraging a plough horse. Sarah thought her heart would break, but soon the water was around her ankles, and Tom had the brake on. She was spent.

"Ye'er powerful," said Tom. "That's the stuff. Run around and dry yeerselves till I clean the water out of her."

Her father caught her hand. "Come on, Sarah," he called. "It is

just over the hill." She squeaked as the pebbles found the soles of her feet. Then they were running on the grass margin. They stopped.

"Well, will you look at that!" her father exclaimed.

They were looking down. The hill they stood on sloped a thousand feet to sea level. It was like standing on the rim of a half broken saucer. The sun was low and was shining on the sea, colouring it green and blue, and glinting off two long beaches of silver sand. On their right many mountain streams rushed foaming into a blue lake, and out of the lake a wide river ran and divided itself under a three-arched humped bridge. On the other side of the bridge lay the village of neat white-painted cottages with slate roofs. They could see a small dot of a dog running down the street that ended at a pier where black masts of boats rested. The fields all around the village looked tiny, terribly green, and were fenced by grey stone walls.

"What a beautiful slum," Sarah said.

"I didn't say that," he shouted. "You are twisting my words. I never looked, that's all. When you are working hard, how can you look at beauty?"

"Rocks and rocks," said Sarah, "and potato patches and hills, that's all, you said."

"All right! All right!" he exclaimed. "I'll show you." He called. "Tom, come here." Tom came, rubbing his hands on his trousers. "Do you think that's beautiful, Tom?"

"Down below is it?" Tom asked. "Arrah, it's all right. What about it? The car is ready now. Come on. We'll be dead late."

"You see!" said her father triumphantly.

"All the same, you deceived me," said Sarah. "You deceived me."

Jack was very tense as the car made its way down to the village. His mind was busy. He saw himself as a boy here on the bog loading dried turf into the pannier baskets of the donkey; fishing the far stream with a worm and a line and a long ash pole; dancing there

16

at the crossroads to the music of a fiddle, and slipping away in the darkness to court Jenny (what was her last name?) at the back of a clamp of turf. He remembered himself, restive, strong, active, with itching feet and a discontented heart.

The car stopped outside a house. There was a neat wall around it and a small iron gate into it. The house behind was new. His brother was standing there.

Jack alighted quickly. He was in his bare feet holding his shoes in his hand, the trousers rolled up on thick hairy legs.

"Joe," he said. A thin serious child had become a lean serious man, calm, unlike himself. With a slow smile. His hand was hard and his handclasp firm. Is this my brother? thinks Joe. Is this my brother, thinks Jack. Great God, the years have passed. And Mary Ann. He hadn't remembered her at all, maybe as a young girl with a polka dotted pinafore and plaits.

Joe was looking at Sarah, a fair-haired girl, loose-limbed, shoes and stockings in her hand.

"Holy God," Joe said, "what did Tuttle do to you?"

Sarah was meeting her uncle. They were both shy so that gave them something in common and they took to one another. "Do you have to let them arrive half naked?" Joe was asking Tuttle.

"Arrah, we only ran into a small puddle," said Tom going in with the suitcases.

"Come in and sit at the fire and dry yourself," Mary Ann was saying to Sarah. "You'll get your death." Sarah liked her.

Jack was looking and looking and not finding it.

"Joe, Joe," he said "where's the house? What did ye do with the house?"

"It's gone," said Joe. "We pulled it down. We used it as a stable for a while and then we destroyed it."

"Why did you do that?" Jack asked. "You shouldn't have done that."

"Times change," said Joe. "There are new ways."

"There shouldn't be! There shouldn't be!" Jack almost shouted.

The house had been the fear and the love of his life. The thatched roof and the black rafters with the home-cured bacon hanging in flitches from hooks. His bare-footed mother with a red petticoat on her bending over a large three-legged pot swinging on an iron bar over the open turf fire. The straight-backed wooden chair with the arms which his father sat in after working like a slave all day, all day with the spade or the scythe or the sickle. He had hated it and all that it stood for that was against his desires, and now it was gone and there wasn't a stone of it left nor a wisp of the straw off its roof.

"You never liked it, anyhow," said Joe. "You usen't to." This was true, but it saddened him to hear it said. He had built a different picture of it in his own mind by now and it was gone and all that remained was the picture in his mind. "Come on in," said Joe. "You are not used to standing in your bare feet."

He followed him into the strange house, neat as a new pin, gleaming with paint. Tom was wiping sweat off his forehead with the inside of his cap. The house was as hot as hell. A huge fire. Sarah was rubbing her feet with a towel. She was laughing. "You could roast a bull on that bloody fire," Tom was saying. "I'm going. I'll be over for a ramble tonight, Jack. Good girl, Sarah. If we have you here for a while we'll make a woman out of you instead of a lady." She laughed. He waved and he was gone.

Jack was a bit dazed, but he noticed Joe going around the kitchen clapping his hands together.

"What the hell are you at?" Jack asked.

"Killing flies," said Joe.

"Are you gone soft in the head?" Jack asked.

"But ye don't like flies," said Joe.

"Who doesn't like flies?" Jack asked, amazed. "I like flies. It's a big world. There's room in it for man and insects."

Joe started to laugh. "I should have known," he said. "They told us ye were mad against bugs."

"Who told you?" asked Jack.

"Other people who had Yanks," said Joe, and then was sorry he said it. There was a silence in the kitchen. Sarah looked anxiously at her father. He dropped his head in his hands. How far away can you grow from you own brother? he wondered. Joe was thinking the same thing.

"So that's all we are, is Yanks," said Jack.

"Didn't mean it that way," said Joe. "It's only a sort of a word."

"Will ye look at yeer rooms," said Mary Ann. That shifted them. They were very neat rooms. No hot and cold but clean clean. There were fires burning in them too. Sarah said to her father, "What, no chickens, Pop?" and then was sorry that she said it, so she went out with Mary Ann to feed the chickens, while Jack looked out the front door at the hills and thought and Joe stood uneasily behind him.

"It takes a time to get used to it again, Jack," he said.

"The years are short," said Jack, "but they are long too."

"Maybe you should have come home sooner," said Joe.

"Yes," said Jack. "You keep saying next year, next year. My wife didn't know it. I meant to bring her. It's too late now."

"I was sorry to hear that she went on you," said Joe. "She seemed a nice woman from her picture. Maybe she's getting a better look at it now than if she was alive."

"Aye," said Jack.

"We have good thick steak for your dinner," said Joe.

"Dammit to hell," said Jack turning into him. "Who wants steak? Don't let everything change. For the love of God, haven't you bacon and cabbage?"

"Now you are more like my brother," said Joe laughing. "To hell with the steak, eh?"

"That's right," said Jack, "to hell with the steak."

And he laughed.

He laughed more that night too, when the people came rambling

to have a look at the Yanks, although he was shocked to pick the faces of the youthful people he had known from the aged faces of the people around him. That was the curse of it, he thought, you remembered people and places as they were, not as they are. You made no allowance for age and change. You passionately held on to your dreams in which nothing had changed. He was shocked when after a long time he saw through the wrinkles and greyness of Jenny McGrath the fresh buxom girl he had held in his arms on many a night under the stars.

There was drink there, a half barrel of porter on tap, dispensed by Tom Tuttle. That livened things up a bit. He saw Sarah really enjoying herself. The local youths were all sparked out in worsted suits and stiff white collars. We never wore clothes like that, he thought, but thick homespuns and heavy hobnail boots. Wasn't it all that I ran away from? He could still smell the wet wool.

It was four in the morning when the last reluctant visitor left and the inside of the barrel was as dry as a frightened mouth.

Sarah and Mary Ann and Joe were left in the kitchen.

"You had a good time, Sarah?" Joe asked.

"I did," said Sarah. "I am happy. I'm so glad we came."

"Is your father happy?" Joe asked. Sarah frowned.

"No," she said. "I thought he was happy at first. But now I don't think so."

"He won't stay," said Joe, shaking his head. "He'll go. If only he'd stay a while we might get to know one another again."

"Where is he?" Sarah asked.

"He must be gone out to ..." said Joe.

"... wash his hands," said Mary Ann finishing it for him. They laughed.

"I'll go look for him," said Sarah. She went into the night.

When her eyes became adjusted to the moonlight, she saw him leaning on the wall looking down towards the sea. She went to him and put her hand on his shoulder.

"Is it bad?" she asked.

He had been thinking; there are only a few hours until dawn. He would hire a car then and get back to the airport.

"You are between two worlds," he said. "That's no good."

The moon was shining on the bay. The water was ruffled with a breeze as light as the breath of a child. They were encompassed by the hills. They could hear rivulets everywhere running to the sea. The grey stone walls were pale.

"There's peace in it," she sighed.

"Not for me," he said.

Then Joe came out, calling, "Jack! Jack!"

"Over here," he called. Joe came over to them. There was a very worried look on his face.

"I'm sorry things are not better, Jack," said Joe. "If it was next year, I would have had a bathroom built and a toilet."

"Don't be daft, Joe," said Jack.

"It would be more civilised to have a bathroom for ye and not to have ye washing yeer hands in a field."

Sarah laughed. She put her arm on his shoulder. "The Waldorf may have the plumbing, Uncle Joe," she said, "but you have the view." She waved her hand at the beauty below them.

Jack was looking at the worried face of his brother. He suddenly thought: All he has done for us, the hot fires and the bugs and the steak. He had a quick thought of all the work that had gone into painting and cleaning and doing up, for this strange brother coming home from America. The warmth of the welcome and the anxiety. Why there's nothing at all wrong with me, he thought, except that I'm a selfish son of a bitch, examining myself like as if I was lying on a psychiatrist's couch. Me!

"Joe," he said suddenly, "tomorrow we take a boat and we go fishing!" He was pleased then when he saw the look of surprise and pleasure that dawned on the two faces opposite him.

"Not tomorrow," said Joe. "Tomorrow I have to cut turf."

"Fine," said Jack, "tomorrow we cut turf and the day after we go fishing. How is that?"

"Why that's fine," said Joe.

"That's all right by me too," said Sarah.

"Right," said Jack, "clear off out of here now the pair of ye until I wash my hands."

They laughed. And he laughed. And mind you his laugh was lighter. And he watched the dawn up over that bay.

Solo and the Sailor

T HE VILLAGE OF Gortshee dipped down to the sea from the hills. These were a range of tall hills, craggy at the tops of them and clothed lower down with heather and fern and short spiky grass beloved of the small mountain sheep who gathered each blade of grass carefully with a curled tongue before snipping it short. If you stood on top of one of these hills on this fine sunny Sunday morning, on your right you would look down where Gortshee nestled near the sea, with its few shops and houses, and up here you would hear the sonorous clanging of the Mass bell, and see from all sides and from all the roads the small dots of people converging on the church by foot and bicycle and motorcar. It would be only an illusion, but you could smell the polish on the shoes, and see the creases in the trousers of the Sunday suits; even smell the mothballs off them.

Turn to your left then and you looked down on a lonelier scene, all the houses widely apart, clinging to hillsides or hugging the shores of the great lake, and by screwing up your eyes you would spot a much smaller church, hidden behind the thickly planted spruce and pine that broke the winds of the winter as they screamed down the valley over the waters. The spire of this church was much smaller, and you would have to strain your ears to hear the calling of the bell. But here, too, on the roads you would see the people, in smaller numbers, making their way, more labori-

23

ously on account of the hills, towards the little church in the trees.

If you started to walk down in this direction, you would have to scramble and walk cautiously or you would end up running and probably break your leg from the impetus of the steep decline, but later it would round out and become softer like the bosom of a happy woman. It was named that way. It was called Brollach na mBan, and farther down its slope you would pause to admire the new cottage set among the green fields. Hah, you might say, this is the place of a good man, from the way the acres had been won from the maw of the mountain, the rounded fields walled by the stones cleared from them and neatly built; the outhouses clean and freshly whitewashed, the haybarn choked with last year's hay; and the ten-year-old conifers planted at the back of the house and bravely climbing against wind and weather to shelter the house. You would saunter past admiringly, feeling that you ought to go into the house and say to the owner how much the sight of his place pleased you and how you felt you had to call and tell him how much you admired his industry, his victory over difficult circumstances, the bravery of the human spirit, and the placid peace he had created from a violent land.

You couldn't do it. You would have to travel down the valley behind the church and go in and talk to a new headstone there, with the name Thomas Patrick Murtagh written on it, and Aged 32 years.

Also it was a good job you didn't put your nose into the house when the idea came to you, because it was by no means peaceful.

The Sailor was on the rampage. It wasn't that Sheila Murtagh was afraid of him. She was a hard girl to intimidate, but he looked gigantically violent. His shirt open to show an enormous hairless chest sunburned and tattooed. He had a head of rich curls, and a blue trousers held up by a thick leather belt. One rarely associates curly hair with violence, but with the Sailor it seemed to accentuate his violent look. She wondered, as she had often done before,

24

how the Sailor and gentle Tom Pat, her late husband, could have come from the same womb.

"I say you don't go to Mass," he was saying. "What happens about the dinner? What happens about the feeding of the animals? Am I expected to be doing all that while you are down below showing off a new coat?"

"You'll get your dinner," she said. "The least you can do for being fed is to do a few chores about the place. I don't go to Mass to show off a new coat. I go to worship God and to ask him to give me patience with you."

He could admire her. She was well built. She had a broad face with strong white teeth, two deep dimples below her jawbones, and a head of blue black, strong hair. Oh, he could admire her all right, if she didn't infuriate him. And his head was bursting from the Saturday night in the village below.

"Damn you," he said. "You'll do what you're told."

"You can stop shouting," she said. "You are frightening Joepat."

Joepat looked frightened. He was holding his mother's coat with one small hand, and peering around her with his eyes wide. He had a thin face, delicate bones, like his father. His father. Near enough dead that Joepat could be flooded with tears when he thought about him, and he associated his going with the coming of this fierce man who was now his uncle they told him. Joepat didn't want any uncles if they were like him.

"You are standing on my ground!" the Sailor shouted. "This is my hearth. It always was. My brother only worked this land out of my kindness, because it always belonged to me."

"You never wanted it," she said. "If it was yours why didn't you stay home and look after it, instead of acting the stallion and running away, running away."

She was pale. She shouldn't have said that. He came over on top of her and he raised his arm to strike her. She didn't flinch. Joepat did. He buried his face in his mother's thighs and cried, "Mammy!

25

Mammy! Mammy!" The Sailor let his arm drop. His eyes were red. He had left home on that account, on account of the girl with whom he had casually mated, and then left. That's what had made him a Sailor. But there was a deeper reason than that, a much deeper one, and that's what hurt him, that it should have come from her mouth like that.

"If you ever say that again," he ground out. He hit a fist into an open palm. Like the crack of a whip. "Take off your coat," he said. "You are not going out that door."

"Oh yes I am," she said. She moved to the door, but he blocked it in a swift move with his big body. "You may own the hearth and you may own the home by law," she said. "But I belong to myself and I am going to Mass."

"You won't," he said. "You must obey me. On account of him," pointing to the trembling boy. "You want it for him don't you?"

"It's his inheritance," she shouted at him.

"Not his," he said, "unless I will it. That's where I have you. You won't let go. You'll hold on, like a weed in a river holding the leg of a man. For him. Won't you?"

She was going to answer him when the form of the young man appeared behind the Sailor. He looked over the Sailor's shoulder. He could do that. He was tall, but not half the breadth of him.

"Hello, Sheila," said the young man, unperceptive it seemed. He had fair hair and blue eyes. "Are ye coming to Mass?" Saying this as if the Sailor did not exist, wasn't blocking the way. Sheila admired that. He must have heard the Sailor shouting.

"Yes, Paddy," she said. "We're just going now." Then she screamed because the Sailor had turned like a flash and saying, "Yes, you are going now, Paddy," he had sunk his huge fist into Paddy's belly. There was force and venom behind the blow, and Paddy went back gasping, his arms around his stomach, and as he went back the Sailor hit him in the mouth so that he fell flat on his back in the dust outside the door. The Sailor wasn't content with taking him so unawares.

He raised him to his feet and hit him twice more before he let him go and he fell again, and only let him go then because Sheila had grabbed his arm and kicked his leg ineffectively with the toe of her high-heeled shoe. He put her aside and made for Paddy again.

"Let him alone, let him alone," she said. "Very well, very well. I will stay. I won't go." That restrained him. They watched Paddy getting to his feet. It was a hard effort. His stomach was very sore. He groaned as he got to his feet. There was bright scarlet blood running down the side of his mouth. He looked at the Sailor, trying to breathe. "Not the end," he said.

"Go on down, Paddy," said Sheila. "I will see you again."

"And don't come back," said the Sailor, "smelling around the widda woman. You hear that. Nothing goes with her. You take her and you take what she stands up in. That's all." But he felt more satisfied. He had expended some of the violence.

"Take off your coat, Joepat," said Sheila, "and come into the house. It's all right, Joepat, don't cry. You musn't cry. You must be a man like your Daddy was. Now." Joepat tried. Trouble was, he liked Paddy Prender. Paddy liked him. And it was such a lovely sunny day, but for Joepat, it was very cloudy.

Solo stopped his car at the turn up to the Murtagh place when he saw the crowd there. They noticed him as he came towards them and they opened away from Paddy, who was sitting on a stone dabbing at the side of his mouth with a handkerchief that was well stained with blood. Solo thought he might have fallen from a bicycle.

"What's up, Paddy?" he asked, and knew that Paddy hadn't fallen off a bicycle when he saw the closed look that came on the faces of the men. Oho, thought Solo, with a sigh.

"Nothing much, Father," said Paddy, "a little bit of an accident." That was that. But Solo wouldn't have it. Paddy's jaws were white, his elbows were pressed into the sides of his stomach.

"Go on down to the church, the rest of you," Solo said, "and tell them I'm coming."

They looked at him, very tall, very broad, very blue eyed, and they went away. "Let's have it now," said Solo. Paddy looked at him. There were some things you didn't tell the priest. Things that you worked out on your own, but he knew Solo well now. He would never stop anyhow until he had the rights of it, and in a way, it was part of his job. So he told him, watching his face. Solo's face didn't change. It still remained as placid and as clear as ever.

"And he didn't give you a chance?" Solo asked.

"None," said Paddy. "None at all to settle, or it might have been different. I feel very ashamed."

"Don't be," said Solo. "He was too fast. The odds were great. The thing to do is to cut down the odds always. Go away down to the church and tell them Mass will be delayed for a little while, and then come up after me."

"Where are you going?" Paddy asked.

"To bring Sheila to Mass," said Solo and started to climb up the path towards the mountain. He turned a little way up. "Fifteen minutes. Give me about fifteen minutes," he called back, "and then follow me." He winked cheerfully and then went on his way. Paddy, feeling a bit more hopeful, got to his feet. He found it hard to walk straight for a while. But it got better. He left the message at the church and then came back towards the mountain road, and started to climb. He felt better. He felt a cold flame burning inside him. He didn't notice but some of the men came after him, five or six of them, and before they turned up towards the mountain, they broke off ash sticks from the trees, hefted them, and followed after Paddy. So there was a long procession of black dots climbing the mountain towards Murtagh's.

Sailor, Sailor, Sailor, thought Solo as he climbed the hill. It didn't affect his breathing. He was in good condition. You had to be in

good condition to be a priest in Gortshee and its valleys. Lots of places you had to go could only be reached by shanks' mare. He had tried to ignore the Sailor. You can't always interfere in peoples' lives. People have to work out their salvation with assistance. But you can't live with them all the time. The Sailor had disturbed the place like a stone dropped in a peaceful pond. All very subtle. Sort of a hero to young unthinking people. A tough man. Puts an unfortunate girl in the family way and off with him. Virile. Then he returns. He has seen the whole world. What tales he can tell! The freedom of the universe. Amazing how in a short time a man who has presumably conquered his conscience can affect a community. Young people taking a little more to drink; conversation more free; and on to behaviour. Solo saw it. Worried about it. Like a contagious disease. What could you do? His dead brother Tom, such a different character. Solo clucked his tongue at the thought. They had been so happy up on the mountain. Like a haven. Then, bang, Tom is gone, peace is shattered and the Sailor comes home, and nothing is the same again for Sheila or for little Joepat, or for that matter, for the whole of Gortshee.

Well, right, here was an opportunity. Maybe now was a chance to get to grips with it. Dear Lord, Solo prayed to the sky, please don't let me lose my temper, or I'll murder him. He clenched an enormous fist, looked at it, loosened it, and said to himself, Now I am calm. I am calm, I am calm.

"You'll drive me too far," Sheila was saying.

"Oh no I won't," the Sailor said. He was sitting at the table, his long thick legs stretched out from him. "I know you. You'd hold on in this place if the skies fell, for your Joepat. One day, you are hoping, the Sailor will get fed up and he will go away and with the help of your God he will be killed in a storm at sea, and then the place will really be Joepat's. Don't be too sure. You'll never know, see. Always in doubt, that's the way you'll be. And you're too stubborn to quit. I know you."

The doorway was darkened, blocked off. He turned his head quickly. "Hello, Sheila," said Solo, "I came to bring you to Mass." Then he looked at the Sailor. He was disconcerted a moment by the flash of hatred he saw in the Sailor's eyes. Solo wasn't used to that. In a way it was the sort of thing that you didn't quite believe existed. But there it was. It depressed him.

"She decided that she's not going to Mass," said the Sailor, rising.

"You decide to commit a sin, just like that, Sheila?" Solo asked.

"Not me," said Sheila. "Is it a sin if you are physically prevented?"

"And who is going to physically prevent you now. I'm here," said Solo. "Put on your hat, girl, and let's go."

Sailor moved towards him. My God, Sheila thought, he would even attack the priest.

"Not today, Father," she said. "It's not possible today."

Solo was face to face with the Sailor. The Sailor was nearly as tall as he, but not quite as broad. Solo studied his face. The eyes met his all right and didn't waver. The face was deeply lined. The lower lip was heavy and sensuous. A broad strong face with very restless eyes. And yet, he thought, somewhere there must be good in him. Where in his face was it? Maybe the thin nostrils, the almost snub nose from the bridge of which not even tropical suns could burn away a few freckles.

"Let's go outside, Sailor," said Solo, and turned his back on him. He walked across the road and over to where the stone wall was built opposite, enclosing a patch of green grass where two small black bullocks and a red cow stopped grazing to look curiously at him. He stopped at the wall and turned.

"Look," he said. "You can't expect me to engage in a rough and tumble with you over this question, but I may say in passing, that if I was a civilian you wouldn't know what hit you."

"Why can't you fight?" Sailor asked. "Are you different to other men? What's so different about you? You can be afraid like other men, too."

"I'm a bit different to other men," said Solo. "You wouldn't under-
stand that, and it's not of my own choosing. You wouldn't understand
that either. And I'm sure my Boss wouldn't wish to see me on a sunny
Sunday morning engaging in fisticuffs, but I'll tell you something. You
are a gambler?"

"I gamble," said Sailor, tensed, a little intrigued.

"When you were young," said Solo and added, "and innocent,
you had a name in Gortshee. You were a good athlete."

"Like you had the name of being a footballer," said Sailor, sneer-
ing.

"Right," said Solo. "You could throw the stone?"

"Better than any man in Connacht," said the Sailor.

"No, no," said Solo, "better than anyone except me. Listen.
We'll throw, lift, and jump the stone. Are you game?"

The Sailor was amused. "She'll never see Mass at that rate," he
said.

"Fine," said Solo, "we will mark a spot." He walked a short dis-
tance into the field and dug a line with the heel of his nicely pol-
ished black shoe. Then he went back to the wall. He kicked at it
with a foot and a lot of stones fell off the top of it. The bottom
stones were not just stones. They were granite boulders. Solo bent
down and took a very big one in his hands and hefted it. He dis-
carded it and took an even bigger one. It seemed to be no effort to
him. Another man would have sunk to his knees under the weight
of it. Solo shouldered it on one hand and walked to the mark. He
paused there, swung his leg, and threw it. It didn't go far, but it
went very far for its size. He wasn't out of breath. "Can you beat
that?" Solo asked.

"I can beat it," said the Sailor and went and collected it. He
didn't expect it to be as heavy, Solo noticed. Its weight surprised
him; it had looked so light in the hands of Solo. He had to carry it
in his two hands back to the mark, before he hefted it. He tried to
disguise the effort it cost him, but when he threw it, it was three

feet behind the hollow of Solo's throw. "I slipped," said the Sailor and went for the stone again. He threw it again and again and again but his best effort was still behind Solo's. Solo noticed with pleasure that his efforts were taking it out of him. "You win that toss," he said then.

"Thanks," said Solo, and went to look for one to lift. It was buried at the bottom of the wall. It was a very big one. Solo dug his fingers under it, feeling the clay going into his nails. The Sailor was watching the black cloth of his coat stretching. Sheila was at the door. Joepat was standing beside her. My God, thought Solo, what a strange scene on a Sunday morning, and why do those sort of things have to happen to me?

He held his breath, clenched his teeth and slowly and reluctantly the great rock came from its hole. He shifted the grip of his hands, slowly, and raised it to the height of his shoulders. No man could raise it any further and Solo didn't try. He placed it back gently on the ground. He was breathing fast now, all right. He had to rub the tendons of his arms with his hands. "It's all yours, Sailor," he said and sat on the wall. The Sailor spat on his hands. He was murderously intent. No white priest could do this to the Sailor. It would be the disgrace of a lifetime. He had always been noted for his strength. Widely known. In every port in the world. He attacked the boulder, instead of approaching it gently. He couldn't lift it. He was flooded with shame and anger and despair. He could only get it as high as his shins, before it beat him. His tongue was hanging out. If he had the strength at that moment he might have hit Solo.

Solo was on his feet. "All right," he said. "We'll jump the wall." The Sailor wouldn't sit. He wouldn't show that weakness. He watched as Solo took two very heavy stones in each hand, stood beside the three foot wall and from the standing position with his two stones leaped over the wall. He threw the stones at the Sailor's feet. "Now you," said he to the Sailor. Funny, he thought, he should

quit, but they were all like that. Never knew when they were beaten. So he wouldn't quit. He took the two stones. They were fearfully heavy. He gathered himself to leap, and leaped and fell against the wall. He took skin off the back of his hand. It began to bleed. He became murderously intent again. So intent that he didn't know that Paddy Prender had arrived and was watching him with clenched fists, and that behind him several determined men with hard faces had also arrived and stood in a ring watching him, ashplants held in their hands. Three times the Sailor tried that leap and three times he fell. He was very breathless when he had to admit defeat, and the third time he rose to his feet, his teeth tight, Paddy Prender was facing him.

Solo put his hand over his eyes and turned away. I hope it wasn't unfair, he thought, but the odds weren't fair before. He went over to where Sheila was standing. "Get your coat now, Sheila," he said. "We'll be going. You too, Joepat."

"I want to wait," said Joepat. "Lookit. Paddy is walloping him. Paddy is walloping him."

"Into the house with you," said Solo, and pushed him in after his mother. He followed.

The Sailor didn't have a chance. How could he? Even fair and square Paddy Prender was a fit man and he was cold and determined with anger. The most humiliating thing of all, for the Sailor, was the sight of the other men watching and seeing him being beaten. It didn't last long. How could it?

Paddy was at the door, breathing heavily.

"Are you coming, Sheila?" he asked.

"Yes," she said, quietly. "I'm ready."

"It can't go on," he said. "Like this. You must come to my place with Joepat."

Solo watched the struggle in her face: all she wanted, for Joepat mainly, and what would happen to it. Her jaw tightened.

"No," she said. "We will stick it out here."

Solo let them go and let the men go. The Sailor was sitting on the wall, his face held in his hands. He walked by him. Always a reason, he thought, always a reason, somewhere, buried. It doesn't just happen that a man turns sour like that, for no reason. But who could probe the reason out of the Sailor. The Sailor raised his face – it was well battered – looking after the men and ahead of them the sturdy girl walking by the side of Prender. Just a flash from the corner of his eye that Solo saw, and he knew. Or did he know?

"How does it feel, Joe?" he asked, pausing by him.

He was unprepared, totally unprepared for him. Gosh, the reflexes are slowing up, Solo thought, as the Sailor leaped to his feet and flailed out with his fist. It landed solidly against Solo's mouth. It hurt. Solo had been watching. The Sailor's eyes were screwed tight as he struck out. Then his eyes opened. Solo saw them widening. He didn't move himself, didn't raise his hand to his mouth. His lip was split. It had gone in against a tooth on his lower jaw. The blood came from it. He licked it with his tongue. It ran down his face. The Sailor looked at his fist, let it fall, became conscious of it, put it behind his back. There was terror in his eyes for a moment, the buried terror of centuries, waiting for the sky to open and fall upon him. He had hit a priest.

"Why, Joe?" Solo asked. The Sailor turned away from him.

"You trapped me," he said. "As if I didn't know. And I fell for it too. Out of pride that was. The stones, exhausting me, draining me. You did it deliberately. And then he could take me and do what he liked with me."

"It's love, Joe, isn't it?" Solo asked softly.

The Sailor turned furiously to face him, crouching almost.

"What did you say? What did you say?" he asked.

"It's love," said Solo. "You always loved Sheila, didn't you? You still do."

"No, no, no!" said the Sailor.

"Oh yes," said Solo. "It was no good, Joe. She preferred the gentle brother, didn't she?"

"She married him," said the Sailor.

"And you cut loose. You hurt somebody else, just because you were hurt."

"They shamed me, that man before you. He said things that would wound. I didn't mean to be that bad. But they shamed me so I got my back up."

"Your brother loved you," said Solo. The Sailor snorted. "He did," said Solo. "Why do you think he called his little son after you?"

The Sailor raised his head. "Joepat, Joepat," he said. "God! That little fellow!"

"He did," said Solo. "He thought you had the best of it. You thought he had the best of it. What's the use, Joe? Sheila and you are of a type. Don't you see that? She couldn't ever feel for you. You are too strong in yourself. That's the way it seems. Not strong at all, Joe. Outside, maybe. Inside, jelly, eh, Joe?"

"Go on talking! Go on talking!" the Sailor spat at him.

"No, no, Joe," said Solo. "Just this. Girls like Sheila will always love only people who can lean on them. Because they are givers, Joe. See that. Plenty to give. Don't want much back. They can stand on their own. What's love, Joe? Love is giving, even without a return. You think over it. Goodbye, Joe." He moved on slowly, taking a handkerchief from his pocket and wiping his bleeding lip.

The Sailor let him go. Then he shouted after him, "I know what you are after. I'm to leave all, hah? I'm to have nothing. You think I would do that, do you?"

Solo turned.

"I don't know, Joe," he said. "I'm just telling you what love is. Love gives, Joe. Real love. No demands. Love is sacrifice. Not hate, Joe. Not terror. Not fear. These are shackles. You will never be free, Joe, unless you give, I tell you. There is the wide world where you have been."

Solo stretched his arms. From up here on this height, he seemed to be embracing the world with them. "Go back free to it, Joe. Sever the shackles. It's for you, for yourself. I tell you."

"I'm sick of it anyhow," Joe shouted. "I'm sick of it. Gaping in my belly, wherever I go. No peace. And she doesn't care. She doesn't even see. She never saw. Just looking at me, seeing nothing. Just the place, the place, the place, and her Joepat and lame ducks. That's all she ever wanted. Lame ducks. I would have conquered the world for her."

"You're a slave, Joe," Solo said. "Free yourself."

"I will," Joe shouted. "When she comes back I will be gone for ever. Not because of you, see. You had nothing to do with it. I was thinking before anyhow. Nothing between you and me but a chance blow in the puss. That's all. I didn't mean that. It doesn't count. I'll be gone and I'll leave her Joepat and the place, before I go. I would have done that anyhow. Do you hear that? I would have done that anyhow."

He had to shout loudly now. Solo was a bit farther down the hill.

Solo had to cup his mouth with a hand to shout back.

"I love you, Joe," he called.

The Sailor laughed. He slapped his leg, laughing, feeling his wounds.

"Oh, you do," he laughed. "Oh, you do like hell! Being loved by you is murder, Solo!" He laughed again at the thought of it.

"Always, wherever you are, remember that, Joe," Solo shouted, and then he was gone, and the Sailor could see him no more, just the sound of his going and from the valley below the sound of the delayed Mass bell, tolling it seemed, a little indignantly, as if chiding the priest for his tardiness.

This Was My Day

I T WAS HARD to leave the comfort of the bed. The floor was very cold to my feet and I could feel the draught around my legs. I didn't switch on the light. I didn't wish to waken my wife. She would be up soon enough anyhow. She worked hard. She could do with her sleep. So I fumbled for my clothes in the dark and got into them by feel. They were cold to the touch. At least the cold wakens you up fully. I went down to the kitchen. I didn't switch the light on here either on account of the fox. These foxes are very clever. Almost human they are. A fox could see a light in a house, miles away.

The fire was raked, so I pulled the hot coals from the ashes and blew them to redness and then banked the turf all around them. It would be a good fire when she came down. It would have boiled the kettle. I would like to wait for a mug of tea now, but I couldn't.

I took down the gun then and I put in two cartridges of heavy shot. Two were enough. One should be enough. If you missed with two you wouldn't get a chance of a third.

I was cautious about opening the door too, very slowly and carefully I opened it. I believe that when foxes are working, they leave a lookout, a sentinel. Other men don't agree with me, but they are entitled to their views. I had hung the boots around my neck. The cobblestones in the yard were very cold, but the nails of the boots would knock the sparks from them, and sound, which could be

worse. I was even careful of the buttons of my clothes hitting against the metal of the gun.

I crept through the yard, around by the gable, through the little wicket gate, and into the garden. I had oiled the hinges of the gate. It opened very silently and I was pleased.

Then I crossed the garden and sat under the hawthorn hedge near the chicken house. It was dead dark. Some men hold they come at sunset, others at dawn. I hold they come when you don't expect them. I could see nothing. The roof of the chicken house was just a black blur. It was cold.

It was some time before the white streak appeared on the horizon. My heart lifted. I was very alone until then. I knew what would happen next. In the bushes all around the little birds started to come awake. You have to smile when you hear them. They are like persons. They grumble and scold one another, and shake the nests and hence the branches of the bushes. Birds are cross in the mornings like people. Isn't that funny?

It was my heart that told me the fox was there. A dull pound. Instinct. I was looking at the place in the wire which they had pulled out of the earth, hardly noticeable, but sufficient for them to get through. I had to squeeze my eyes almost shut to spot that they were there. I had the gun in position. The blood was pounding in my ears. I didn't raise the gun to my shoulder. I directed the barrel of it with my knee. I pressed the first trigger and then the second trigger. The noise ripped hell out of the dawn. It was a very foreign thing, and the red blaze of the gun was shocking. It seemed to have startled the morning awake. I rose from my cramped position. I had to straighten out my legs. Not as young as I was. There were two dead foxes. I couldn't miss. The big one was the vixen. Very big. The other might have been her son. A young fox.

I felt sorry looking at them. I don't really like killing. But then it has to be done. Pity foxes don't eat grass like rabbits, I thought. I lifted them by their bushy tails. They smelled very heavy. I carried

them out of the garden. I felt a bit proud too, I suppose, like you do when something you have planned is successful.

I left them outside the door. Mary was up. She was making the tea. She looked a bit sleepy. "I heard shots," she said, "if that means anything."

"I killed two of them," I said quietly.

"Oh, the hero," she said, a laugh in her eyes.

"It makes up for all the misses," I said, but I could see she was pleased, and I felt good.

After that I turned the two cows and the calves out into the field across the way and brought a bag of turf for the fire. We ate our breakfast. We had a big table. Time was it would be filled. Three sons and one girl. All gone, scattered over the world, all that remained of them bits of ink on paper and foreign stamps. Pleasure when they came home to visit, but like shadows that come and go with the sun. Make you feel sad if you thought of it too much, but then young people will have their way. Maybe one day, the eldest would come back for good.

So I took the cans and went to the milking. Can between my knees, I was relieving the black poll first. A good cow. I was thinking overmuch of my absent sons. Otherwise it wouldn't have happened about Red. That's the bull. A good bull, pleasant enough, but as you know there are times when you have to be careful with them. This was the time. It was early spring. I shouldn't have been careless. Feeling sorry for myself. That always brings its upsets. The rain of milk in the can has a soothing effect too. Makes you careless. But I heard the big fellow when he was in motion. I should have heard him snorting earlier. They always do, and rake the ground with their hooves. Should have heard that too. When I did hear the pounding, I looked over my shoulder. It was almost too late. He was nearly on top of me. But I had time to go under the poll's belly and get to the other side.

That stalled him. But the can of milk was spilled on the grass. He

drew back. He was determined. He had a wicked look in his eye.
He came at me from the back then with his head lowered. I got a
bit of a fright all right. I admit that. But then I knew it wasn't his
fault. He was just answering his nature. It was my own foolishness.
I slapped the poll on the side and she came around. That blocked
him again. He wouldn't attack the cow, but he might give her a flick
to get her out of the way. "Walk! Walk!" I said to the poll then,
scratching her back. She hesitated and she walked. I had my arm on
her neck and pressed her towards the gate, and when Red drew
back for a charge, I would turn her sideways towards him. This way
I got to the gate, opened it and slipped out. But I had to take off my
cap and wipe the sweat off my face with it, even though it was a
frosty morning. But then we are all only human.

I couldn't let him get away with that, of course. I went back to
the stable and I got the long handled crook. I came back with that.
Then I climbed over the gate and stood facing him. He knew what
was up. You could see that in his eye. But he was too upset. He
decided to charge me. It's a bit of a terror to see nearly a ton of beef
coming at you like that. It makes you feel how brave them bullfighter
fellows you read about are. Your feeling is to stand stock still with
fright. But if you do that he will get you. So I advanced on him. I
gave a shout, and then I reached with the pole and hit him on the
nose. He could have come on but he didn't. All the same he stuck
his ground. You have to admire his courage. I hit him again, and he
put his head into the air and waved it from side to side. To dodge the
blows. But I hit him again. I had to in order to get the twist of the
crook into the bronze ring in his nose. Then I had it in. The poor fel-
low was at my mercy. I held it in my left hand and twisted it. You
can bring him to his knees that way. Then I shortened my grip and
bit by bit I got near to him. I kept the twist on my with left hand and
reached for his neck with my right. I scratched his neck. You could
feel him trembling all over, but he was feeling the hurt as well. So I
talked a bit of blather to him, and then forced him to walk. Around

and around the field we went, and he became calmer. When I got back near the gate on the fourth round, I freed his nose and let him go. He shook his head and he snorted. I didn't show any fright. Just stood there talking at him. Then he walked away and started to graze, so I knew he was all right again. I heaved a sigh and got my cans and finished the milking.

These are the things that happen to you, that shouldn't happen. If he had killed me now, they would have said it was his fault. Not his fault at all. My own fault for being careless. God gave man the mastery over animals, but He didn't mean man to be careless about them.

I left the milk in the dairy for Mary. She would look after it, and then I took to the hills with my bottle of tea and the few switches of bread. It was lambing time for us, and you have to keep an eye on them. I freed Collie from the barn. She doesn't like being locked up in lambing time, but I don't think any dog should be free at night. How do you know they won't learn bad habits from sheep killers? If she's in, she can't be out. She was overjoyed to see me, and I felt a bit sorry for having her locked up, but then like the bull, you can't be careless.

It was a pleasant day, climbing the mountain. The sun was shining. The sky was steel blue. Frost in the air, but that's the right kind of day to climb the mountains. It makes it less of a task. The sheep had wandered far up. It's amazing how far they can travel in a day. Funny how you can recognise your own sheep. Can't explain that. It's just a feeling. Wouldn't you think one sheep is the same as the other sheep. But they are not. I suppose that's how God knows human beings too, able to tell one from the other like a man can tell his sheep.

I looked from the top of the mountain. On one side was the valley, with mists in it now from the warming sun, and on the other side was a calm sea. That was fogged a bit too. I wondered how my sons could prefer to live in great factory cities instead of here. But that's something you have to learn, I suppose.

The Grass of the People

Seeing that island out in the sea near the shore then made me
think of The Fault, so I crossed over and went down that way. The
Fault, they say, was caused by an Irish giant getting mad with some-
body one time, and scooping a bit of the mountain out with his
hand, throwing it into the sea. There's tales like that everywhere.

My heart sank all the same as I came close to it and I saw the
sheep on the edge of it. She was bleating, and I could hear a thin
bleating coming from below. "Oh, no!" I said then. "Not now!" But
it was so. The sheep didn't run from Collie. That was a bad sign,
and when I lowered myself on my stomach and looked over I was-
n't surprised to see the lamb down there. A good thing, it was a
week-old lamb. I don't know how they are not killed when they fall
down, but they never seem to be. Looking up at you, bleating
plaintively as if it was your fault. The only danger leaving them
there too long is that the grey crows might attack them. I should
have gone back down the mountain for a rope.

But I didn't feel like doing that.

I started to climb down. It's not a good place for climbing. It's
about fifty feet of a hole, but it is limestone and you can get grips
for your boots by kicking at the rotted parts. I had rubber boots on,
but mostly it must be done with your hands.

It wasn't too bad going down, as I thought. Then I had to catch
the lamb. You could see the thing's heart beating like mad, and he'd
run halfway up the wall to get away from me. So I had to sit down
and talk to him, to calm him. It was cold down there. The sun
couldn't get into it. I talked about it was all right being frisky and
having to jump around with joy, like they do, but for the love of God
not to do it near holes in the ground. Once I got hold of him, he
calmed enough. I suppose they sense that you're well meaning. Then
I had to get a bit of string from my pocket and when I was wearing
the lamb around my neck like a fur collar, I tied his little hooves.

I didn't find it as easy to get up this time. I suppose it's because
I'm getting old, and my wind is not as good as it used to be. Then

42

he kept bleating, answering his mother above, and a lamb bleating that close in your ear is no pleasant sign of spring I can tell you. I was well washed out by the time I reached the top. When I freed the lamb I had to lie down on my back until my heart stopped thumping, but at least Collie felt sorry for me, because she licked my face.

Then I thought: You blame the lambs. Why should you blame the lambs? Isn't it your own fault for not fencing the hole around. You see? There's a reason for everything, but there's no use blaming the poor animals. It's rarely the animals that are at fault. I excused myself this way: that there are lots of things I know should be done, but when I haven't my sons to help me, how can I do everything? But again that's only feeling sorry for yourself and what use is it? Some day my sons might come home for good.

It was late dark when I got home. I could smell the dinner cooking. It was a wonderful smell.

"Well?" Mary asked.

"They dropped ten more today," I said. "They are doing well."

"Thank God for that," she said.

It was nice to eat a good dinner and stretch your feet to the bright fire.

But then Mary's brother came. That's why I'm at this. He has a car. He is a nice chap. He comes to see us sometimes. Stays a night or two. He works in an office. We had a pleasant drink of whiskey.

Then he talked, about how hard his life is. His day in the office. Books and figures and things, from nine until six, he says, and do I realise what a grand life I have out here. What do I do all day? Not much, he says, now that it's not planting time or harvesting time. His year is all the way round working, working, working. No ceasing. Talk like that.

So when he went to bed and Mary went to bed, I sat down at this. I was worried about it.

"What kept you up until this hour?" she asked me.

I sat on the edge of the bed. Whispering.

"About your brother," I said. "He has a hard life. I go over all the things I did this day and they don't amount to much."

"Well," she said, "what he does all day amounts to much less, I can tell you."

"Ah, no," I said, "working the head is a very hard thing."

"It's a very easy thing, with my brother," she said.

"No, you don't understand," I said. "If it's all written down, my day today amounted to very little in comparison to his."

"All right," she said. "If I can't talk sense to you, please permit me to go to sleep."

So I let her go to sleep, but it worries me. Did I do much or didn't I? Was my day not as important as his?

Maybe he's right. Maybe I have a grand life and not much to do.

The Storm is Still

I T WAS A glorious day.

He came down the narrow flint road, crumbling into a white dust from the heat of the persistent sun, and paused a little before walking haltingly on to the stones of the pier jutting out into the lake. There was a gentle ripple on the waters of the great lake and they reflected the glint of the sun like the flashing beam of a million mirrors. The delicate wind came in gentle puffs to ease the heat. It came, wafted in gentle eddies from where the Connemara mountains lay blue and squat, snugly powerful even in the distance. The sky was coloured a filmy blue, as if somebody had stretched a white gauze cloth over its immensity. The lake lay stretched before him, lost in the miles, calmly reflecting on its bosom the clusters of verdant islands whose reflections were broken as if an artist had etched them in straight pencil lines.

Like the reflecting ripples, he thought, it brings a million memories.

Then he heard the splashing and the laugh of a girl. It restored his thoughts and he watched with interest as a sunburned arm appeared over the end of the pier.

She came out of the water like a seal, her brown hair clinging wetly to a well-shaped head. She paused there, holding on and laughing down at somebody below her in the water. He could see the white evenness of her teeth in the brown face, and he liked the

way her nose had refused to grow down but had uptilted itself, and as she pulled herself completely up and stood dripping lake water on the stones, he saw that she was young and very lissom, and something caught at his heart. Her scantily clad body was that of a maturing girl, like a sapling before it turns into a tree, and the still shiny wet bathing costume showed the budding breast and the flat stomach and the rounding thigh. She bent down resting her hands on her knees.

"Now didn't I beat you to it?" she asked and laughed.

"Like all women," shouted a voice from below, "you took an unfair advantage. Here, give me a hand."

She laughed again, just like the silver tinkle of the altar bell, he thought, and then she bent down and grasped the hand of the speaker, preparatory to hauling him on to the pier. There was a great amount of laughing and snorting and the splashing of disturbed water before he stood on the stones beside her. He was taller than she and he was fair, but his body in the short bathing trunks was the body of youth, narrow and widening and smooth, with immature muscles rippling in his limbs. He will be big, the man thought, and very well shaped.

They had stopped laughing and were looking into one another's eyes.

Slowly the smiling lips closed down over the teeth until the mouths had a look of set attention. Funny, the man thought, how I can record all the details? The laughing crinkles went from the eyes too, and the lids opened widely as they stared into one another's eyes. The breast of the girl heaved more quickly and the boy's chest breathing became agitated. It seemed that they looked into one another for a century, and then the two bodies came together as their lips met.

Not practised, the man thought, as he felt his own pulse quickening a little. No, not practised. They have never kissed before, and then he wondered if he would be able to get away without

disturbing them. He lifted his right foot from the stones and turned it preparatory to bringing his body around after it, but his bad leg betrayed him. He was bringing it around in the usual way he had, taking the weight of his body on the stick, when the boot hit a loose stone and sent it rattling along the pier.

They looked up and back at him, startled, like, he thought, the look on the faces of early-morning-disturbed rabbits before fleeing for their burrows.

The man looked at them in a sort of apology.

I suppose, he thought, my appearance would not reassure them.

They could see a tall man, bent now, leaning on a stick which was obviously a prop for a crooked leg. He was dressed like the countryman he was, his grey hair to be seen under a black Connemara-type hat, his still big body covered by a bainin coat, much worn, which would smell of the turf fire if you were near it, a striped shirt held at the throat by a brass stud, and his blue trousers held at a narrow waist by a broad leather belt. They could see a face which had been so very strong rutted with the permanent creases of age, burnt almost black by the suns of the seasons, the big nose and the jutting chin, which had once been its best features, now merely serving to heighten the appearance of age. If they could see and read, the blue eyes were still there. They had never grown old like the rest, but it was hard to get at them and read the sympathy there for them and the embarrassment of having intruded on them, and worst of all the longing to be understood by them.

As they looked at him with their startled eyes, his own blue eyes looked back at them, and in the few seconds left before the looks of both would separate from him for ever and descend to the mundane emotions of embarrassed or unembarrassed modern youth, as the case might be, he told them a story with his eyes and hoped that they would see and understand.

I was not always as I am now, he told them.

Once, so long ago, I stood on this pier on a morning something

like this, only far different, as you will see, and my name was Fergus O'Flaherty. Can you see me as I was then, I wonder? I was over six feet tall, and these grey curls were as fair as the hair of you, boy. My face was big and I knew that I had great power in my shoulders and in my arms. Why wouldn't I know that, who could feel the lepp of a strong grey fishing boat under the oars in my hands? My legs were straight too, and very strong, since my right knee still had to feel the burst of a dum-dum bullet fired by the enemies of my country. That was later, much, much later, and had nothing to do with me then. I was young and strong and I had a song in my heart. And why wouldn't I? Didn't everyone know that I was one of the best boatmen on the lake, that I knew the lie of the fish as if they were my own brothers, and that I was afraid of no man, and bore none a grudge, and also didn't I know that I would be seeing the girl that morning and that if God was good that I would be the whole day in her company since she was coming fishing with her father? The whole day in her company!

Wouldn't I be able to watch the play of the sun on her skin and the wind tossing the brown curls of her head? Yes, she had hair just like you, little girl with the startled eyes, and she was like you too in the youth and the clean cut look of her. And her hands were small with narrow fingers, and I often thought of them resting in my big palm and that it would feel like the wing of a butterfly, just like your hand must feel to him now where it is resting on the bare flesh of his upper arm. Isn't that why the very look of the pair of you has brought all this tearing back to me, opening up a wound deeper than I got from the bullet? I suppose I was meant to walk down here this morning so that I would see and remember. Oh God, remember so clearly.

Because I was a country boy, and she was the girl of Major Gifford, who had come to the lake every year since he was a child for the fishing. He came for the mayfly fishing in the summer and he came for the daddy-long-legs fishing and the grasshopper fishing

in the autumn. It was like a religion with him, as it should be to all good fishermen, and when I was not born at all, he came with his father, and then he came himself and my father was his boatman, and then when my father became old and died, as we all must do, I was his boatman and everybody knew that.

He was a very good fisherman, and he came alone and he fished alone, and the days were full for both of us who would never tire of the thrill of a struggling fat fish in the hand before you hit it on the head and it dies and changes colour. The Major would no more allow a woman into the boat than he would fish for trout with worms. And then one year he turns up with his daughter. Her name was Sive, and when she came first she was very young, all eyes and pigtails like the egg of a trout when it is three weeks hatched. The Major was daft about Sive, and no wonder, because she could twist anyone around her little finger.

He even brought her fishing!

To tell the truth I was very uneasy about this at first, and I was even thinking about telling the Major that he would have to get another boatman. But he was very apologetic and his neck got red in the way he had, and he hummed and hawed and practically sweated away with embarrassment, so I relented then and we took her. She was a cute little devil, and she must have known I didn't approve because she set about me immediately, in the ways she had, and before half an hour had passed she could have asked me to jump in the lake and I would have done it. It was something inside of her that created the magic. A sort of a bubble of living that fermented in her and looked out at you through her eyes and the smile and the cocky cut of her upturned nose. Oh, she was a terrible child, the way she could put the comehither on you.

So here I waited for them. It was their last day, since it was very late in the season, and one moment my heart would be black at the thought that I would not be seeing her again, and then it would be bright because at least God had given me this day. Like now the sun

was shining very brightly and people said it was an Indian summer and very quare for this time of the year and there must be evil behind it, and it's true that it was too hot. The boards of the boat were scalding to the touch and the waters of the lake were very glassy, and if I hadn't been waiting for the sight of her, I might have noticed that my feet felt heavy in my boots, and I mightn't have liked the look of the coppery sky over the mountains, but divil a damn did I care, because Sive was no longer a child with the pigtails but a grown girl, as brown as a nut, with a look in her eyes that would melt a slab of granite.

I was young then too. I know you will find it hard to believe that I was the man I was. You can't even look at your own father or mother and imagine that once they might have been tall and strong with glowing flesh and shining eyes and pumping pulses. If you can't imagine your own father, how can you see me as I was then? My neck was thick and the curls grew low on it, and I knew my skin was clear under the tan of the sun, and as true as God, I could have lifted a mountain on the palm of my hand.

I heard her coming as I was bending over the boat adjusting the rowlocks. I counted four before I turned, because although I loved her I was very cautious, because if she saw that I was that much in love with her, she might have been insulted at the thought of a country boy having such a feeling for her and she might have turned on her heel and gone away, and wouldn't the light have gone out of my life then?

She was alone, and she was swinging the lunch basket in her hand. My God, how she caught at my chest then. She stood up there laughing at me, her legs apart and her feet in white sand shoes, and she wore a sort of very simple dress of white that was caught at the waist with a belt. And her arms were bare, and her neck and her hair, and so brown she was that it seemed to make the eyes of her look even browner than they were. And she was smiling at me, and I had to drop my eyes from hers, because I was afraid

that even an eejit could see the feeling that was in them, and I had a hard to-do to stop my limbs from the tremble and to ease my heart or it might have burst its way out through the walls of my chest the way it was thumping.

"Ha-ha, the brave Fergus," she cried then, and ran over to me and placed her hand on my upper arm the way she had and kneaded my muscle with her fingers. "The big strong Fergus," she went on, laughing and bending her head sideways to try and look into my eyes, and me ashamed of the way that the red flush crept up into my face, and thanking God that I was burnt black by the sun or she would have noticed it easily.

"Where's the Major, Sive?" I asked.

Yes, I called her Sive to her face, but you must know that men who live by great lakes are free men, and we had always been free, and we had never bowed our heads to any man. Yes, we were respectful to our betters, but we have never sold our souls like other slaves in the land, bowing the knee and scraping the dust of the road on to your trousers, Yes-sirring and no-sirring, little bits of men on account of the few shillings a day which you would earn from the fishing. That's why I liked the Major, because he was a free man himself and could understand how I and my brothers felt. So Sive she was to me, and many's the time I have said the name over and over to myself, inside, the sort of caressing music of the sound of it.

"Daddy's not coming," she said then, stepping down into the boat. I was startled.

"He's what?" I asked, my mouth open like an amadaun.

"He's not coming," she said. "He's in bed in the hotel with a very heavy cold. It would be murder to bring him out."

"But it's his last day," I said, still looking stupid.

"Well, of course," she said then, her head bent, "if you don't want to come with me, if you give me the oars I'll go myself."

That displeased me.

"Ah, no," I said. "It's a shock, that's all. Sure the Major has never missed before, and his last day, too."

"My dear Fergus," she said, "when will you learn to take things as they come. Daddy's sick, really, and he can't come out. He might have made an effort, I suppose, but he looked out and said there would be no wind anyhow and that he'd nurse his cold."

I looked at the sky.

"There will be wind all right," I said, out of my knowledge. "It'll come up fairly strong in an hour or so." What a prophet, but of course I was displaced, as I said, and I only looked at the sky casually.

"Well, come and let us be on our way," said Sive then, smiling up at me, getting into the boat and sitting on her hands. I forgot the Major at that point as if I had never met him, and it was to be some time before I even thought of him again.

We pushed away from the quayside and I eased the boat out into the lake and pulled slowly towards the far islands, so that we would be on good ground when the wind came. She talked and I watched her when her eyes were not on mine. I would watch the way the tendon pressed the skin of her neck as she turned to point out the sight of a cormorant standing on a rock, silhouetted like a black emperor, and I would see the way her neck formed its way into her chest as she stretched back to watch a gull standing motionless in the sky, as if he was suspended by invisible wires from heaven.

She talked to me as well, in the eager way she had, and it was grand the way she used all of herself in the talking, and when she would laugh she would clap her hands and bring them up to her mouth, and she would lift her feet too, and bring up her knees and bring her head and her hands down to meet them, and her laugh would ring out over the waters of the lake, and I would laugh too, a deep one coming from my stomach, but it's funny now that I don't remember much of what she said on the way out. It's just because I was so intent watching her and the ways of her and the

beauty of her and the life that sparkled from her, and sometimes I thought I was going to be sick with the welling of excitement that grew in me. I didn't feel that I was in a boat at all, on water. It seemed to me that I was halfway between heaven and earth, like the gull, and that I was rowing on a lake of clouds.

It was most wonderful, and I can still imagine the way I was, so light in the head, as if something had sucked out my brains and pumped in air, so that it was like a most pleasant dream.

The wind came all right.

It came quietly like it does on a glassy day. The water just started to heave gently under us, in quarter-mile undulations, and then these became a little smaller until they developed into long flat waves, and finally they settled down into a gentle rounded wave that is excellent for the fishing. We were near the last of the big islands when it came, and in no time at all I had the two big dapping rods fixed, and Sive's blow-line was being puffed over the water with the awkward daddy-long-legs straddling a wave and the green-grasshopper resting beside him on the same hook. It was a good bait and Sive praised me.

"My God, Fergus," she said, "if I was a trout I would go for that myself, so I would."

"Be quiet now, and concentrate," I said, because you must understand that even though I loved her, I am also a fisherman.

I really blame the big trout for the whole thing.

He came to Sive's bait off the point of Hare Island. He was a big divil too. I knew that when I saw the quiet way the bait went. He just sidled below it and sucked it down into his stomach like the big fellows do. The small fellows make more noise with it than a dog in a pond. Sive was never a very good one for concentrating and she was regarding the behaviour of a balcoot when the fish took her bait. I didn't shout. That would have been fatal as she would have pulled it away from him too soon. I gave him five seconds to get it really down into his gullet and then I roared "Strike". Almost fright-

ened out of her wits, the poor girl was, and she raised up the rod, and from the way it bent you would think that there was a calf at the other end of it.

"I have him, Fergus," she shouted. "I have him and he's a monster!"

"Then for the love of God," I shouted back, "hold on to him!"

I was excited myself. I suppose when I am two hundred and ten I will still be excited at the noise of a screeching reel. I won't tell you about the fight. You have felt it yourself. A ten pound trout at the end of a rod is a noble thing, when he is a fat fish as broad as he is long. He came out of the water like an antelope and he shook his head at the top of the jump. Then he dived deep and he came up again and went down again and went off in a rush, taking the line with him, and he came up again and down again and he would have gone under the boat if I hadn't been aware of him in time and got it around. He did everything it was possible for a trout to do to get his freedom, and all this time Sive was roaring or laughing or shouting or on her knees saying, "Sweet God, just let me land this one and I'll never ask another," and I was swearing a little, I'm afraid, and shouting directions because I wanted her to get this fish. It was the biggest one she had ever seen outside of one stuffed in a case, and it would have been right for her.

"She got him, and I still remember, oh so clearly, the exhausted look of joy and satisfaction of her face as I took the hook from the big mouth of him and then crunched his head with a blow from the priest.

It was only then that I noticed the boat was rocking alarmingly and that the rushing waves were white-capped and very ugly, and that the water had changed its colour to a muddy grey. I looked behind me then and my heart nearly failed me.

We were in great danger.

All great lakes are the same. They can change from ponds to raging seas whilst you'd be looking around you. Lakemen are never

caught, because they have learned to read the sky. I was a lakeman and I was caught because I hadn't paused to read the sky. One look was enough for me. I saw the long coppery fingers of the clouds coming from the blotted mountains stretching greedily for the sun. The waters of the lake were a churned up maelstrom, but I knew with a sinking heart that this was only the very beginning, and I instinctively turned the bow of the boat into the waves and tried to keep it there. Sive was looking at her fish gloatingly, unconsciously holding the sides of the boat to steady herself. I saw her look up at me with the smile on her face. Then I saw a realisation of something dawning on her. She looked at the waters, now being beaten into colossal waves, and then she looked at me. My heart missed a few beats. I was not afraid for myself, you see, because long ago I had acquired a sort of rough-hewn philosophy, that what was going to happen would happen, as God willed it to happen.

But not for Sive.

You see, what frightened me was that we had passed the last island and were being driven out into the wildness of the wide lake. There was no going back. I was a strong man, but not even steel arms could have pulled the boat back to the island in the face of the wind and the waves that were being hurled before it. There was a twelve mile stretch of water between us and the far, far shore to which the wind would drive us, but it would be impossible for the thin boat to weather the water between. I had only moments to decide. Away to our left, about three miles, was a small island, but to turn the boat in its direction and pull across the waves would be murder. But I thought that if I could let the wind drive the boat and with the help of God ease it over in the direction of the island, that we might just get within striking distance of it. It was our only chance anyhow, so holding my time I watched the waves, and when the boat was lifted on top of one, I buried the oars and pulled. It was dangerous because we could have been swamped, but my timing was right, and she had her back to the next wave, which poured

itself into us, drenching Sive and flooding the boat, but we were turned and the wind was behind us.

It took all the strength in my body to keep it that way, but somehow the grimness departed from me and the bleakness from my heart when I saw Sive, her dress clinging wetly to her, grabbing the bailer from under the seat, and trying to scoop the water over the side. I laughed then. She didn't hear me because the wind whipped the sound of it along with itself. But it was good, and you see why I loved that girl.

I have never been in a worse storm then or before and never will be again, and indeed that day is remembered and has passed into the history of the lake, so that men say their mothers and their wives or their brothers died the night of the day of the Big Blow, or were sick or ailing or got married or were born.

Sive looked at me then and I felt it was worth it all, worth the awful burning in my chest and the strain in my legs and the unendurable cramp in my arms, but I managed to hold the boat, and nodded at her and backed my head towards the island on our right now. And she looked over there, and my heart was tight as I saw the brown curls shaping into her head and her breast gushing wetly against the cloth of her dress. She looked like such a little girl, and I said, "She will be all right, so she will. I will bring her safe out of this." She turned back then and winked at me and I felt that I could have taken a sycamore tree from the ground by the roots and beaten the lake into flatness again. I fought the waves across and I beat the wind. I am an old man now, and therefore my talking about this time is not boasting. Any man will tell you that it was a feat.

I got the boat near the island.

It took one hour of time, and a century of strength.

I got the boat near the island, but that was at the end of my endeavour. I felt empty of blood and courage and my straining chest had burst the buttons of my shirt. The wind was driving the waves screaming, scouring the side of the island. There was no regularity

there. It was like being caught in a whirlpool. The waves took that boat and flung it, and I only knew we had met disaster when I felt myself going down, down into the water. I felt the blow on the head too, from the rock, but I turned and put up my head.

I just felt the dress of Sive being rushed passed me and I clutched her instinctively and pulled her body close to me. The last of the boat I saw was the floorboards being tossed disdainfully.

I got her to the island.

I still don't know how, to this day, and I have spent a long time of my life trying to work it out. It was fear and love and a great anger that got me there, scrabbling at rocks and cursing and beating the white foam with my free arm. But I got there and I stretched her out on the short grass and went down on all fours like a dog and retched and panted and closed my eyes.

It was the slanting wall of rain hitting my body like icy daggers that brought me back to myself. I looked at Sive then, and I was very afraid.

Her eyes were closed and the lids were blue, but there was a movement of her chest. My blood flowed again.

The rain shut out the sky and God from me, but I had my oil-skin tobacco pouch with the few matches in it, and to a man like me who had been on the lake all his life, it wasn't much bother to make a shelter even from that rain and to gather the dry sticks from the underpart of the hazel bushes and to light a fire that burned damply. I gathered ferns and I lay them under her, and I took off her dress and I wrung it in my hard hands and I held it to the fire with sticks, and I washed the blood from her forehead and her hair and cleaned the deep cut, and I dried her dress and I dried her body with the grass and the ferns, and I put back her dress and I covered her with the dry hay which had been left for the cattle grazing on the island.

All that I did, and then I sat and watched her.

I am not a holy man, or a pious man, but I prayed then, not out

to the sky and the wind and the rain, but deep inside me, I prayed, because there was nothing else I could do.

It seemed like a long lifetime before her eyes fluttered open.

I went close to her then and I held her hand in my two big craubs, cradling her hand. There was a warmth in it.

Her eyes moved about a bit, and then they rested on my face. She smiled and then she spoke. Do you know what she said?

"Fergus, I love you," she said.

Honest to God, she did; she said that thing there to me then!

Do you know what happened? I couldn't help myself. The tears, hot ones that were forced all the way from my soul, came out of my eyes, and I dropped my head. What then? I felt her hand going up to rub my hair and I raised my head and looked into her eyes, and they were very soft eyes, for me only, and I felt I would be drowned in them, and then she pulled my head down to hers and my lips rested on her lips. Sweet God, but this is true!

So you see. This is why I want you two young people to understand me, to understand that I never meant to see your first kiss, that my presence would be like a spit at the Mass. It was just the sight of the youngness of you that held me here and the memories plucked from the barren years.

"The storm was still," as the poet said, and I held her in my arms all that night when the sky was clear and a moon riding high, and the morning time we walked that little island and her hand was in mine and there were no words between us, just a great understanding, and the birds sang after the storm, and the raindrops were very pretty on the leaves of the trees, glinting in the morning sunlight. And the waters of the lake were lapping the shore, and the seagulls soared high in the sky, and you could hear the plop of the rising trout and the flitting of the flies. This was heaven.

They came early in the boat and took us off and they were all very relieved to see us alive, and the Major took Sive into his arms,

and I saw tears too in his stoical eyes, and he thanked me (God, as if I wanted thanks!) and he took her away.

I never saw her again.

Why?

You see this shattered leg of mine. It was painful when I got it and for sometime afterwards. And I could open my shirt and show you other wounds, but inside me there is one that is worse than any of those. Can you imagine?

Why did she never come back? What happened to her? Did she die then or before or after? I never knew. I knew she loved me then, out there, and I felt she had the feeling for me that I had for her, that is still burning here inside of me as I try to tell you this. But she never came back, she never tried to write, she....

He brought back his mind and looked into the eyes of the two lovers. The girl's hand was dropping from the arm of the boy and her eyes were falling from the blue eyes of the man.

What's the use? Fergus asked himself.

He brought his hand halfway up to his hat in a sort of a friendly wave.

"Good day," said he politely then, and he turned his bad leg, brought the stick forward, and walked hesitantly back the long lane, the way he had come.

The two young people looked after him until a turn of the lane took him from their sight.

How to Poach a Salmon

T HE RIVER ROSE out of the lake that drained the great mountains.

They were very tall, stern-looking mountains. They surrounded the lake and kept the shine of the sun from it for the greater part of the day so that it looked gloomier than it was and rather sad. It was high up, and once the river left it, it seemed to become exceedingly jolly as it ran out of the shadow of the mountains.

First it was wide and deep and placid, but as it started to fall on its ten-mile journey to the sea, it narrowed and twisted and foamed and fell and threw up banks of yellow sand where salmon loved to lie. As it got nearer to the coast, it cut its way through tall gorges of rock and it fell over high falls until, in places, it was a rippled foam-laced interruption cutting the bleak plain, where cattle discontentedly eat at the sparse grass of the poor soil. The nearer it got to the sea, the greater its fall, and here there were high, rounded hills that were very fertile. Trees grew on the hills and they were subdivided and looked green and pleasant under the sun with white cottages built between the fields, and way out beyond you could see great stretches of silver sand where the sea would wink bluely or greyly under the direction of the sky.

And here, a few hundred yards from the estuary, the river was glorious. It fell over a twenty-foot fall in an eternal rumble that never ceased. Many people would walk down to gaze at it there,

and you'd think the river knew it was an object of admiration and awe. There were pools above the fall and pools below the fall, and it was very natural that apart from the people who went to admire, there were also people there with long rods in their hands, whose purpose was to catch the powerful fish waiting below to jump the fall or as they rested above, after their supreme accomplishment. Foolish people who really didn't care about eating salmon would spend hours watching them leaping there; to see the powerful fins catch hold in the white strength of the water, grip it and move the powerful tails and swim up and up and up until they vanished at the top of the fall with a disdainful and triumphant flick of their tails. Some of them did not succeed. Sometimes they left a smear of scales and red blood on an outcropping black rock.

But the river was good for a show, either way.

Twenty yards from the falls there was a road that went down to the sea, and by the side of the road there was a two-storey house surrounded by a garden that held many spring flowers, and in this house, in a certain room in it, a telephone was ringing. Nothing could be more incongruous than the difference between this occurrence and the river.

It was a square room with shelves all around the walls and a long, wooden table and forms and notices hanging up about such things as dipping sheep and precautions against the warble fly and notices faded and yellow with small print that few people could take time out to read. A tall young man dressed in the blue uniform of the Civic Guards came in and took up the phone. His tunic collar was opened and a cigarette hung from the corner of his mouth. He looked sleepy. He took up the phone and said, "This is the Barracks," and such a barking and sizzling proceeded to come from the instrument that the young policeman pulled the cigarette from his mouth and dropped it on the floor and ground it with his heel,

and then started to button up his tunic. His only words of conversation were, "Yes, sir. Yes, sir. Yes, sir."

Then he placed the phone back on the table reverently, emitted a cautious sigh and went quickly out of the room. He ran upstairs on the double and knocked at a door from which the sound of singing was coming, entered on a grunt and said, "Sergeant, it's the chief superintendent on the phone and he's leppin'."

The sergeant looked at him from the middle of a soap-covered face. He was wearing trousers and a shirt. His hair was scanty and stood up on top of his head. He was a big man wearing a comfortable stomach and blue eyes that were filled with humour.

"Leppin' is he?" the sergeant asked.

"Mad," said the young man.

"Hum," said the sergeant. "What have we done wrong, Moloney?"

"Divil a thing, Sergeant," said Moloney. "What the hell could we do wrong here?"

"The only safe place to say a thing like that," remarked the sergeant, "is a place called hell. All right. I'll go down and listen to the man."

He didn't hurry himself down the stairs. The young policeman walked impatiently behind him. He was boiling with curiosity. It was such a small place they were. Nothing ever happened. Nobody seemed to know they were even in the place. Moloney felt sometimes that people would know more about them if they were in the middle of a desert. For a chief superintendent to call them up was really something big.

The sergeant took up the phone and sat at the table.

"This is the sergeant," he said.

The phone started barking at him.

Moloney knew that the news wasn't pleasant because the sergeant didn't answer back at all. He just rested his big, half-unshaven face in his hand, listened closely and looked out over the

land through the open window. It was obvious that the man at the
end of the phone would leave space for an answer, probably in the
affirmative. But there would be no answer so he would go on.
Eventually he had to run out of words. The yapping was silent, then
barked an exasperated query to which the sergeant gave a slow and
considered, "Yes," a long pause and then, "Chief superintendent,"
and put down the phone on the rest. He put both his elbows on the
table and chewed at his knuckles with the nice white teeth that
weren't his own. He saw where the waters of the land and sea meet
at the estuary, and the very white houses along the line of the wind-
ing road, and the neat green fields and the reeks of turf piled up.

"That bloody river," said the sergeant.

Moloney was hopping from one leg to another.

"Well, what was it, Sergeant? What did he want?"

"Moloney," the sergeant questioned him, "is this a bad village?"

"It is not," said Moloney, "more's the pity. Aren't they all like
red-blooded saints except on St Patrick's night?"

"Am I liked in the village, Moloney?" asked the sergeant.

"Well, considering everything, Sergeant," said Moloney, "I think
so."

"So we have a respectable village where the police are popular,"
said the sergeant. "Do you think this happened overnight,
Moloney?"

"I don't suppose it did," said Moloney.

"How right you are," said the sergeant. "I'm here twenty-three
years and if the place is like it is now it's me that med it that way,
and I med it that way because I used a bit of me thinkin' apparatus.
Listen, Moloney, you have all them philosophers writin' books. If
I could write a book about this psychology stuff I'd make a holy
show of them fellas. Do you know that?"

"Listen, Sergeant," Moloney burst out. "What the hell did he
want?"

The sergeant ignored him. He rose, went to the window and

leaned out on the sill through the open window, his balding head in the sunshine.

"And now that goddamned river has to spoil everything," he said. "Look at it, tumbling its way into the sea, and because of it I have to destroy the hard-thinking work of twenty-three years and have them all again pulling down blinds over their eyes when we meet together on the road."

"I have it," said Moloney joining him. "It's about the fishing."

"Yes," said the sergeant. "The river got a new owner lately. You saw him. He kem in here to tell us that anymore if we wanted to fish we'd have to give him half of everything we caught. You remember him, a small, sawed-off piece of parasite that never did a day's work in his life, with two thin lips on him like a knife slit in skinny bacon. He's been places, that little man, tho' you'd wonder how the bird's legs he has would carry him that far. Yes, he's seen the chief and he's written to the castle and the Dail and the Taoiseach and Dublin Castle and the upshot is that they say we are not co-operating with the worthy owner of the fishery, that too many salmon are leavin' by the back door, and that he wants action and they want action. Everybody wants action. I had it all worked out. I know how many fish were leavin' the river. Not a lot. Just enough. They all knew me. I'd put up with a certain amount they knew. Now I strike. What happens? Forty times the fish will leave the river and what happens to the village? It will become contrary. I know. They don't know. They don't give a goddam. I've built this village. I've reared it like a mother, and now I have to destroy what I built in a night over that little" He banged down the window and sat on the form.

"Why didn't you explain it to the chief superintendent?" Moloney asked.

"You're young," said the sergeant. "You'll learn."

"I see," said Moloney doubtfully.

"So tonight," said the sergeant, "we go after Mickey."

"But, Sergeant," said Moloney, "Mickey is your best friend."

"I know," said the sergeant. "That's why." He looked into Moloney's wide-puzzled eyes.

There was a bright moon that night.

"You stay here," said the sergeant to the water bailiff. The sergeant disliked the man. He had sandy hair and prominent teeth so he always seemed to be sneering.

The sergeant wanted to say to him, "If only you did your job right all this wouldn't be happening." Which was hardly fair. Sandy tried hard, but one night about ten years ago when he was really trying he ended up in a deep pool in the river and had never shown the same enthusiasm for the job. "If he sees you, it's all up. Come on," he said to Moloney.

The sergeant had an old raincoat buttoned up around him and an old hat on his head. He went along the favourite side of the river with a short stick in his hand. In the deceptive light it looked like a gaff. He would pause at each pool and he would get down on his stomach as if he were examining the lies. Then he would rise and meander on. He cursed frequently under his breath. He felt very bitter. His heart was heavy. He could see the train of inevitable things that would happen after tonight. After this they would want an army with heavy artillery to keep the whole village away from the river. And they were so blind and stupid that they couldn't see it.

He knew exactly where Mickey would be. And Mickey was there. He knew that Mickey had spotted his manoeuvring. Mickey could see a single horsefly in the middle of an alder bush. The only thing that would puzzle him would be the identity of the amateur poacher. The sergeant kept up his wandering, getting closer and closer to the Priest's Pool. It was a pleasant place where the river wound. On the far side, there was a yellow gravel beach. This side the river flowed free, and by reclining on the thick grass you could caress the water with your fingers. Mickey was lying stretched

there, only his eyes appearing over the edge. He was looking at something in the water. His hand was held by his side. Any minute now the sergeant knew, that right hand would flash and a glittering, contorted fish would be rising helplessly in the air.

The sergeant rose up.

Mickey saw him. He signaled him down.

"You fool! You fool!" Mickey said to him in a harsh whisper. "Keep your shadow off the pool."

The sergeant instinctively ducked, and then rose up and threw away the hat, opened the coat and threw that away.

"I don't know who you are," said the sergeant, "but I arrest you for the illegal procuring of salmon on another man's river."

He saw the amazement on Mickey's face. It was a pleasant face. Black, virile hair even though he was nearing fifty, a burned face seamed with laughter wrinkles all over it and blue eyes. He always wore faded brown clothes. They merged better. Amazement on his face and incredulity. Is this the man I sit and talk with for hours into a morning, while we sip beer and smoke too many cigarettes, and arrange the world between us — what's wrong with politics and religion and the country's youth?

He saw a protest forming on Mickey's open mouth. Was he going to call me Brutus, wondered the sergeant? Then Mickey threw the gaff on the ground and turned away. There Moloney rose up to face him. Mickey saw the buttons gleaming in the moonlight and then he turned back, and the sergeant knew he was leppin'.

There was only one way to break free. The sergeant blocked the way, so Mickey threw himself on the sergeant.

I'm an old man, the sergeant thought, as he felt the power of the smaller man in his arms. Squirming like an eel, flicking his body like a powerful fish leaping the waterfall. They fell to the ground clasped in a sweaty embrace. For a moment on the ground they faced one another. The sergeant was the stronger man. There was sadness in his eyes. They looked at one another. Now is the time for him to spit

out a curse and name at me, thought the sergeant. To his horror,
Mickey just shook his head, released his grip and relaxed.

At that moment the sergeant threw the chief superintendent out
of the window.

"Hit me, Mickey, for God's sake," he said.

Mickey was quick. He hit him.

You'd hear the sergeant groaning over in the next four counties.
He rolled on the ground and sat up, holding his head, while Mickey
was up and away like a shadow. Moloney came.

"Are you hurtit?" he wanted to know.

"I'm dying," said the sergeant.

"I got a look at him," said Moloney. "I'd know him agin. He ran
into the first house up on the road."

"You'll get promotion out of this, Moloney," said the sergeant
bitterly.

"Where's that moron of a water bailiff?" he asked then.

"He's twenty yards away on a hill lookin' at us, Sergeant," said
Moloney.

"He would be," said the sergeant, staggering to his feet. Then in
a loud voice. "After him, Moloney. We'll get him now on a double
charge." He limped after Moloney. They came to the house. There
was no light in it. The sergeant looked back. Sandy was behind
them, watching. The sergeant banged on the door. "Who lives
here?" the sergeant asked.

"I don't know, Sergeant," said Moloney.

"Well, there's one thing sure," said the sergeant. "We can't break
into any man's house without a search warrant. That's the law. It
may be a bad law, but it's the law and that's all that's to it. I'll go
and get the search warrant and you stand guard here at the front
door.

"But what about the back door, Sergeant?" Moloney asked.
"Couldn't someone slip out the back while I'm watchin' the front?"

"That's a good thought, Moloney," said the sergeant. He called

then in a loud voice to the water bailiff. "Here, you! Come and stand guard at the back door, and hurry up or your man will have slipped out the back while you're comin'. How can I catch poachers when I get no co-operation?" He said this in a loud voice.

Sandy came running. "Ye nearly caught him, all right," he said. "But he's holed up proper now."

"Go to the back door," said the sergeant, "and stay there until mornin' if you have to. I'll have to rouse a justice of the peace for a search warrant, but I'll be back as soon as I can and we'll grab him." It's a good job, he was thinking, that Sandy is as dumb as a bucket of water. "On guard now, min," he said to them, "and don't let him out of yeer sight. I'll collect the evidence below at the river and I'll be back."

He walked away from them to the riverbank. He was humming a bit. He was thinking, well, to hell with it, I'm nearly pensioned off, anyhow, as it is. He picked up the gaff where it had dropped in the struggle. He went to walk off, started and paused. What had Mickey been looking at? Well, it doesn't matter. He walked on. Then he walked back. I'll just look, anyhow. He got down on his belly and peeped over the edge. He whistled softly: Great God, he must be up to twenty-five pounds! He was beautiful. It was the moon betrayed him. He was motionless in the clear water. A small head and a round body on him. Beautiful. That's the way, said the sergeant. His heart was pounding. He rose to his knees. I might as well get back. He used the gaff to get himself to his feet. The gaff. The sergeant looked at the wicked winking point of it. Terrible things, terrible things, man.

He got back on his belly. He looked once. He struck. Something jolted his arm as if he had hold of an exploding hand grenade. Great God! The eyes were bulging out of his head. His heart was turbulent. Full of triumph, and a great fear that somehow he was going to lose the beautiful creature.

He started to pry him loose from the water.

A soft voice from his right-hand side, tsked, and tsked.

"What's the country comin' to?" the voice asked. "Corruption in high places. Bloody poachers in the police force. And amateur poachers, at that," went on the voice urgently, as the salmon started to play the sergeant.

"For the love of God, help me, Mickey," said the sergeant, "or he'll get away."

Sukos

I MET HIM in Lough Derg.

From this you may presume if you like that he was a hard ticket, for an awful lot of hard tickets like myself do the three day and night penitential exercises in Lough Derg. If you do it for one year you are good; two years you are a hero; and for three years you will be guided to Heaven, probably the hard way.

I had noticed him when we were doing the stations in our bare feet. There's an awful lot of granite there. His feet were bleeding. I was behind him once and I saw the prints of blood that his feet were leaving on the stones. He had white narrow feet. The parts you could see were white. The rest of them were dust-stained and sweat-stained and blood-stained. It made me wince each time he put his feet down on the stones. I got away from him, because my own feet were fine, dusty but fine, but then I always had good strong spawgs, since we were young and threw off the shoes at the beginning of summer and at the end of the summer we could walk on nails and kick football with them.

He had a dark polo-necked jersey on him and dark trousers rolled up to the shins. That's an odd thing you see there, the hems of fifty guinea frocks in the dust or cheap cotton frocks or very expensive trousers rolled up to the shin and all the hitherto well-tended feet: delicate, tender, tough, bunioned, corned, beautiful, ugly, shapely, arched, all taking a hell of a beating so that you may save your soul,

or pass your examinations; or recover your health; or that somebody
you love may recover their health; that you may get a good husband
or a good wife or that the ones you have may become better than
they are; or alternately just to say thank you for all those things
which have already been granted to you. Nobody really knows. All
you know is that hundreds of people, young, middle-aged, old, ugly,
beautiful, every known profession and every known race from the
ends of the earth, they are all there, eating nothing for three days
and nights except black tea and dry bread once a day and not sleep-
ing the whole of one night and all the next day.

I noticed him again in the night watch.

We would go into the Basilica to pray communally for an hour,
then come out and smoke a cigarette and walk around for an hour.
It was very cold out there. The concrete in the night was terrible
cold on the feet. Everyone was muffled up as well as they could and
the midges were rising off the lake in clouds and devouring every
bit of uncovered flesh they could find. I saw him rubbing with his
hand time and again at his face. In the light of the moon his face was
very hollowed and his eyes very deeply set. He had kind of reddish
hair that was unruly and fell over a high forehead.

I had come prepared for that kind of thing, so I walked up to him
and presented the little bottle of verbena and I said, "If you want to
stop the midges this is the only thing. They'll eat you else."

He looked at me and stretched his hand for the bottle and then
withdrew his hand again, shook his head and smiled and said, "No,
no thank you, I will put up with it. That is penance, is it not?"

"No," I said, "that's not penance; with those midges it's murder."

"Ah well," he said, "let them do their worst." And he rubbed
away at the poison bumps they bring up on you. I walked with him
for a while. I noticed that when he said "thank you" there seemed
to be an "s" sound instead of the "t".

"You are not from here?" I asked him, hoping that he was long
enough in Ireland to know that every individual in it is as curious

as a cow at a gate and is never bashful about seeking to know your business.

"No," he said, "I am from over there." He was looking over to the east where there was a thin red line in the sky beyond the shores of the lake and the dark bulk of the undulating land. That line was the dawn. Somewhere below it the sun was beginning to send out coloured tracers. He named the country. He said its name very softly, very gently, like I would say the name of my own country if I was a few thousand miles away from it and had a hole in my heart like you get. Then he smiled again. "It's no use telling you *my* name," he said (I thought, he is used to our curiosity all right!) "because you wouldn't be able to pronounce it. It is full of w's and s's and z's. Where I am now they call me Murphy." This made me laugh. He laughed too, and then the bell rang and I flipped my cigarette over the wall, and the air was so still, I heard the water quenching it. I think he was glad to get away from the midges.

The next time, he sought me out.

I was sitting with my back to the wall of the hostel, with the warm sun shining on me, and trying hard not to doze. If you dozed you were done. That was part of it. You must keep awake until nine o'clock that night. You could sit, but not recline. If you were caught reclining they gave you the boat, bag and baggage back to the mainland.

"You do not sleep, I hope," he said as he squatted beside me.

"No," I said, "I just have my eyes closed thinking about cool sheets, feather pillows and spring interior mattresses."

"Oh!" he said, and laughed. I wondered at the warm feeling I had for him. I felt very pleased that he sat beside me. I felt that I had known him from a long time back. He had very candid brown eyes, but now that I saw his face in the daylight, I noticed it was very heavily lined, almost scored, as if the lines had been carefully dug in with a chisel. I could also see that close up his hair was greyer than reddish, as I had thought.

"Your feet are in a bad way," I said, nodding at them. He raised them in the air to look at them. They were like two lumps of raw beef, I thought, and then stopped thinking about beef because I was hungry. "Are they very sore?"

"No, not very sore," he said. "I could bear with worse."

"You seem to be intent on punishing yourself," I said, "with midges and sore feet."

"Yes," he said, and looked away at the lapping waters of the lake.

"What brought you this far?" I asked him, cursing my curiosity, but the question was out before I could haul it back.

He didn't seem offended.

"What brought me here?" he asked. "I suppose you could say it was a man called Sukos. I will tell you about Sukos." He turned and smiled at me. "You will find that it will be better than spring interior mattresses to hear about Sukos. Yes?"

I laughed. "They don't worry me that much," I said.

"You will like to hear about Sukos," he said. "Everybody I tell about him, they like him. It was the time the Communists took over. You know about the Communists?"

"I do, the bastards," I said in my unthinking peasant fashion. I assured myself it was fervent, though, like the time at home finishing the retreat when we were all renouncing the devil with lighted candles in our hands, and the missioner asks, "Do you renounce the devil?" and we all thundered, "We do!" and old Johnny added in the pause "the Bastard" — my way was fervent like that.

"You must not hate them," Murphy admonished me now, gently. "It's the creed, not the people. You can hate smallpox or leprosy or black plague, but you don't hate the people on whom the disease falls?"

"No, that's right," I said.

"In our town there were then about a hundred thousand people and over all these people was the commissioner. His name was Paul. He believed. He was very intense. More suffering and terror

is engendered by true believers than by soulless monsters of expediency. Their terror is coldly callous; the other is personally active and more painful. Paul was like that. He would not spare his own mother if she rejected the fire of his belief. Things weren't good in our town for many years. It was the usual thing. The gentle almost useless middle classes with their paunches and soft hands were herded on farms or into camps. Many died. That was the idea. Many reformed, but they were carefully watched. That was the idea too. Many saintly holy fathers died, very painfully, and some of them rejoiced. I know. I saw them."

The boat was coming into the pier near us. It stopped. The men started to manhandle packages towards the kitchens, the staff kitchens. I saw many wonderful things: butter and a few legs of lamb and chickens wrapped in greaseproof paper; all for the hard-working people who kept the place going. In fact now that I had seen all this food, I thought I could smell on the warm sun-kissed air the delightful smell of frying bacon. The water came out of my teeth.

"The Palace of Paul they called the centre of interrogation," said Murphy. I was glad to pull my thoughts back to him. "It had been a seminary at one time. It wasn't unlike this place here, with three-storey stone buildings for the students, built around in a complete quadrangle. The empty church was in the centre. They shot many people against the side wall of the church. The stones were pock marked with bullets, splashed with blood. Paul liked the idea of the seminary as his palace. It was a place of worship, scholarship and learning. It became a bleak place to avoid. Until Sukos came."

"Was Sukos a new commissioner?" I asked.

Murphy smiled. "In a way, I suppose he was," he said. "He defeated Paul."

"Do I have to love this Paul, too?" I asked. "It's a bit of an effort."

His face clouded. "You should try to," he said. He bent his head and started gathering little bits of gravel with his fingers. They were

long thin fingers, the kind you see on very active people, who are always doing something. I thought they looked wrong on him because he appeared to be too tranquil for his fingers.

"Sukos," he went on then, "was a simple working man. He worked in a steel mill. He was average size, lithe, with white hair and a tonsure of baldness. Sukos' trouble was that he went to Mass every morning. He was very adamant about this. He was looked up to in the mill and naturally it was thought that he was giving very bad example. So he was spoken to once and he was spoken to three times, but always his name was there in the notebook of the observer who stood outside the one church that remained open. It came to the point that Sukos was giving scandal. Many of the mill workers, even those who had never gone to Mass at all, even in the old days, they started to troop off to Mass every morning. Something had to be done, so one morning before he could go into the church Sukos was collected and brought to Paul."

I was sure I could smell frying bacon, but it didn't interest me as much. I don't know that I wanted to hear about Sukos either. It appeared to me that Sukos was going to get into trouble. I wasn't sure, here in the warm sun and the gentle blue sky and the lapping water, that I wanted to hear anymore about Sukos.

"By this time Paul had a name. It pleasured him to see the apprehension in the eyes of the people who were brought to him. He was very clever. If you work at a thing long enough or hard enough, with practice like everything else, you know in a few sentences how to deal with people before you. He looked at Sukos. He would look at him for five solid minutes. That would be very disconcerting. It always was. Not now, because Sukos, who was holding a big missal in his hands spoke, first. Sukos said, 'Tell me, Paul, what have you done with the Lord Jesus Christ?' Nobody moved. 'I knew you and your father and mother,' Sukos said. 'I saw you receive the Lord Jesus Christ on your sixth birthday; I saw you confirmed in Him on your twelfth birthday. What have you done with Him, Paul?'

"Paul was gripping the table. One of the men beside Sukos hit him on the side of the head with the butt of his gun. Sukos fell on one knee, but he rose again and there were streams of blood flowing down his face.

"'Why do you strike me, comrade?' he asked. 'You could wear Christ on your shoulder.'

"'Shut up! Shut up! Shut up!' the man said and raised the gun again.

"Paul had to get to his feet. 'Don't do that!' he shouted and hit the man in the face with his fist. Because this was all wrong! Paul had never personally laid a hand on anybody, and this violence was a complete upset to his methods. The man staggered back, and Paul turned on Sukos. 'You bloody traitor!' he shouted at Sukos. 'See what you have done! It's for the like of you that the old autocracies are toppled, so that your wife and your children may have food in their bellies permanently, and what is your gratitude – to lead men astray on the old superstitions. Is that your gratitude, when you should be an example?'

"'Paul,' said Sukos, 'what have you done with the Lord Jesus Christ?'

"This was terrible, you understand. Nothing like it had happened before. Paul was in a frenzy. 'If you don't abjure your superstitions here and now,' he screamed at Sukos, 'and cease leading honest men astray, you will die! You hear that? You will die right away! Sign it, Sukos! Sign this.'

"All Sukos said was, 'Paul, what have you done with the Lord Jesus Christ?'

"They hit him again, the others, before Paul could stop them. Sukos was badly beaten. They seemed to be in a frenzy, too. Finally Paul stopped them and he shouted, 'Take him out! Take him out! Give him a last chance before the church.' They dragged him away. Sukos was silent. He couldn't walk upright.

"Paul leaned on the table to get his breath back. He was

completely upset. His eyes strayed to the floor. Nothing on the floor except blood and Sukos' missal, bloodstained, with all the little holy pictures scattered. Paul got down on his knee and shuffled them all together and distastefully shoved them among the blood-clogged pages. Then it struck him what he had done. This dreadful giving away to emotion. Sukos musn't die. Not like this. The mill hands wouldn't like it. The Party wouldn't like it. It was too quick, too emotional.

"What have I done?

"He ran down the stairs. He looked from a window on the passage. They had Sukos against the wall. There were five lined up to shoot him. There were the two men holding his sagging form. Paul shouted 'No! No!' but the window was thick, and couldn't be opened. He had to run down and down the winding stairs. He got into the quadrangle in time to hear the orders for the execution, and in time to hear Sukos addressing the firing squad. Sukos was asking the firing squad, 'Comrades, what have you all done with the Lord Jesus Christ?' They didn't shoot him. The two men beside him started to club him with their guns. The men of the firing squad, who seemed to be taken with the same madness, rushed in towards him, and the gun butts rose and fell, rose and fell, and then ceased before Paul could come within reach of them. He stopped. He saw the men fall back, back, well back, their red faces losing colour, not knowing what to do now that it was over. Sukos was merely a red blotch by the church wall."

His voice ceased. I wasn't hungry anymore. I wasn't sleepy.

"That should have been that," Murphy said, "but it wasn't, and here you are up against the unescapable and the unbelievable. You see, there before their eyes, it was as if a green sward was pulled over the pitiful remains of Sukos. I'm telling you this. An actual green sward grew around the dead Sukos, so that you couldn't see him, just a green sward, there in front of their eyes. You think that affected them? Yes, it did, of course, to the extent that they got a

bulldozer and they tried to wrench that green mound from the ground. They couldn't do it. They scattered dynamite. They couldn't do it. They had to leave it and they had to leave that place altogether, because the mill hands came. Steel mill workers are precious. You understand that? Too many of them cannot be killed? That is a reasonable thing. They stood around the spot where Sukos was. It is no longer the Palace of Paul. It is all empty now. All except the church. They had to allow it to open; they couldn't forbid the people gathering around the mound of Sukos. This is a terrible and incredible thing, and how do I know that it is true?"

"You know it is true," I said in a blast of certainty, "because you are Paul."

"Yes," he said. "God help me, I am Paul, and later if you wish, I will show you the missal of Sukos."

"I would like that," I said. "I would like that." Paul got up and went away.

Such a long way to come, I thought, such a long way to come, all the way over here, but it wasn't until the next morning after we had finished the stations once more and washed our feet and put on our socks and shoes and packed our bags and headed for the boats that I saw him again. He was dressed in black clothes and a white collar with a black strip down the middle of it. I understood then. Murphy was a student for the priesthood. I saw the missal. I held it in my hand. It was stained all right.

I was in the motor-boat, so I would reach the other side first. He was sitting in the big rowing barge. In the middle of the hymns and the farewells and the greetings and goodbyes, I stood up and waved to him. He stood up, too, and waved.

"Goodbye, Murphy," I roared at him, "and good luck." Good luck indeed he would need, because, of course, he would be going back, going back to work with Sukos.

The Mare with the Foal at Foot

MANNING, DISH-WASHING, was drying the last cup when he heard the car pulling into his yard. He moved to the door and looked out. It was a winter's evening, cold but clear and most of the light was gone out of the sky, but he recognised Joe Toole's car and his heart sank, because Pierce Malone was sitting beside him. What a terrible pity it is, he thought, that God doesn't give farmers more work to do in the wintertime, so that the devil can't occupy their thoughts for them.

But then he mused, what's the use anyhow? and decided to become cheerful about it and waved the cloth he was using.

Joe Toole came out of the car like a rocket. He was always that way. He was always attacking things, always on the go. Fortunately for his wife that she was a placid woman.

"Mann," Joe was saying as he rushed to the house, "get into your best suit and a collar and tie, for I have found the very one for you."

"Ah, no, not again, Joe," said Manning.

"Listen," said Joe, "this is it, I swear to you by all that I hold sacred. How many have we paraded before you, tell me?"

"A few hundred," said Manning.

"Wait'll you see this one," said Joe. "I tell you she has been waiting for you. Pierce and myself saw her at a fair in Gortaburn last week, and the minute I clapped eyes on her, I said to him, "There's the woman for the Little Mann. Did I say that, Pierce?"

Pierce was the same age as Joe, about thirty-five, but he was tall and lanky where the other was middling sized, powerfully built, with black curly hair always falling over his eyes.

"Hello, Mann," said Pierce. "You should see her. She's the one."

"There's no chance of you leaving me alone is there?" Manning asked. "There's no way of persuading you that I am happy on my own and that I don't want a woman?"

"Don't talk like that, Mann, for God's sake," said Joe. He was in the kitchen, his back to the fire. "You are a nice fellow, Mann. Everybody likes you. I tell you I can't sleep at night thinking of this place of yours without the touch of a woman in it."

"What's wrong with it?" Mann asked. "Would any damn woman keep it as clean and neat as I do myself?"

"To hell with that," said Joe. Joe's blue eyes were intent. Pierce was straddling a chair grinning. "You have a nice place. In fact it's one of the nicest places in Greenriver. You aren't forty years of age. Who are you going to leave the place to? Don't you want to have little Mannings running round? Haven't you any heart in you at all?"

What's the use? Manning thought. They did this every year and they would keep on doing it, so he sighed and said, "All right, I'll get ready. I'll go along with you for the sake of peace."

"Good man," said Joe, catching his arm and clapping him on the back. "I tell you this time you're in. This is it, Mann. I felt it in my bones. All them other times were only skirmishes, you'll see. I swear it by the grave of me mother."

"It's from her you got your damn matchmaking inclinations," said Mann, moving to his bedroom door. "She caused more trouble in Greenriver than a war."

"God forgive you, Mann," Joe shouted after him, before he winked at Pierce and rubbed his hands.

Manning switched on the light in the bedroom and started to change his clothes. He knew well that Joe was only getting fun out of him. He was an intelligent man. He had read enough to be able

to read other people. He knew that Getting a Woman For Little Mann was the main occupation and subject of conversation in Greenriver for the winter and it would have been a pity to deprive them of it.

He was very small. He wasn't even five foot. He knew that, always knew it, for his size had deprived him of a lot of things. He was well shaped, of course, and his face was lean and handsome. His hair was dark and his eyes were brown and twinkled deep-set in his head. He knew all this about himself, but when you are small like that you are very handicapped. People are not inclined to examine your features or study your mind or probe your feelings. They only look at the package and say: What a small little man! So when you are younger you don't go to dances; you'd only make a laughing stock of yourself. There are so many things you can't do that normally attract the eyes of marriageable girls towards you. So he had schooled himself to a lonely life and had filled it with many satisfying things like hard work, intelligent spending on his place, books; the making of money to provide a lot of modern comforts. Taking it all in all, he was quite happy, and almost content, but he despised himself in a way, because although he resented this yearly buffoonery of Joe Toole, in a sneaking way he enjoyed it, because always at the back of his mind was a faint hope that one day, you never know, one of these girls and he, maybe. But he was no fool.

"All right now," he said to them going out.

Joe was shaking his head.

"God, Mann," he said. "You look well. By all that's holy if you were only another six inches from the ground you couldn't keep the girls off you. Come on now. Wait'll you see her, Mann. She's a gift."

They were going out to the car.

"What's wrong with her?" Manning asked.

This hurt Joe.

"Mann, what are you saying?" he asked.

"I'm just asking," said Manning. "All the others had something wrong with them. They were left in the dip."

"That's gratitude," said Joe, starting the car and driving dangerously on to the main road, switching on the lights. "What's Maura Carroll like, Pierce? Tell him. Go on, tell him!"

"She's neat," said Pierce. "Dammit she's not much bigger than yourself, Mann. Dark curly hair she has and blue eyes. Very neat. Peaceful, quiet. Not much yapping. Don't know how she wasn't grabbed years ago."

"She hasn't a wooden leg?" Manning asked.

Pierce laughed. "We didn't get that far," he said. But Joe didn't laugh.

"Ye shouldn't be talking like that," he said. "This might be the very one you have been looking for all your life. If she wasn't grabbed, couldn't it be that she was specially appointed to wait for you? Don't you believe marriages are made in heaven?"

"It's you helping heaven that gets me worried," said Manning.

The car swerved as Joe gestured with his hands.

"Someday you are going to thank me," said he. "One time before I was wed I would be looking at the girls on my own behalf, but never now. All I think of is: Would this one be the one for Mann? Isn't that true, Pierce?"

"You were born with it," said Pierce. "You are like a loving brother to Mann."

"Listen," said Joe. "When we get there, Pierce and I will go in to the house and talk, Mann. You stay sitting in the car. When she has her first look at you through the window, you will seem a normal size and her heart will turn over and after that it wouldn't matter if you could be fitted into a matchbox."

Manning laughed.

"You should have been in a circus, Joe," he said.

The place was twenty miles away. That would account for Manning never having heard of Jay Cee Carroll and his daughter, or

anyone else in Greenriver for that matter. Sometimes twenty miles might as well be a million.

There was a moon. It was a neat house looking very clean from the outside, and very white against the shelter belt of dark green forest trees. There were curtains behind the glass. The light shone through them. They were lace curtains, starched. That told Manning a lot.

"Stay here," said Joe. "Don't move a muscle. We'll bring her out. Lower the window of the car. Just give her the twinkle in the old glad eye. Don't say anything rude now, Mann, like other times. She's a nice girl, I tell you."

"I'll be fierce polite," said Manning. He lighted a cigarette as they left him. He chuckled. He always pricked Joe's bubble. He would say something sarcastic, not directly involved with the fact that the girls might weigh half a ton or be cross-eyed, or drawing near the old age pension. But he couldn't help the things that came out of him.

The old man was sitting on a stool near the open fireplace. You'd think he had been carved out of rock there the time they were building the house, Pierce thought. Only his eyes moved. He was dressed in old-fashioned heavy clothes.

You'd think Joe knew him since the day he was born.

"How are you, Jay Cee? Don't you know me, Joe Toole from Greenriver?"

"Ah," said Jay Cee, "your mother was an interfering old woman."

Joe laughed a bit weakly.

"She was a great one for helping the neighbours," said he.

"She was a great one for minding other people's business," said Jay Cee, decidedly, spitting accurately into the turf ashes.

Pierce laughed. Joe glared at him.

"Sit down," said Jay Cee. "Pull up a chair. What brought ye over this far?"

"I'll tell you the truth," said Joe. "We have a fellow in our place.

He has the best bit of land in the parish and the neatest place and it's a crying shame that he is the only bachelor, and that's what brought us. Because you have a daughter."

The old man's eyebrow went up.

"I have at that," he said, "but who is your man and has he ever seen her?"

"He hasn't but I have," said Joe, "and she's a sweet picture and my man is a nice fellow and if God ever meant two to meet it's those two so help me God, and that's what brought us."

The old man chuckled.

"Your mother never died," he said. "Bring in your man and let us have a look at him. Has he leprosy that he won't come into my house?"

"It's Manning," said Joe desperately.

"What?" said the old man. "That little twitch is it?"

"What's wrong with him?" Joe asked indignantly. "What's wrong with his possessions? Hasn't he a kind heart, and isn't he good look-ing beyond reason above the collar?"

"I never heard bad of him," said Jay Cee, "but he's as small as a fairy. Maura! Maura!" he called suddenly. "Come down a minute and make a sup of tay. Call in your man and let us have a look at him, or are you afraid he'll melt in the firelight?"

Joe was flummoxed. "All right," he said. "Call him in, Pierce. There's good goods in small parcels," he said.

"Small men are the divil," said Jay Cee, putting the kettle on the crook over the fire. "Look at the history books."

Joe's eyes were on the girl then. She looked calmly at him.

"Hello," she said.

"Hello," said Joe, thinking, I was right. She's a good looking girl, calm looking, intelligent too, I'd say, and damn well built.

"These fellas brought over a man for you," said Jay Cee, with a chuckle. "If you don't like him you can throw him back."

This made her smile.

"You're embarrassing Mister Toole, Father," she said.

"He has a thick skin," said Jay Cee benevolently, "or he wouldn't be up to his tricks. We'll give them tea anyhow, love."

Maura put a cloth on the table and started to get cups from the dresser.

Pierce filled the door then. He was grinning. He stepped aside. He seemed to do this deliberately to emphasise the difference between his own height and the small man he disclosed.

Manning looked first at the old bright-eyed man on the stool and then looked at the girl. She looked right back at him. She didn't look him up and down. Imagine that, Manning thought! She just looked at his face and his eyes.

"Please come in," she said.

"Thanks," said Manning. He took his eyes from her but she was registered.

Attractive, very attractive. Neatly dressed in a blouse and skirt, with shapely hands roughened by hard work. A slight feeling of despair came over him. She was the kind of girl he would have really liked, but she was too nice, that was the trouble. Something wrong.

"I'm glad to meet you, Mister Carroll," he said. "Some actions are not of our own making. You understand this?"

"There are always Joe Tooles," he said.

"But they mean well," said Manning defending his friend.

"Humpf," said the old man.

"Did ye have anything at the last fair?" Joe asked in a loud voice. Start on cows, Joe thought, and get the conversation going.

So they talked about cows and animals and the weather. And they drank tea out of china cups and ate nice home-made bread. So Maura makes good tea and has an easy hand with a cake. Manning liked the relationship between herself and her father. It was affectionate. They were both intelligent people. They could talk beyond cows and the weather, he found. They knew what was happening.

They read the papers and they listened to the radio. They had views.

Sometimes he found her eyes on him, and he wondered. Once as she mended the turf fire, she brushed by him. His pulse rate increased a little. Maybe, he started to think, hopefully, she was too intelligent. Maybe that was it. Maybe there wasn't lunacy in the family or some other awful hereditary disease, as nearly always happened in these trips. When she looked at him there was no amusement in her eyes, no speculation, no waiting until he got outside the door to laugh at him.

There was nothing at all wrong with her except that suddenly from the room where she had come down to them, a baby started to cry.

There was silence in the kitchen. Manning saw the old man looking at them sardonically, watching their reactions. Manning found himself watching too, as a slow flood of disappointment welled up in him. I ought to have known, he thought. I ought to have known.

"Excuse me," she said. "I must attend to my baby." She left them and went up to the room. Jay Cee was grinning at them. His gaze was mainly concentrated on Joe. Joe was very moral, Manning thought. He would prefer the girl to have a loathsome disease than to have had a baby. He was very flustered.

But Manning was angry. What right had the old man to sit there like a Buddha gloating over them. Joe's intentions had been honest if they were interfering. He had meant well, like all interfering people. His face was red now. He was rubbing his shoes on the concrete floor. He could hardly think of an excuse to get out of there fast enough. So he rose and stretched himself and talked about having to be up early in the morning.

"You want to get up earlier than that," said Jay Cee. Jay Cee was needling him. You could see that. So they said good night and as they were going out the door Maura came down again.

She said, "Are you going? May the road go kindly with you."

Yes, she is looking at me, Manning thought. She is not really much taller than I, a few inches. Small and neatly built, and a good mind. Look at her, nearly everything I would want if I could have got it, and look at her standing there, one hand holding the other in front of her, not defiant, not sorrowful, just, he thought wildly, a slight sadness that they couldn't meet and talk again.

But he was raging. Because they were so calm and Joe and Pierce were so red and so sweating and so upset. So he drew away from the door with the other two and he kept looking back into the kitchen and he said in a loud voice that was distinct on the night air: "I like the mare, boys, but I don't like the foal at foot."

It was very deliberate, very cruel, and he watched her. It was the same as if a whip had been flicked across her face. That was all. He was sorry then, sorry. She walked to the door and her voice floated out after them, softly, calmly.

"May you have a safe journey," she said.

They got into the car and drove away. They were silent. For a time.

Then Joe was pounding the wheel and saying, "Oh God, Mann, I'm sorry! I'm sorry, I didn't know. How was I to know? Great God!" His sorrow didn't last. Pierce started to chuckle, and then Joe did. They became a bit ribald. Wait'll Greenriver hears about this and what Mann said. Did you hear what Mann said, Joe? The mare with the foal at foot. Oh, that was classic that was. Lord, wait'll they hear about this.

But Manning was silent. He couldn't go along with them. He had laughed before, but he hadn't it in him now. It was so cruel. Because they were decent people, decent people. Mann's saying would be around for this winter and many winters to come.

They left him, laughing. They would probably wake up the neighbours to tell them about it.

But Mann unraked his fire and lighted it and boiled a kettle and sat in front of the fire with a cup and drank tea, and the more he

thought the smaller he felt, if that was possible. There was no rea-
son for it, he thought, no reason, just hurt, but who brought the
hurt? These people had nothing to do with it. We went there unin-
vited.

Which was why, some hours before dawn, he got out the bicy-
cle that was the only concession he made to his vanity. A boy's bicy-
cle would have fitted him perfectly, but he always bought a man's
bicycle and lowered the saddle as far as it would go. He had to go
up and down on it a lot even at that, but he couldn't ride a boy's
bicycle. He went on the road in the dark and he cycled the twenty
miles. The dawn was just coming into the sky when he parked his
bicycle, and going inside the gate and the wall in front of the house,
he sat there on a stone and patiently waited.

He knew she would be first up. She would have to light the fire
and put on the kettle and go and milk the cows. He saw her doing
that as if he had been there every day.

The door opened. She didn't see him. She went back in and he
heard her doing things in there, and finally she came out with the
big milk can and she paused to look up at the sky so that he saw her
throat, and then she turned to go towards the stable and she
stopped when her eyes lighted on him.

He watched her eyes. He could read them. Slightly startled, con-
centrated, and then amused. She wasn't laughing at him, you
understand. Nor, he thought, was there any grudge in her for the
hurt he had given her.

"You look like a leprechaun sitting on the rock," she said.

He rose and went over to her. He took the can from her hand.

"Can I help you with the milking?" he asked.

She walked beside him towards the stable.

They didn't talk. When the cows heard them coming they start-
ed lowing. There were two cows. Manning squatted and started to
milk the cows. She stood looking down at him, her hand on the
cow's hip.

"I didn't mean to be cruel," said Manning. "Your father is right. Small men are inclined to be cruel."

"But they are good milkers," she said, watching his small capable hands on the cow's teats.

"If you will be so kind," he said, "I would like to see your baby." She turned away.

"His father is dead," she said. "It may be as well. His mother was hard. She owned the place and she owned my Tom."

"I swear I do not want to know," said Manning.

She mightn't have heard him.

"So he decided to break away from her," she said. "He went across the way, labouring. He was in a deep ditch. They scoop them out with big machines. This one caved in. Just the day before I went over to him. That was our wedding day."

Manning sighed.

"Was he a big man?" he asked.

She laughed.

"No," she said. "He was on a level with my eyes."

She left him then. She walked away. Manning milked the cow and then he went and milked the other cow. He carried the loaded can out into the morning. There was a heavy froth of fresh milk on the top of it. She was leaning on a horse cart, her chin resting on her arms. She heard him. She turned to him.

"It's real luxury," she said, "to have somebody else doing the milking for me."

"I am useful in a lot of ways," said Manning.

They walked towards the house.

"Sins have to be paid for, you know that," she said.

"I threw a stone at you," he said. "You can't forget that."

"Indeed I can," she said. "Will you come in and have some breakfast?"

He thought of her father, a sardonic man. He hesitated. Then he grinned. She knew his thoughts, he knew.

"All right," he said. "Sins have to be paid for."

The old man was in the kitchen in shirt sleeves, yawning. He left his mouth open for a bit when he saw Manning. But he recovered.

"Oh," he said. "Did you not go home at all?"

"I did," said Manning, "but I came back."

"Well, you're welcome," said Jay Cee.

"Besides," the girl said, "we like having small men for breakfast. They don't eat as much."

And Manning left the can of milk over on the side table and suddenly he felt hungry.

The Green Dream

JOHN P. WAS overwhelmed when he finally reached the saloon on 69th and 3rd Avenue.

Willie had by this time ejected all the customers who didn't count, foreigners mainly from the west side. Willie himself opened the door for him, and when he had shouted a welcome at him and clapped him on the back, he dulled the clamour of the friends at the counter, roaring like a bull: "Silence there, and hearty greetings for the distinguished traveller, John Patrick Morahan."

They came from the counter with their glasses in their hands, laughing. The place was decorated highly by Willie. It was a few weeks short of St Patrick's Day, so as Willie said, he was only doing a little anticipating anyhow. The lines of tinsel shamrocks were strung across the mirror at the back of the gleaming bottles of Irish whiskey, and the picture of St Patrick himself had an honoured place between Power's Potstill and John Jameson.

Willie's daughter Patricia was behind the counter. She was wearing a green silk dress with a respectable neckline and a different coloured green ribbon in her brown curly hair. They were all there: Phil Logan, the fiddler, with his grey hair and the eyes of a poet; and Tim Horan, the writer man, with his flushed face and the hat on the back of his head and all the mischief in the world in his crinkled eyes; and Paddy Tomelty still wearing his hall porter's uniform and clapping John P. on the back with a hand like a Virginia ham. These

were the specials, and Mary Brodel on the stool at the far end with her hair coming down over her face from under the pot-hat she wore when she went out to get drunk every March, July and September.

"Pour the man out a large one now, Pat," said Willie then.

So she did, and he took it in his hand and looked into her eyes and she said, "So you are leaving us tomorrow, John P."

"I am," he said, "and maybe I'd never come back anymore."

"Ah, listen," said Tim Horan, "don't say that. Don't say we are going to lose such a lovely bad pool player like yourself."

"There will be a serious drop in our spending money until he comes back," said Phil.

"Maybe you will meet a nice Irish girl over there," said Patricia, "who'll put a spell on you."

"It could be," said John P. "It could be. I guess it's quite possible at that."

She saw that he meant it. "I suppose," she thought, "he would be quite attractive to them too." He was tall and lean and his hair was fair and cut close and he had deep-sunken eyes that could be very serious one minute and very lively the next. They were very bright now.

"Will we go over now and bring a few bottles and help you to pack up?" Paddy Tomelty wanted to know.

"You will not," John P. told them. "It's all done."

"He's not really all that good-looking," Patricia thought. "Looked at from some angles he is quite ugly. His nose is not straight and his chin is crooked and the long scar in his jaw that he got in the war might repel a lot of people."

"And you are very excited at going?" Willie wanted to know. He was behind the counter now, resting his beefy arms. He had a very kindly face for a saloon keeper, Willie had, but he could be tough too.

"Excited?" John P. enquired. "Listen, you have no idea, fellas. All my life I have had my old man talking, talking about it. I don't have

to go there at all to know what it's like. I know every house in that village. Left and right. Three on the left. Four on the right. Yellow straw thatches and the green fields sloping to the sea, and in the middle the river coming down from the mountain with the old stone bridge and the decayed mill, and the slope down to the river where the cattle go to drink. And the water of the river is as clear as a pearl, and when you look into it from the bridge you can see the little trouteens waving their tails, and they more highly coloured than goldfishes in bowls. All my life my old man talked about it."

"And never got back to see it himself," said Tim.

"No," said John P. sadly. "He never had enough to get back, and then when the time comes that we can send him, he has to die."

"The poor devil," said Willie. "Here, have another."

They had another and another, and John P. became eloquent. All the poetry of his father's longing came into his talk.

"I lived with it all so long. Thirty-five years he was away from it until he died, and he thought of it every day, and about how he would go back and walk down the street, and they would come out from the houses to greet him, and they would all be shouting welcomes at him and saying, "'Well, would you believe? John P. Morahan has come home to roost.'"

Phil Logan said that he hadn't heard it quite that way. John P. was getting it at second hand from his father. He, Phil, had got it a bit from his father, who had got it from his grandfather, so that John P. had the advantage of Phil that he was a narrowback while Phil was a narrowback once removed. They talked about their grandfathers and great-grandfathers and the places at home they had come from, but John P. was the only genuine narrowback in the place that night.

"There used to be a girl living in the middle house of the three on the left. My old man always talked about her. Peg Brady her name was. It was like the story of a ballad. She had brown hair and a waist like a greyhound and her skin was as soft as a peeled barnacle. That's what he used to say. And when he left home, he kissed

95

her down by the river and he said, 'I'll come back for you, Peg, someday.'"

"Aw, jeez," said Paddy Tomelty, rubbing a hand on his eyes, "wouldn't that break your heart?" Paddy was a bit on the sentimental side.

"So," said John P., "in a way it's not me that's going home to Ireland really, but my old man. It's a sort of a pilgrimage."

"Pilgrimage, hell," said Tim, "you'll be getting a few weeks away from stinking New York. Imagine feeling real Irish air going into your lungs. Imagine getting clean away from this lousy city."

They agreed that New York was lousy and that they hated it: the soot and the noise and the stifling heat in the summertime and the stuffy pool room where they played and the horrible old-fashioned club where they congregated and the buses and the cabs and the apartments and the cops. In fact, the only decent thing to be done with the goddam place was to give it back to the Indians.

They parted then, wishing him all the best of luck, and that he was to send them postcards to keep them informed, and that if he met Peg Brady's daughter he was to marry her and settle down in the little village and be happy for evermore.

Only Patricia saw him off at the boat.

She inspected the cabin and approved of it. Actually she looked very nice. She had a small hat with a little veil on it and her figure looked very trim in a light green silk gaberdine suit. She noticed that her head reached just to his shoulder, and she also noticed that if she had been dressed in nothing at all he still wouldn't have noticed her. He kept wondering when the ship was going to go, and what kind of inefficiency kept it at the pier half an hour nearly beyond its sailing time, and that someone should write to the president about it, and finally when the visitors-ashore gong banged, he practically ran her off the ship, so that she stood there, a small lonely figure watching the smug tugs pushing the big boat into the river, and there were tears of anger and sadness in her eyes as she

waved a small handkerchief at him, the big bum with the green shamrocks in his eyes.

He stayed on the deck to see the shoreline fading away and to see the Statue of Liberty looking much smaller than the photographs, and then he went and ate a very nice dinner. It was lucky for him that he did, because it was the last good meal he had for some time.

It was a big boat, but as soon as it got into the Atlantic it was greeted gleefully by thirty-foot waves that threw it about like kids throwing a baseball.

John P. got to know his cabin very well indeed, from constant viewing of it from the prone position. First he lost his taste for food and then he lost his taste for cigarettes and finally he lost his taste for life, and he was continually galled by the thoughts he had had of his days in the sun on the top deck, waiting for the coastline of the green land to come closer and closer. Dally a little with dames, perhaps, and tell them all the tale of the son who was carrying out the mission for the dead father.

And he also had a picture of his friends gathered together cosily in Willie's place, saying, "Isn't it well for John P. on his cruise in Atlantic waters, dallying with dames and getting nearer and nearer to the green hills?"

One day before they reached Ireland, the storm died, the sea calmed, the sun shone, and John P. felt there was some hope after all as he staggered abroad, carefully keeping his distance from the dining saloon.

He hired a chair and cushions and a blanket and said, "I will lie here and watch the green hills of Ireland come into view."

That evening there was a thin smudge on the horizon. "Tomorrow morning you will see Ireland," he was told, and he went to bed and slept for the first time and thought, Well, everything is not completely destroyed. Tomorrow will be different. He arose early in the morning to a loud booming and went up to discover the ship enveloped in fog.

"It's just over there," a sailor told him, pointing his finger. John P. could hardly see the tip of his finger. The boat was blowing, and over to the left there was another yoke that said "Boo-oo-boouck" like a cow with a base baritone that had been kicked in the belly. "That's Cobh, Ireland," he was told.

"Anyhow," John P. thought, "I have reached Ireland, even if I can't see the green hills."

He peered for the rest as the fog lifted a little, allowing them sufficient visibility to pick up the pilot and later to search for and find the tender.

As he stepped from the ship on to the little tender, the fog gave way to a thick wetting mist with a north-easterly wind behind it. John P. thought that knives were piercing him as the wind cut a way through the gaberdine raincoat and the light wool suit. "Bring a raincoat," they all said. With his teeth chattering, John P. thought it was a fur coat he should be wearing now. He went down to the saloon. He ordered whiskey. "Is it always like this?" he wanted to know from the little man in the white coat.

"Lord bless us, no, sir," the little man answered. "I remember last July twelve months we had a day that there was no rain. But sure it's lovely soft rain, so it is. It'll give you a complexion like a lassie."

"It's very cold, isn't it?" John P. ventured.

"Cold, is it? Lord bless us, this is a grand warm day, so it is. Isn't it the middle a spring, near? Even the lambs is gambollin'."

"I hope they don't get pneumonia," said John P., drinking more whiskey and pulling the coat around him.

"Spiled ye are in America," the little man went on, winking, his face creased into thousands of wrinkles. "That central heatin'. It has ye all brought up like plants in a hothouse. I don't know how ye venture into the fresh air at all without passin' out."

"I wouldn't mind the fresh air," said John P., "if I could see the bloody thing."

"Ah now, don't be downhearted," the man went on, "tomorrow

is another day. Maybe it mightn't be rainin' tomorrow. You never can tell. I heard on the wireless this morning that it's goin' to continue wet, and that's a good sign for a fine day." He laughed. John P. didn't feel like laughing.

He pushed himself up on top, huddling in his clothes, peering through the mist, sheltering near a lifeboat. He couldn't see a thing. Even when they had pulled right in near the quayside, he couldn't see a thing. And he was so cold. The customs man was nice. Very fast. Wished him a good time on his holiday. The narrow train with the hard seats was cold. There was rain on the windows outside and condensation inside. He rubbed it with the sleeve of his coat and peered and peered. He felt very sick. This was the island of dreams and it was hidden in a mist. He went to a hotel. The few streets he passed through were grey and wet. The streets were narrow. Lights were on in shop windows and condensed over. He could have been back in a small town at home. He just ate in the hotel. He found the food strange. He thought they had burnt all the meat to a cinder. The waiter was funny. "Ah, I see now, it's a bloody steak you want. The Lord save us, I don't see how you could ate it like that. It'd turn me stummik."

He sent a telegram to Michael Joseph Morahan, Ballygowran, Co. Galway. He had been deceived. He thought you just got off the ship and got a train and you were there. It was only a small island after all. "Ah, begob, sir, now wait a minute, you can't do it like that. First you go to Limerick, and there you get a train that takes you to Athenry after a little wait, and then you take a train to Galway after a little wait, and after that, if you are lucky, you get a bus to Ballygowran."

"Don't tell me," said John P. "After a little wait."

The rain lasted. He waited in Limerick. It rained. The sky lowered. He waited in Athenry. It rained. It will be sweeter when the sun shines. The land was flat. Whatever mountains might have been away in the distance were hidden in the low-lying grey clouds. He

waited in Galway. The bus went away. It was full of country peo-
ple: women in thick shawls and men in homespun clothes that were
wet and smelled peculiar, like tweeds always do when they are wet.
They were all talking another language. He presumed it was Irish.
It made him feel awkward and alone in the bus. They flashed looks
at him from their bright inquisitive eyes. He heard them say some-
thing like "an yank" as they looked back over his shoulder. Some
said "yank" and some said "puncawn". He must remember that for
them when he got home. They were puncawns. He ignored them,
looked out the window into the greyness. All desire for talk had
left him. This was so different to his pictures. In the pictures he was
sitting and telling them all about himself. About his father. The
time he had left Ballygowran.

"You get off here, sir," said the conductor.

"Oh," said John. "I suppose they will have sent a car for me."

"Oh divil a car," said the conductor. "There's none at the cross-
roads. Maybe one'll come along later. You never can tell."

"Is it far down?" he asked.

"Only a step, sir," said the conductor. "It couldn't be more than
four miles if it's an inch. Sure, it's a grand soft day for a walk. God
bless you. Your shoes are a bit thin, that's the only thing."

John P. stood at the crossroads with his bag in his hand and
watched the bus vanishing over a hill. Maybe his uncle hadn't got
the telegram at all. He was beginning to suspect that things weren't
quite as fast in this country as they were at home. He should have
hired a car in Cork, of course. Standing here in the rain, feeling the
mud under the thin soles of his shoes, his body shivering with the
cold. What in the name of God Almighty am I, John P. Morahan,
doing at an Irish country crossroads in the rain? What madness
came over me?

He pulled savagely at the collar of his coat and turned down the
narrow road. It was sadly cut up with the wheels of carts. He
walked as carefully as he could, but there were so many puddles

that he couldn't avoid all of them. It was no wonder my father came away.

He heard a cart behind him and stepped out of the way. A big fat man with a cheerful face, wearing no overcoat, his shapeless hat flopping wetly about his face. He stood aside to let the equipage pass. It didn't pass. He pulled the ass to a halt.

"Tell me," he roared then, "are you John P. Morahan?"

"I am," said John P., something warming inside him for the first time.

"Well, hop up," said the man, moving over a bit on the board that was stretched across. "Didn't Michael himself, God bless him, ask me to pick you up at the bus when I'd be passin' and wasn't the oul hoor of a bus late, and what with the weather and all, didn't I go down for a quick pint around the bend, and the oul thing comes when I have me face stuck in the porter. I'm Thady."

"Pleased to meet you," said John P., firing his bag behind on the straw and sitting on the seat. Thady clicked at the ass with his tongue and it went on despondently.

"Wasn't the bit of a message you sent late?" said Thady. "It was lying athin at the Post Office, and it'd be there yet if somebody didn't chance to read it and send out word. And you're Johnny Morahan's son. Well, begod, I'd never know you out of him. You're a proper gent, so you are."

"You knew my father?" asked John P.

"Didn't I go to school with him?" asked Thady. "Didn't we get to sixth class together? I knew him like I knew me own shadda in a pool. Don't I remember well the night we had the wake for him before he went off from the station in Galway? He was a good lad. And he did well in America, they tell me."

"He did all right," said John P.

"And he never came back?" said Thady.

"He meant to," said John P. "I have come in his place."

"You're welcome, man, welcome as the flowers in spring. My

wife remembers him well too. Ah, Peg and him was friends. Long time ago. We often spoke of him, God help us, and wondered what happened to him."

Why did they feel sorry for him because he went to America? John P. wondered. Should he try and tell Thady the difference between New York and Ballygowran? No.

"Was her name Peg Brady?" he asked.

"Well, now, isn't that a miracle?" said Thady. "You to know her name. Well, who could get over that now? Isn't that a strange thing now?"

There were slates on all the houses.

He saw that even in the rain.

"What happened all the straw thatches?" he wanted to know. "My father always spoke about the straw thatches."

"God bless your head, man," said Thady, "sure nobody nowadays can afford straw thatches. You'd want to be a millionaire or an American to keep your house thatched every year." He laughed at this, slapping his thigh. His hands were raw and red from the rain and heavily calloused.

They welcomed him at his uncle's. It was odd to have an uncle. He felt no attachment at all to the tall thin man with the grey hair, wearing a heavy coarse shirt and waistcoat. He was no more like his father than he himself was like the uncle. And the uncle's wife was a tall woman, too, with a sort of thick check shawl around her head and a heavy red petticoat with a check apron over it. There was a big open fireplace with pots swinging over blazing turf. That was good anyhow. For the first time in his life, he knew what it meant to be really warm. He changed his clothes, up in the room. It was bitterly cold in the room. It smelled of new whitewash. There was a spotless white quilt on the bed. He sat on the bed. It was a hard mattress of stuffed hair. There were many holy pictures on the walls. It was very clean. He spared a thought to their anxiety that things would please him. He pulled out the presents for them. They

looked a bit silly now. A gold wristlet watch for his uncle with an expanding strap. A dozen nylon stockings for his uncle's wife. There were strangers in the kitchen. "Oora, lookit, will ye." His uncle holding up the watch, putting it on his stringy wrist. They laughed.

"Begod, you want a new Sunday suit with that, Michael."

Sheer nylon stockings for the uncle's wife. He thought they would die laughing at this altogether as she lifted her petticoat to show her coarse stocking and held up the delicate beauty of the nylon near them. She laughed herself. It was funny. "Oora, look at that, will ye!" She had big gums and some of her teeth were missing. "I'll give some of them to Peg Brady's daughter, Moll. Here Moll. You haven't met John's son, named after his father."

Peg Brady's daughter.

He took her hand into his.

How great a stretch is there between shadow and substance? How great a stretch is there between two ways of living?

Her skin was clear. Her eyes were blue. She wore a nice blue dress with dots on it and her hair was black and gleamed. He felt the hardness of her hand in his own. There was diffidence in her eyes. Her teeth were very white and her gums were red. No lipstick. No make-up. Red cheeks. He thought of Willie's Patricia and his heart started a dull pound.

They talked and they laughed until it was well after dark. He tried to sleep, but he couldn't sleep.

The sun shone the next day.

There were three cottages on the left and four on the right and the bridge was there and the old decayed mill, and apart from the thatched roofs, it was the same as his father's memory. But it was smaller. The mountains at the back were smaller and the stream was pellucid, but it was only a stream. The grass was very green, the bogs were brown, the heather would be purple in another month and the gorse was peeping yellow, but the nearest telephone

was five miles away. He walked to it. "Call up America? God bless us, are you away from your mind? It costs a pound a minute."

Never mind. Called Willie's number to hear a voice without a slow drawl, caressing the vowels, sliding the consonants. To eat fried chicken. To drink iced water. To feel the surrounding comfort of central heating. "Sorry, sir, it's a bit early for that number. It's just five o'clock in the morning over there. Can I call you back?"

"No, thank you. Forget the whole thing."

"Thank you, sir."

A precise voice from London that. Strange denizens from still another world.

He went to Galway on the bus. He got drunk in there. He talked to a man with glasses. "Listen, it's all wrong. Out there they have a house and a kitchen, and right at the end they have a big open fireplace. What happens? All the heat goes up the chimney. So I say, 'Listen, it's uneconomic. Shift the fire to the middle of the kitchen in a big stove and the heat goes all around. You conserve. It's better.' No, sir. They laugh at me."

"Know what's wrong with you?" said the man in the glasses, who was also a little drunk.

"What?" asked John P.

"You're plain homesick," he said.

"You're a liar," said John P.

"Another thing," said the man in the glasses, "you're a bloody foreigner. So we speak English. You speak English. Does that make us brothers? No, man. You go to France, you don't speak French, so you realise you are in a foreign country. Just because we speak the same language, you come here and expect us all to be the same as you are at home. No, man. You are homesick and you are in a foreign country, and when you realise that, you will have a good time."

Homesick is it? For what? For lousy, sooty, unmentionable New York? He suddenly smelled the peanuts of Broadway, the fuel oil of the apartment house where he lived, up on the nineteenth floor

where he could look out of his window and see a panorama that could be duplicated nowhere else on the face of the earth. He thought of Willie's saloon, of Phil Logan tucking the fiddle under his chin. He thought of the sight of Manhattan at night, looking at it coming across the Queensboro Bridge, of the cycle cops presenting a ticket to an outraged, protesting, innocent citizen on the Northern Parkway. He paid his score and he went out of there and he called a taxi and he said, "Drive me like hell to Ballygowran, bud." And he got out there and he packed his bag and he shook his uncle by the hand and pressed dollar bills into it, and he kissed the leathery cheek of his uncle's wife, and he patted Thady on the back, and then he was away.

"Drive me to Shannon Airport, bud," he said, "and step on it."

His mind hummed with the engine of the car. He saw the planes circling lazily over La Guardia. From all the corners of the earth.

He would send a cable and maybe she would be there to meet him, trim and neat, like as if she had just been made.

Twelve hours from Shannon.

The sun was shining now.

Ah, see the land is green and the hills are green. That's what the whole thing is. It's a green dream, that's what it is. He wondered if it wasn't better after all that his father had never come back. Would the reality have lived up to the green dream? Because your mind creates things that could never be. Next time, he would come back as an American, not a narrowback with shamrocks in his eyes.

But he would have things to tell them nevertheless. He had been there and he had seen for himself.

He had seen three houses on the left and four on the right, and the farther he got from them the more the slates seemed to mist and die and be replaced by the yellow straw. So he could tell them all this and about the river being there, just like his father said, and the bridge over it, and the people slow-moving and romantic, living their own lives, different from ours, of course, much different,

for after all aren't we all foreigners? And Peg Brady's daughter, just like the Peg Brady his father talked about, the real Peg Brady, not the old bent woman who wore a red petticoat and walked with the aid of two sticks, her cheeks caved in because she had no teeth left. Ah, it was all there if you wanted to see it in the green dream. He would tell them and show them, as long as trim Patricia was waiting for him at the airport. Great God, let her be there, and someday we will come back, when the sun is shining always and there is no rain.

"Double fare if you step on it, bud. To hell with the cops."

The driver grinned and pressed his foot down hard.

Challenge the River

SOME CLAIMED THAT Garveen was the prettiest spot in the whole parish. It consisted of an area of about four hundred acres almost entirely surrounded by low hills except where the river that drained the far side came through the gap in the hills and, dividing because of the total inflexibility of the earth at that point, ran in two directions to meet the sea. Garveen faced the sea, then, a fairly rough coast except where the butty stone quay clove itself into the maw of the waves and on the sheltered side of itself had created a small beach of silver sand. Here the black boats and the currachs rested. Where the river divided, there was a bridge, a sturdy one of three stone arches, and in bad weather when the river was high, this bridge was the only possible way of access to the place. The river was called The Gap. This sounds ugly in English, but its name in Irish had a sweeter sound.

On account of that feeling the people had of being sort of shut off, they were a little different from other people. They regarded themselves as being a cut above them, and like all men who derive their livelihood from the sea, regarded themselves as being superior to men who till and toil. There were only six houses in Garveen, no shop, no pub; so that when they wanted groceries or strong drink they would have to journey the few miles over the bridge into the village of Gortshee.

The town was also notable for one other thing: It held the only

blacksmith in the whole parish. His name was Tom Tate, and he would be the last blacksmith. He had no assistant. The coming of the tractor was almost putting him out of business, and apart from odd horseshoes, or the wheel of a cart, or cleats and bolts and things for the few fishing boats, he wasn't kept very busy.

What I am going to relate would never have happened but for that freakish January storm. It came from nowhere, swept over the country, and then was gone, leaving torrential rain and a lot of destruction in its wake. Unfortunately, it coincided with a very high tide, which the wind blew even higher, so that it ran up the double estuary like a scalded cat. The running tide made matchwood of three currachs and blew them over half the village, and one of the fishing boats was neatly deposited, almost uninjured, in front of the Backs' house, which was the one nearest to the sea.

It was a frightening storm. Some storms you can view from your window, admiring the forked lightning against the piling, monstrously black clouds. Some storms just put the fear of God into you and leave you timorous and cowering, and this was one of those. It turned night into day and sent walls of water from the sky to the earth – almost solid walls of water that would test a strong man to get through. The river was high anyhow from the melting of the snow on the hills and the eternal draining of the deep bogs behind them; but with this rain falling and the sea contemptuously throwing back the waters of the river, it rose and rose higher – higher than in the memory of man.

The wind stripped the thatched roof off one house as if it was peeling an orange and tore the galvanised roof off another with a dreadful tearing noise that rose above the screaming of the wind, so that the people in the houses had to come out and look in horror and then scurry like refugee ants to the solid two-storey house of the Backs. But the sea when it came invaded the lower part of the house, so that kitchen chairs were floating and everybody was wet

to the knees, and it was very fortunate that little Mary Backs, since she was very sick, happened to be in the bedroom upstairs.

She was very sick, which is another and probably the most important reason for what happened. Her sickness and that storm would nearly unhinge a person's mind. Certainly her mother and Jerr, her father, were practically driven out of their minds with fear. Mary was lying in the bed and she was very hot. Somebody said you could roast an apple on her forehead. And this sickness fell on her almost as fast as the storm had fallen on the earth; one minute just a childish ailment, and the next, people were sure she was dying. The face of her mother was stark white as she bent over her, rubbing her small forehead with a work-worn hand, crooning to her. And on the other side of the bed was her grandmother saying, "What'll we do? What'll we do?"

Jerr, a big man with gray hair, wearing a heavy blue gansey, said, "Don't grieve, Julia; don't grieve. I will go now into Gortshee for the doctor."

"Cross of God, if you go out in that you will be kilt, Jerr," the grandmother said. "She will be fine. The fever will break in her."

"I'm going," he said, his heart torn watching the small, pale face, the sweat-soaked brown curly hair, hoping that like some miracle, if only he went away, when he came back everything would be all right.

"How is she? How is she?" they asked him downstairs. All the people cowering in the kitchen, sitting on the table, on the backs of chairs. "Not good," he said. "Not good. I will have to go into Gortshee for the doctor."

"No, you won't, Jerr Backs," said a tall young man they knew as Boulder on account of the blackness of him and the sturdiness of him and the endurance of him. "I will go for the doctor and you stay here and keep the house." And before Jerr could protest, he was gone and the people were barricading the door behind him, cursing the inrush of water that his going bequeathed to them.

Boulder was soaked right into his skin in a few seconds. The force of the wind took his breath away until he turned his back on it, and then it was like a giant hand pushing him from behind. Wasn't it great good fortune, he was thinking, that none of us was at sea when it fell. He paused a little, watching the black boat coming up on the tide. But wonders in these few hours were almost becoming commonplace, so he pressed on, running. He had to stop on the bridge and watch. He couldn't believe that the river could rise so fast and with such power. His brown hands instinctively clutched the coping of the bridge. It was trembling under them. What? his mind asked. Who in the name of God ever heard of a stone bridge trembling? But it was, and the roadway under his feet. The water was a monstrous maelstrom of lashing white foam and dirty-brown, wicked-looking bog water. He made the sign of the cross on himself, shaking his head. Then he ran on to the village. There wasn't a sinner to be seen in it. Slates were flying off the roofs. He kept close to the walls of the houses.

The doctor was in. He was young, slight, fair-haired, and already patient and unsurprised at urgent calls always coming at the most inopportune times. He questioned Boulder about Mary and her appearance. In his own mind he thought she might have pneumonia severely, so he packed his bag accordingly and got his car out of the garage. Boulder admired him for his lack of words and his decision.

When they cleared the village and got on the open road to Garveen, the wind seemed to be slipping its palms under the car and tossing it up and down. Boulder, who would be quite calm in a small open boat in a heavy sea, was terrified at the movements of the heavy car in the wind. The wipers couldn't seem to keep the windshield clear of the belting rain.

When they were coming up on the bridge, Boulder opened the window on his side and stuck out his head, purely from instinct, he said later, and shouted, "Stop it! Stop it! Stop it, now!" Fortunately

the doctor had the brakes clamped in a few seconds or the car would have been into the river.

Because the heavy stone bridge was gone, just gone as if it had never existed, as if it hadn't withstood the worst that could befall for nearly two hundred years. All that remained of it were the two pillars on which the arches had rested, and you could only see those occasionally in the swirling, chuckling, savage flood.

"My God," the doctor said, standing there looking at it.

"I felt it in me bones," Boulder said. "I knew coming over. It was shaking like an old man in winter."

They just stood there then, looking, in the rain, finding it hard to keep their feet.

"How do we get in, now?" the doctor asked, his lips at Boulder's ear.

"We don't," said Boulder. "No way in now at all, until the river drops. Poor Mary, poor little Mary."

The doctor felt bad. Impotent. Angry. That little child. But there was no way now. Then they saw the figure on the opposite bank. Boulder recognised Jerr. He was cupping his hands around his mouth. "Doctor, what can we do? What can we do?" he was calling. But his words were whipped away on the wind, and the doctor's words of advice to him. Even Boulder shouting across the mad torrent couldn't make himself heard. Such a helpless position to be in. Boulder ground his teeth.

Then they heard Jerr saying something else. "The nine irons," he was calling desperately. "It will have to be the nine irons now." Frantically, he waved his fist at the sky and the storm, as if that would do any good. Then he was gone.

"What does he mean, the nine irons?" the doctor asked.

"The silly superstitious blasphemers!" said Boulder. "Instead of being down on their knees. What good can those oul wives' cures do?"

"We'll get back," said the doctor.

Before returning home the doctor stopped at Father Solo's house. He always called and told him when a person was really ill. He found Solo out in his backyard nailing down the galvanised roof of a fuel house. He told him about little Mary Backs and the bridge and then, laughing, said, "Anyhow, it'll be all right. They are going to work the nine irons on her. That ought to be better than any pills."

He was amazed at the reactions of Solo. "What?" he demanded. "What did you say?"

"Something about the nine irons, they said," said the doctor. "Going to work the nine irons on her . . . What are the nine irons?"

Solo didn't answer him. He jumped down from the ladder and ran for the back door.

The doctor caught up with Solo outside. Solo was sitting behind the wheel of the doctor's car. The doctor just got in beside him before the car took off. Said Solo, "You think the girl has pneumonia. Tell me what I have to do with her."

"But you can't get across the river," said the doctor.

"Tell me! Tell me!" said Solo urgently. "I know that Thady Crumpaun. The bloody old pagan, God forgive me. Tell me what I must do if I get to the girl."

Bewildered, the doctor tried to tell him, showed him the compartments in the bag and what they contained. "But there's no use," he said. "Nobody can cross."

The people of Garveen had known almost as soon as the bridge went, and they brought word to the Backs house about it, and the people of the house were thrown into utter despair. Julia Backs, always a calm, almost phlegmatic woman, was on her knees by the bed, still holding the child's hand and crying, crying, enough to frighten you. Big Jerr, helpless, clenching his great fists. Only Thady calm. A small little randy-looking man, with a white moustache and whiskers. Small, no spare flesh at all on him, and piercing pale blue

eyes. Lived alone up on the far hill. A house of his own, managed on his own.

Men respected Thady, but they didn't love him. Too self-sufficient maybe. But they listened to him now — they would have listened to anybody at this despairing moment — when he said, "Look, people, there is nothing left for it but the nine irons."

The grandmother looked at him and crossed herself. "God forgive you," she said.

"How many men are walking about this day who should be dead, with the nine irons on a ring?" Thady asked them. Some of them nodded. They knew people with the nine irons. "What hope is there else?" Thady asked. "You hear, Julia. Let us make the nine irons."

Julia wasn't thinking. "Make anything, anything, anything," she said. "What will we do without Mary, Jerr? She is going from us."

Thady ran to the landing outside. "Are you there, Tom Tate?" he asked.

The voice said up, "I'm here, Thady."

He was back in the room. "You hear now," he said. "Hold on. We are away to make the irons." He went down the stairs. It was then Jerr left the house too and ran to the bridge to make sure for himself that it was down. He saw Boulder and the doctor on the far bank of the broken bridge, and he was filled with despair.

Tom Tate wasn't like a blacksmith. You expect blacksmiths to be big and broad. Tom was small, and it was only when they reached the forge and he took off his coat that you could see the heavily muscled arms and could recognise in them that he was a member of the profession. "You name them, Thady," he said. "I have forgotten."

They were not alone now. A lot of the people had left the Backs house to come with them. This was a chance that you didn't get every day — to be at the birth of the nine irons.

Thady thought. His eyes were sparkling. He was thinking about

Solo. He didn't like Solo. Thady had a good hand with sick cattle or horses or animals or humans, they said. It was mostly done by old incantations. He had the power of healing, they said.

"In this day and age," Solo had said scornfully, "all you are, Thady, is a medicine man. You should be living in Africa with the most primitive tribe possible. You would be really big there."

Thady didn't like that. People called him the medicine man afterward. His enemies said it with laughter and malice. That's why he thought about Solo now. Gleefully, because there was nothing Solo could do. And, besides, the nine irons were good. They had worked before. They would work now.

"Here it is," he said. He spoke the names in Irish. They were the plow, the harrow; spade, fork and chain; the shovel, scythe; the axe and slean.

"You have them now, Tom Tate?" he asked. He repeated them.

Tom Tate nodded, and then he gathered from the bench nine pieces of sheet iron and he brought tools with him to the anvil. He repeated the names and started with delicate fingers to cut the models from the sheets. As he was at the anvil, Thady went around it, and in the old language he recited the ancient verses, and this is what they meant:

Iron plow, fertile ground;
let the little sick be sound.
Iron harrow, breaking soil,
with your spikes her fever foil.
Iron spade, digging deep,
give her rich rewarding sleep.
Iron fork, probing prongs,
strike till death unties the thongs.
Iron chain, great with power,
close the ring around her bower.
Iron shovel, heaping clay,
let her eyes regard the day.

Iron scythe, sweet and clean,
carve the fevered misty dream.
Iron axe, sharp and thick,
cleave the Gaunt One's falling stick.
Iron slean, burnished bright,
cut the clasping arms of night.

It was a weird scene in that forge. Some of the onlookers said afterward that they felt the hair rising on the back of their necks. Thady kept repeating the rhyme and walking around the anvil, with Tom crouched over it, cutting delicately at the tiny implements.

They stood on the bank watching the river and the broken bridge. There was only one alleviating feature: the wind was not as fierce by a few degrees; but the rain was very heavy, and the river was beginning to cover the banks and still swelling up.

"What did I tell you?" the doctor asked.

To tell the truth, Solo's heart quailed as he looked at it. Boulder was there. He came up to them. "Tell me, Boulder," said Solo. "Is little Mary really in danger of dying?"

"She's very bad, Father," said Boulder, "and no mistake. But God is good."

"And the nine irons," said Solo. "What about them? ... Give me what I will need," he said then to the doctor. He took out his tobacco pouch and emptied the tobacco out of it. Then he put the little bottles into it and rolled it tightly again and put it in his inside pocket.

"What in the name of God are you going to do?" the doctor asked in amazement. "You can't swim that river. You'll be killed."

"I'm not going to swim it," said Solo, moving down. "I'm going to jump it."

"Holy father, are you raving mad?" asked Boulder.

I probably am, Solo thought as he regarded the river. There was the buttress near him, just under the water, and ten feet away he could see the stones of the first arch appearing occasionally from

115

under the torment of water. Ten feet away again there was the other arch support, and ten feet away again the buttress on the other side. He didn't stop to think any more. He backed up about ten paces and ran for it, timing his take-off from the last inch of stone.

The doctor turned his back to the sight of him after shouting, but Boulder, his mouth open, his fists clenched, kept watching him. He saw Solo's big body flying through the air and his feet landing in the welter on the stones. Now, he's gone, Boulder thought.

He nearly was. He dug his arms into the water and gripped the edges of the stones with his fingers, just to rest. The flood rose on him, dashing madly at his bent body. It went over his head, smothering him, and then it cleared again. Boulder saw him emerging like a seal, his black clothes shining wet and clinging to him. There was terrible force in the water, pulling at his fingers, pulling at his body.

"Lord," Solo shouted silently, "I know I am rash, but it is in a good cause." He started to rise slowly, bracing his great legs well apart, stiffening the muscles of them against the current.

Now he is gone, Boulder thought.

He is still there, the doctor thought with wonder, looking, thinking about the god of drunkards and holy fools.

This is where I sink or swim now, Solo thought. He couldn't jump ten feet now to the next arch support. He would just have to throw his body at it and grip it with his hands. His heart almost failed him at the thought. His strength felt spun out already. He thought of the nine irons, the winking, polished little things, each as small as the fingernail of a baby, and it made him so angry to think of his people putting those superstitious things before God that he leaped. His clutching hands found the edges of the rocks and held tightly as his body was swept down with the raging current.

Boulder and the doctor didn't breathe as they watched.

Solo thought the stones might give under his clutching fingers. The bridge had been built long, long ago and stuck together with a mixture of lime and bullocks' blood. He pulled himself toward the

stones, groped with a heavily muscled knee, gripped with it, and slowly pulled himself on to the mass of stones. He had to keep gripping with his fingers, with his knees, with his toes, straddling the stones as the water flowed over him, tearing at him.

When it was not covering his mouth, he breathed. Then slowly he raised himself to his knees, then a knee and a foot and then his two feet, and he stood braced to the drag. He was breathing very hard and there were red spots in front of his eyes. Well, he had had red spots many times before. Playing fast, unrelenting football for a solid hour with a ten-minute interval often gave him spots in front of his eyes. And none of that was for anything but pleasure and spectator pleasure. So here now he had only one more hop to go, and he dug in and threw himself again. He barely made it, and if the current at this side had been as great as in the middle between the two arches, that would have been the last anybody would have heard of Father Solo.

He was gripping the far buttress, and then he was lying on it and he was saying, "Lord, I thank you. I didn't really mean to be brash, it was just that circumstances demanded it, and I won't do it again."

The others were watching his prostate form with their hearts in their mouths, and breathed again when they saw him slowly pulling himself to his feet. Then he turned to them, and they could see the white teeth of his smile before he turned and set off down the road, squelching wet.

Boulder sat on the wet ground. He wiped the sweat off his eyebrows. "I don't want ever to see a thing like that again," he said.

Solo went as fast as he could. He was so wet that he couldn't be any wetter, he thought, and that itself was a consolation. How long would it take them to turn out the irons? That was his problem. He would have to be there before them or his journey would have been in vain. They could always say afterwards that it was really the irons that did it.

Tom Tate was putting the finishing touches to the irons. They

were all made, very neatly. He had bored tiny holes in each of them to attach them to the iron ring, but before attaching them he was polishing them with sandpaper, so that they gleamed.

"Oh, lovely, lovely, lovely," Thady was saying to him. Thady was in no particular hurry. The little girl would keep. He knew the toughness of the human body, how hard it was to kill it. Better have everything just right. "Now put them on the ring," he said. "Then we'll put the ring on a round of fine wire to put around her neck. You'll see, the touch of the cold iron will chase the fever."

Solo was surprised to see the boat resting in the front of the house. The tide was receding. He saw the wrecked piers, the wrecked boats. He groaned, because he would be the one who would have to set in and fight the authorities and wade through the masses of red tape to get everything repaired again. He opened the front door and went into the kitchen.

They rose and looked at him as if he was an apparition. "Father," said Jerr, "you came to us. How did you come to us?"

"I crossed the river," said Solo. "Where is little Mary?"

"But no man could cross the river," said Jerr. "She is upstairs. God sent you. Everything will be fine now. I know it will."

Solo went up the stairs. Before he did so he took off his squelching shoes and socks and rubbed his bare feet on the floor. It didn't do much good. The floor was wet from the water that had passed over it. But it felt better. He mounted the stairs. He went into the room. His heart contracted at the sight of the little girl. He closed his eyes for a moment before he went over to her. He didn't mind the adult sick and dying. But children always upset him. It seemed such an immense break in the pattern of living.

"It will be all right now'" said Solo. "Everything will be all right now, Julia." He bent over the little one. If he could give her some of his own strength, push it into her. Not that he was as strong as he would have been normally. He took off his wet coat, extracted the bottles from the pocket and set to work.

The men came from the forge in a cavalcade. Early on, they had been inclined to jeer a bit. Later their jeering became discomfort when Thady turned his pale blue eyes on to them, the way one who believes can silence the scoffers. They knew Thady's worth. He knew all the many herbs of the mountains and the streams. You remember penicillin that they were reading about. Hadn't Thady known all about that long ago, things he used to pick and boil from the spot where the mushrooms grew? And the way he could cure the horses' hooves with poultices of mouldy bread. They often felt that the doctors were only catching up on Thady's knowledge. He had a powerful pull over the back of their minds. And now they were not in much doubt that the nine irons would do all that Thady claimed for them. So they followed him eagerly in a procession up the road.

Thady stopped dead outside the Backs front door, because there was a stranger standing up there waiting for him. A very big-built stranger dressed in old trousers and a fisherman's blue gansey and big boots on his feet. It took them a long time to realise that they were looking at Father Solo. It couldn't be Solo, Thady thought. How come he crossed the river? But it was he. He was smiling.

"Hello, men," said Solo. "If ye have come to ask about little Mary, she is sleeping soundly now. I think the fever has left her."

"You couldn't have crossed the river," said Thady.

"God is good, Thady," said Solo. "What's that strange thing you have in your hand. Do you mind if I look at it?" He held out his big lacerated palm.

Thady looked at him. He was furious. But he had good control over his face and his features. Only Solo could see it in his eyes. How could you fight that, Solo wondered. It was buried deep in him. He should have been living a thousand years ago. Solo was glad he had crossed the river.

You cannot win, Thady, he told him with his eyes. The forces arrayed against you are too strong. Yours are wilted, if still powerful.

Thady knew it was too late. He could never get into the house now. It was too late anyhow when he hadn't reached the house first. He looked at the irons in his hand, then he turned and flung them from him. They rose tinkling in an arc, and then they fell into the waters of the sea. "Nothing, nothing, it was nothing," he said, and he turned away from them and headed off toward the hills. They watched after him. Only Tom Tate looked with sorrow after the irons. He had taken such pains with them and they looked so neat.

Solo felt sorry for Thady. He could be happy, he thought, if only he'd let me talk to him.

Then he said to them, "The tide is going down. The river will soon be falling. Gather a lot of boards and things and we'll bridge the river as best we can and get Mary out of here into the hospital. All right?"

They paused and then they said, "All right, Father," almost with a sigh, Solo thought. Back to the humdrum, the commonplace things that get you to heaven. But the nine irons were colourful, they were exotic, they stirred buried things in you.

The climbing Thady was a diminishing figure on the side of the hill.

The Tangler

THE TANGLER WAS a small, butty man who lived by himself up in a cottage near the sea. It was a small, neat cottage sloping away to a sandy beach, with a vegetable garden and a few fairly good meadows where he grazed his transient cattle. A tangler, as you know, is a man who is a sort of commission agent to a cattle jobber. When the jobber wants to buy cattle and hasn't the time to do the rounds, the tangler will buy for him and earn a few pounds in the process if he buys shrewdly. The Tangler was the shrewdest tangler in the business, which was why he was known almost universally under the honorary title.

He was a pleasant man, always cheerful. He had sunken eyes that vanished in a ripple of wrinkles when he was amused. He was nearly always amused. He liked all this animal buying business. He liked getting up at an unearthly hour in the morning to travel long distances to fairs. He was a good man who prided himself on his honesty, integrity, calculation and supreme knowledge of animals. He was a hard bargainer, but honest with it, and so he was really very popular.

If you close your eyes and examine your life as it has gone by, you will find that out of the welter of your experience one episode stands clear and unforgettable. This was the way it was with the Tangler and Sunny Mahon. They were alike, those two, in appearance. Both very short men with wide shoulders and long arms, grizzled hair, heading for their fifties, but Sunny was never happy. He was a fairly big farmer living about six miles from the Tangler

on about forty acres of good land. But he worried. If things were good he was worried about how they were going to get bad and if they were bad he was worried about how they were never going to get good. He had a nice plump wife but no family, and people said it was as well. He was never happy and that was why he was known as Sunny instead of Edward Joseph, which was his name. He enjoyed misery. There are lots of people like that and more power to them. The world would be a pretty unbearable place if everybody was laughing his head off all the time.

It was at the local October fair that the incident had its beginnings. Tangler saw a cow.

"That cow is not too bad," said Tangler to the sunny sky. "She'll not drop dead for a few years yet, and if she is a good milker I know a fellow in Cornamona who would appreciate her. Who does the poor unfortunate thing belong to?"

Sunny took the pipe out of his mouth and spat in the dust.

"If you weren't a friend of mine," said Sunny, "I would sell you that cow; I would make you a gift of that cow for forty-five pounds, but since you are a friend of mine I can't let you have her because she has a defect."

"Ho-ho!" said Tangler, his eyebrows raised at this honesty. "What defect?"

"Last June I bought her," said Sunny. "I gave fifty pounds for her. May hell roast the dishonest scoundrel that sold her to me with his tongue in his teeth. She's a leaper."

"Is that all?" Tangler asked, relieved. He wanted the cow. If somebody says you cannot have a thing, you are more than ever determined to get it. "That can be cured. All you have to do is spancel the bitch."

"This one belongs to the devil," affirmed Sunny. "She can jump a five-barred gate. She has me worn out, I tell you, getting her back. She'd eat the toughest spancel ever put on her legs if it was made of steel."

122

"You're an old man, Sunny," said Tangler. "Give me one week with that cow and she wouldn't jump over a box of matches. For forty pound notes, I'll take her and train her."

"Faith you won't," said Sunny. "I'd get more than that from the glue factory. Do you want to drive me into the poor-house? Forty-five and not a ha'penny less. I paid fifty for her, and had nothing from her but trouble."

"You had milk from her," said Tangler.

"Aye, there's that," said Sunny. "But she was nearly the death of me from the travelling she put on me. Look at her udder. Isn't it bursting?"

"Forty-two," said Tangler.

"… and ten," said a friend of Sunny's and they agreed on that and Tangler handed over his forty-two pounds and ten shillings. He drove the cow down the road to the end of the village and hurshed her into the gate of the field belonging to his friend, Bob Andrew.

Bob was leaning on the gate looking at the cow. He was a very big man; he looked to be as thick as a turnip but, in fact, he was very shrewd, and as honest as the 21st of June is long.

"You're admiring me cow, Bob?" Tangler asked him.

"You bought her?" Bob asked.

"Aye," said Tangler. "A bargain too, from Sunny Mahon."

"She's no bargain," said Bob.

"I know she's a leaper," said Tangler.

Tangler looked. The cow was drinking her own milk.

"She's more than that," said Bob. "Look at her!"

"Oh, my God," said Tangler in anguish. "She's a sucker. I'm undone."

"She is and you are," said Bob.

Tangler rested his forehead on the top bar of the gate. You can always be taken in, of course. Cattle may have some disease it is easy to spot from your knowledge. There are very few defects that don't show signs. But this one is unnoticeable. It's rare enough, but

naturally the cow that is given to it looks very healthy indeed. Why wouldn't she?

Tangler kept his head down. He could imagine what would be said about him. He would be laughed out of the country. He thought of the way Sunny had covered up one defect by naming another and Tangler had fallen for it just as if he had never been at a fair in his life. "Oh, the bastard!" Tangler groaned. "Did you know this? Did anybody know this?"

"No," said Bob. "He kept her under cover since he bought her. She wasn't from here. Nobody knew."

"He has me," said Tangler. "I'll have to kill him. I'll have to kill him stone dead."

"No need," said Bob. "It was a very dishonest thing to do. He musn't get away with it. How much did you pay?"

"Forty-two pounds, ten shillings," said Tangler in anguish, caressing each pound note as it passed his lips.

"All right," said Bob, reaching into his pocket. "Here's forty-two pounds, ten shillings. Now she's mine."

"No, no," said Tangler drawing away, his hands behind his back. "What are you doing? Are you mad?"

"Take the money, I'll do the rest. Sunny has to have a new cow, hasn't he? He didn't buy at the fair. He's scalding me to sell him the young cow of mine. She's good. He knows it. Take the money and go away. Don't let me see you again, not for a time."

Tangler took the money and watched Bob walk away.

The fair was dying like the sun. Only a straggle of animals left on the street; thin ones, young ones, hard-to-sell ones. Bob found the pub Sunny was drinking in. He saw the gleam in his eye.

"You still won't sell me that cow, Andrew?" Sunny called across to him.

"If you keep on annoying me much longer about her, I might," said Bob.

Sunny put down his glass and came across excitedly. The other drinkers crowded around.

"God bless you, Bob," said Sunny. "I have been watching that one like a hawk since the day she was born."

"You know her," said Bob. He emphasised it. "She's the cow inside the gate at my field just outside the village. The field with the beech tree."

"I know every hair of her," said Sunny. He didn't have to see her. Bob Andrew was an honest man. Everybody knew that. They had great fun making the bargain. Everyone joined in. The price of the bargain? Forty-two pounds, ten shillings. Bob emphasised it again and again, about his cow in the field of the beech tree. He even walked down there with Sunny, the money in his pocket.

The cow was up, cropping the grass.

"There she is," said Bob. "She's a nice cow. I bought her from Tangler. She is all yours."

If only he wasn't such a big man, he would be stretched! But he was big and his eyes were cold, and Sunny knew.

That should have been the end of it. After all, neither man lost any money. Money just passed around and each ended up the way he had started, one with his cow and the other with his money, but there is such a thing as pride, or is it vanity? Whichever it is, both men, like the rest of us, were loaded with it.

Both of them drank deep, and both of them brooded.

Tangler brooded over the fire in his kitchen, staring into the flames, thumping his fist on his knee, hitting his forehead with his hand. He was shamed. It was unbearable. At three o'clock in the morning he rose from the his stool and put on his hat and went to do something about it.

Sunny sat in his kitchen in front of the fire and he brooded. He groaned. He shuffled his hobnail boots on the concrete floor. Every half-hour his wife would call from the bedroom above, "Will you come to bed, will you? You'll drive yourself mad, I tell you. What

harm has been done?" Finally she came down in her night shirt and she took away the paraffin lamp, and blew it out and went back to bed, but Sunny brooded, and finally he rose from the stool and put on his hat and determined to do something about it. It was about three o'clock in the morning.

Six miles separated them. It was a dark moonless night. You know what it is like in October. You could hardly see your hand in front of your face. They grunted at one another passing by, just two dark figures passing in the night, like ships at sea without lights. In wartime.

Both their thoughts were red. Both grasped sticks in their hands, and now and again they stopped to hit the sticks on the stones of the road.

Tangler entered Sunny's house with the stick grasped tightly in his hand. The door was open. This didn't surprise him. He was too upset. He was visualising the stick thumping the shoulders of the man.

He went into the kitchen. The angry voice came down from the room to the sound of his moving. "Come into bed out of that, you silly eejit, and forget it! What does it matter? Isn't it all for the best? Come on up to bed when I tell you, so that I can go to sleep. Aren't you selfish keeping me waking as well as yourself, aren't you?"

Tangler thought, and thought, and what did he do? Well, he went into the bedroom and closed the door behind him.

Sunny came to Tangler's kitchen and found the door open and he stalked the house shouting and roaring and thumping his stick on the table and chairs and the bedclothes, and when he had got rid of most of his spleen, he thought and he thought, and he went outside and came back with something, and he went in and he put it in Tangler's bed.

Then he left, chuckling.

When the woman beside him was breathing deeply in satisfied sleep, Tangler rose and dressed himself carefully and went out and closed the door softly.

Then he left, chuckling.

They passed one another on the road in the blackness, and they grunted a greeting at the sound of one another.

Sunny was greeted by the voice of his wife when he made a lot of noise in the kitchen. "What did you get up again for? What are you doing?"

He went in and stood in the bedroom door.

"What do you mean, again?" he asked.

She saw that he was fully dressed.

"Nothing, nothing," she said, and kept her mouth shut. Sunny went to bed and chuckled beside his wife.

Tangler was also chuckling, but in a polite way, as due to a lady; he undressed, blew out the lamp and plopped into bed and then left it screaming with the bundle of rusty barbed wire embedded in his flanks. It was very painful.

Afterwards when Sunny saw Tangler limping, he would cover his mouth with his hand and he would chuckle.

When Tangler saw Sunny and his wife, he would raise his hat politely to her and smile.

The Bachelor

I T WAS IN the spring that things came to a head.

Our village was a peaceful place. If you came from a city, you probably wouldn't think much of it. It is bare land with heavy outcropping of rocks in the poor soil. At the back of it there are low hills running to the tall mountains. In front is the sea, with a beach of silver sand, and on either side of the beach there are high cliffs. When there is a storm blowing in from the Atlantic the waves are higher than the cliffs.

So all the houses in our place are built snugly in folds of the land. They are small houses, but they are fresh and new, and the people wash them in different colours, white or pink. The biggest buildings we have are the church and the technical school.

The technical school is very new and, in a way, could be said to be responsible for most of the trouble. It is a single-storey building, with a slated roof and fine big windows. There is land around it, and it would amaze you the things they have made to grow there; things that people swore their oaths could never be grown in our poor soil at all.

At first people would have nothing at all to do with the school. Is it grown men to be goin' back to school learnin' how to make a table or a chair or how to grow tomatoes in glasshouses, or expensive vegetables in poor land? But the teachers were very patient, and now nearly the whole village goes there.

They'll take you any age. Mostly they have the young ones who have left the national school at 14 and who continue to learn things like grammar and languages and how to write letters to business people. Then the older ones go for carpentry or to learn how to grow difficult things, and what kind of cocks to set to your hens so that the chickens'll lay nineteen to the dozen. People are now proud of the school and not ashamed to go there and learn things. So it has done a lot of good.

It did a bit of bad, in the way I will now tell you.

Most of our people make their living from the sea. There are one or two big boats that fish far out, but, in the main, two men fish in the canvas-covered currach, and with the fish they catch and the few crops they sow in the scratches of earth, they don't do so bad. They all have good health anyhow and stomachs that are flat and untroubled by city diseases.

Finbar and Turloc were two happy men until Turloc got the notion of growing tomatoes. The government of this time gave men a grant so that they could build glasshouses to grow them, and Turloc built one at the back of his house with his own hands, and decided to go to school to find out how to be a success with tomatoes.

There couldn't be two fellas more at odds in all than those two, but they got on very well. Turloc was a shocking big man. There was no doorway in our place that he wouldn't have to bend under to get in. He had thick fair hair, and very clear skin and a regular sort of face, and two happy eyes. Nobody since the beginning could ever remember him with his dander up. He always had a soft word, so that small nonentities could insult him to his face and he would only laugh at them instead of squelching them with his thumb like you would a black beetle. There was nobody in our place with a bad word for him, and when you think about human nature, that's a terrible fine tribute.

Finbar was different.

Finbar was small where Turloc was tall. He was small but he was very neatly put together. He was dark and delicate-looking and handsome. He was very active. You should have seen him dancing or scaling the cliff out there after the birds' eggs, or running a race at the sports on the sands in August. Very lively. His eyes were the same. He could play the fiddle better than oul' blind Carolan, the poet, God be good to him.

They shared the currach. They did everything together, and they got on very well. And then Turloc had to go to that damn school.

But it was in the gardens where they grew the vegetables that Turloc met Maighread.

Nobody ever noticed this one until she grew up. She grew fast. She was about nineteen at this time. She had been away training and she had come back to teach in the school. She taught the young ones, but she was a divil for a garden, and it was there Turloc met her. Look, he could ha' fitted her into his pocket! She was small and neat with little hands and feet on her and a small head of brown curly hair that was like a boy's, it was so tight to her head.

She helped Turloc with the tomatoes.

She went around and inspected the glasshouse and she went with him and his donkey when he went up in the hills to fetch some of the good soil up near the lake.

She found him good company but a bit slow. They'd be sitting in the heather up on the hill with nobody in sight but the sheep, and what'd happen?

"Turloc," she'd say, laying back, her arms under her head. "Doesn't it make you feel good to be lying in the heather on a day like today?"

"Aye," says Turloc. "It's a grand day, Maighread. Tell me, in the cold night, is it a good thing to put an oil lamp in with the tomatoes?"

"You can put in a lamp if you like," Maighread says, "but there will hardly be any need now for a lamp from this to September."

"Aye," says Turloc, "but I do be worrying about them. There's a sort of yella mark now on a few of the lower leaves. I wonder what would that be?"

"For goodness' sake, Turloc," Maighread says, rising and dusting off her dress, "I'm going home. I'm sick of tomatoes. Do you hear that?"

Turloc was sad. "But I was only sayin', Maighread," he said.

"'Only sayin'! Only sayin'!'" she said back at him. "I'm going home."

And she went home. Turloc was very miserable following her with his eyes. He thought, what will I do? If I take her hand I might hurt it with the size of me own. For almost the first time in his life Turloc was aware of his size. How could Maighread put up with a man the size of him? A poor man too, and her father a well-seasoned man with the only grocery shop in the village. He found it hard to talk to her, sometimes. When they talked about tomatoes he was on sure ground, or about birds. Or about fish. Or sometimes even they just sat and said nothing at all, and Turloc felt very happy. He could feel that there was a wave of liking coming to him from her, that would bring a big lump into his throat. But afterwards he would tell himself that he only imagined it, and he made up his mind that there was only one thing for him to do, and that was to put all thoughts of her out of his head and become a bachelor, for ever.

Finbar was a born bachelor. Finbar had an attraction for girls. He could make you laugh two minutes after you buried your mother. He played and danced at many dances, and he never left a dance alone. There was always a lassie willing to go the road home under the moon and caffuffle a bit with him at a gable end or near a haystack. That was all. There's nobody going to catch me, says Finbar, drawing a low mocking note from the violin.

Until Maighread gets him.

Finbar afterwards felt that he had been hit on the head. Their

two bodies were made for one another the way they fitted in a dance.

He took her home one night after a dance in the school. Turloc never danced. They were afraid to let him on the floor anyhow. One lepp out of Turloc and the place shook to its foundations. He'd just stand at the door and look on. And he always went because he knew she would be there and he could look at her. This night she was mad with him. She came close to him.

"I won't stand it!" she said. "I won't stand you there looking at me, just like a dog that was kicked in the stomach. Go away, Turloc!"

Turloc was outside leaning against the wall with his head down.

"Look, Turloc," Finbar said. "Women are all the same. The only reason they are made at all is to crucify us. Do you really like that little one?"

Turloc nodded his head miserably.

"Did you tell her ever that you like her?" Finbar asked.

Turloc shook his head miserably.

"What do you expect so?" Finbar demanded.

"There's no use," said Turloc. "I'm not good enough for her. I'm too big for her. She only liked me on account of the tomatoes."

"Will I talk to her?" Finbar asked.

"No, no, Finbar, for the love of God!" Turloc implored him.

"Well, something will have to be done," said Finbar. "You're a liability until you get over her. You have me back broke in the boat pulling and you there dreaming. You'll have to get over it, Turloc. Will you be long getting over it?"

"No, on me oath, Finbar," said Turloc. "I'll be well over it now in a few weeks. It's just like a pain in the stomach, that's all. It'll pass."

Finbar went back in there mad with her. Everybody liked Turloc and the longer you were with the big eejit, thought Finbar, the more you liked him.

He took her out for a dance.

"What the hell have you done with Turloc?" he demanded angrily.

"Turloc is a big ape," she said. "I was only talking to him about his tomatoes and then he becomes a silent man, groaning like a cow that's got the croup."

They were in the middle of the dance by this and it took that long for Finbar to realise how well they fitted together.

"You dance very well, Finbar," said Maighread.

"You're not bad yourself," said he.

Finbar took her home in order to talk to her about Turloc.

She made sure going out into the night that the big Turloc saw them. She took Finbar's arm. Finbar liked the feel of her hand on his arm.

At the turn of the road there was a convenient mouth of a small boithrin, laced with bushes. Finbar took her in there with a practised swing and put his two arms around her and pulled her close to him.

"Oh, no," she said, extracting herself from his embrace. "I'm none of your light ladies that you take home from the dance and put out of your mind at the turn of the day."

She maddened him. She mocked him. He caught her hands and pulled her close, and after a struggle he kissed her. The kiss didn't last long. It inflamed Finbar. But Maighread won free and walked into the road. Finbar followed her, looking at her carefully. He saw her for the first time.

She went to more dances with him. She gave him insomnia for the first time in his life. She seemed to welcome his attentions. He lay beside her in the heather and talked to her about the things she wanted to hear. Sometimes he bent over and kissed her, but she would roll away and rise to her feet and run across the land. He never got close enough to her, and the space between ate into his mind, so that he could see nothing but her. He woke up many times and heard her laugh on the edge of a dream.

One day he realised he was in danger.

One day at sea he turned his head and saw Turloc standing up behind him with his hands clenched. He was looking at Finbar. His eyebrows were pulled down. There was a big vein throbbing at his neck.

"What's wrong with you, Turloc?" Finbar shouted. "Sit down or you'll have us in."

A red light went out of Turloc's eyes. He sat down slowly.

"You spoke her name," said Turloc.

God, Finbar thought, she had me fevered. He didn't remember speaking her name. But he wouldn't forget the red light in Turloc's eyes.

He took to watching Turloc. He realised that Turloc and he were no longer friends. That amazed him. Was Turloc capable of such deep feeling? He thought of the depths of his own feeling for her. If Turloc was that way, then they were both in a bad way. What was the use? Turloc could never get her.

He was afraid of Turloc. He was so very big. He had known big amiable men before who could go crazy over something silly like a woman. But Maighread wasn't silly. The trouble would be that Turloc didn't know his strength. He often took the currach out of the sea with one hand and raised it on his shoulder. Turloc might get a red fit some day and be very sorry when he came out of it and found the broken neck or back of Finbar in his hands.

That became part of Finbar's dreams. Maighread running away from him over the heather and Turloc coming over a hill to him with his arms held out and the red light in his eyes.

Finbar decided to conquer his fear. He was a small man. What could he do if Turloc one day reached for him with his hands? And Maighread seemed to encourage the madness of Turloc. She would often come down to the beach to meet them when the boat came home. She would just say "Hello" to Turloc. She would put her hand on Finbar's arm, and smile up into his eyes.

Finbar didn't care. Every time she came near to him and touched him, he felt he could fight a thousand giants. If he goes for me in the boat, he thought, I will slip over the side. He was a good swimmer. Turloc couldn't swim at all. Every nerve he had became raw when they were at sea, waiting for big hands to come at him from behind. The fishing became an agony to both of them. They were glad when they came home.

It had to break. It broke one spring day on the beach.

It was her fault. Finbar should have told her not to come to meet them. But he wanted her to meet them. It would have been a blow to his pride to tell her not to come, that he was afraid of Turloc.

She was in good form. "Spring," she said. "It's spring. Everything is green. You and me will be dancing tonight. There's one at the crossroads."

She danced about him. She put her arms about his neck. He caught her mood and he danced with her.

"I love you," he said, and tightened his hands on her waist and pulled her against him and kissed her.

"Turloc!" he heard her scream. She was looking back over his shoulder. Finbar felt the small hairs rising on his neck.

Then he felt the blow.

He seemed to be propelled. He rolled many yards in the sand. He was feeling in his pockets. He'd better get them quick; there would be little time.

Turloc came closer. Maighread was shouting, "No! Turloc! No! I didn't mean it! It was only to waken you up!" Then she pulled at his arm again. He swung it, and she ran up the beach toward the houses, calling.

All this Finbar saw, and then Turloc reached for him.

Finbar rolled away, very fast, and then got to his feet. He gave the big man no chance. He ran at him, ducking low, and dived and hit his legs with his shoulder. Turloc fell on the sand. Finbar had the lead weights they used for fishing in his hands now. He had been

carrying them in his pockets for two weeks, ever since he had decided to conquer his fear. He stood over Turloc and swung with his right hand at the jaw. It landed, and Turloc's head went back against the sand. It was little use. Turloc's hand came out and caught Finbar's foot. He pulled and Finbar fell, and Turloc raised himself up again. Finbar reached out with his left weight and hit at the fingers holding his foot. He hit them systematically three times until the blood flowed from them and a crack came from one of them and a grunt from Turloc, and then he wriggled free as the hand loosened and got to his feet.

He saw Turloc's eyes. They were glazed with the madness. As Turloc got to his feet, Finbar hit him on the back of the head with one weight and kicked him in the stomach with his heavy boot.

Finbar saw people running down from the houses. Men, with Maighread in front of them.

The look was nearly fatal for Finbar.

Turloc was bent double, in pain; but still bent double, he reached with one hand and caught Finbar's shirt in the grasp of it and then raised the other and hit him two blows in the face. Finbar twisted and turned and got away, leaving the front of his shirt in Turloc's grasp.

Two men ran in, one on either side of Turloc. They tried to grasp his arms. He shook his two arms and both of them flew away. Then he moved slowly toward Finbar. He was a terrible sight. There was blood all over his face and the blood dripping from his hand was being soaked by the sand. Finbar knew that he himself couldn't last much longer. If I don't get him now, he thought, I'm done. He dodged from left to right and then ran at Turloc and jumped as if he was doing the long jump at the sports.

Turloc fell.

Finbar straddled him.

He raised the weights and hit left, hit right, beating the big head from side to side.

Four blows did it. Turloc moaned and lay still.

Finbar stayed a few moments more, but there was no stir from Turloc. Then Finbar went down the sand to where the small cold waves were lapping and he rubbed the salt water all over his face. It went into his cuts and it stung like hell. He lay there breathing hard. Then he staggered to his feet. He looked at the weights in his hands. He raised his arms high and threw them out, out, where they landed splashing in the deep water. Then he walked toward the people on the sand who were surrounding the fallen man.

Maighread had Turloc's head in her small lap.

She was crying. Tears were pouring down her face. She was lifting his head, kissing his cuts, wiping away the blood with her small fingers.

"Oh, Turloc, Turloc," she was saying. "I didn't mean it, Turloc. You were so slow. You'd never speak if I hadn't gone with him to jizz you up. Oh, Turloc, forgive me! I never thought you would be hurt that bad. I never thought you had such a terrible temper. Oh, please, Turloc darling, speak to me!"

There was only a slight flutter from his lashes.

She glared at Finbar.

"You dirty little bully!" she said to him. "What have you done to him? What kind of a mean nature have you that you will hit a poor defenceless man with lead weights? What if you had killed him? Oh, you are vile, vile, vile! If you had to make him fight you, why didn't you fight fair?"

Finbar could only look at her with his mouth open.

Turloc groaned and opened his eyes.

"Turloc, darling," she said to him, "I love you! I love you!"

Finbar saw that the eyes of Turloc were clear.

"I didn't mean it, honest, Turloc," she stated. "I only went with him so you'd get mad and do something. I never meant that he should have been so cruel. Oh, Turloc, forgive me! Forgive me!"

Turloc raised his hurt hand and put it tentatively on her hair.

She turned her face and kissed the hand.

A great beam of a smile came on Turloc's battered face.

Finbar left then.

Yes, I left then.

Can you understand women? Can you get over that? Putting a fella in danger of his life from a big lovesick maniac, all to jizz him up if you please. By ——, I was caught once but I'll never be caught again!

Here he is now, coming down to the beach, the great big, thick, ignorant lug. A big smile on his kisser and half a ton of fishing gear on him as if he was carrying ferns. She's with him, of course, skipping along beside him like a little girl. Holding his big arm. He's laughing into her face. He's a happy man.

Naturally I don't feel the same toward him. We get on very well. That's the curse of him, the way he makes you like him by not trying.

Women's ways! Women's ways!

Is it any wonder I'm a bachelor?

The Coll Doll

I WAS AT a loose end this Monday morning in March, see. I get up
in the morning all right. I have my breakfast, ready to go to
work, but there is no work to go to since I was sacked on
Saturday but I haven't passed on this item of information to my
father and mother. There are eleven of us in the house including
them, and you have to shout all the time to make yourself heard. It
was that foreman. He didn't like me. I like to be clean and well
turned out. That is my own business. Even if you work in a facto-
ry you don't have to look like a coal heaver all the time. I liked clean
working clothes, and I liked to keep my hair well. This was my own
business.

But this fellow sneered a lot at me, 'Brilliantine Boy', he would
say and 'The Scabby Gent'. He was a big burly fellow and I took a
lot from him. I don't think he meant to be nasty. He was just a big
stupid, half-human ape.

I am nineteen, so on Saturday I clonked him with a spade han-
dle. I know I shouldn't have done this. It didn't do much damage to
his skull, which is as thick as his intellect, but I had no case, and
nobody wept when I got my cards.

It's hard to tell your people a thing like this. All they see is that
the money coming into the house is short. They don't see that a
man, even if he is only nineteen, is entitled to his dignity, and enti-
tled to defend it.

141

I like my oul fella, you know. He's all right. He just works, and comes home and washes and goes out to his pub and spends the night over a few pints with his friends. He'll clout you one or maybe two, but he mainly roars at us to keep quiet. My mother is all right too, but looking after a houseful, after giving birth to them, and losing a few on the way, doesn't give her time to sit down by the fire and talk over your frustrations. You see what I mean?

I didn't like working in factories. I got a scholarship from the primary school and went on for a few years to a secondary school, but I had to quit and go to work. The money was needed at home. There's no use giving fellows like me a scholarship if they won't give the parents a sort of scholarship too, to make up for the loss of probable wages.

So I wasn't even half educated in a way. I tried to make up for this by eating books from the County Library, but you feel you are reading without direction. Your mind is going so many places at once that it is too much for it. It is like sucking the sea through a straw, see. My pals call me Schol, and pretend to defer to my knowledge, but this is just for laughs. I know myself how limited my knowledge is, and I long for it, but at the present I see no way, no way at all. All those young ones coming up after me that have to be fed and clothed on what my father earns and what I earn, or rather what I don't earn now.

So I walked, out into the country. I thought I'd take in a bit of this nature stuff, just to pass the time. It's not done, you know. Maybe on account of the tight shoes we all wear these days. All right for show and dancing, but you rarely use them to walk, just up and down the streets of the town, and you can't call that walking.

It was a bright sunny day. The sea looked happy, grinning away in the sunbeams. The hills across the bay were misted and coloured. It was odd to be walking the promenade on a Monday morning. Just a few old ladies going to Mass in the church and elderly fellows, past working, walking dogs or sitting on the seats smoking pipes.

I felt guilty, see, uneasy. I should be at work, earning money, not strolling on the prom on a Monday morning. To hell with it. I jumped down on the sand, and threw a few stones at the sea. Farther on I got flat stones and started skimming them on the calm water, seeing how many hops I could get in. The best was eleven before the stone sank.

Then I felt that the walkers' eyes were on me, saying: What is a young fellow like that doing on the sand on a Monday morning? Why isn't he working, or emigrating? One look at me and the way I was dressed, my whole appearance, and they would know I wasn't the son of a moneyed gent.

So I went away from there, seeking loneliness; even the windows of the houses and hotels seemed like accusing eyes to me. I left the promenade and walked on the winding road that left the sea and ran up and down the hill: past small rivers and down in a hollow through a wood. I leaned on the bridge here for a little while, looking at the clear water running over washed stones. I could see a shelter in the woods there, a glade that was stabbed with sunbeams shining through the branches. I thought it might be nice to go in there and lie on the grass, and stay forever, just listening to the sound of the water, but then a large red cow, one of these walking milk bottles came right into the middle of the glade and dropped a card, plop, plop, plop, ruining everything, see, like life, so I laughed and left.

My shoes were hurting me now. I had to stop and wriggle my toes to ease them. I was sorry I wasn't younger, like years ago when you could go in your bare feet, until the soles became as tough as leather. That was necessity. Now young people would rather be seen dead than in their bare feet. I suppose this was progress too. Here I was, thinking like I was a hundred years old.

I saw this sandy lane, so I turned down it. It looked a lonely lane, deep cart-wheel tracks on it, and dry stone walls each side of it, and it was aimed in a crooked way at the sea. This was for me. The sand was soft on the feet.

It opened out into a rock-strewn beach at the sea. There was a brave smell there, of healthy things, and sea weed. There was a sandy beach as well, and at the far end a cliff rising straight up, like the back of it was covered with a green carpet. There were sheep grazing on it. Now that's the place for me, I thought, and headed for it.

I was halfway towards it, walking on the sand, thinking: Well there's no one here but me and the birds, when a girl suddenly came from the shelter of these rocks and almost ran into me. She had been behind a rock taking off her shoes and stockings I would say, and then turned for a run on the sand.

'Oh,' she said, startled. 'I'm sorry.'

Her feet were very small and nearly as pale as the sand.

I saw fear in her face as she looked at me. All right, I was an odd fellow to see at this time and place. What did she think I was going to do? Jump on her straight away without even an introduction and rape her? She was a nice little thing, maybe seventeen or so. That's what I say, she reminded me of one of those colleen dolls you see in boxes in shop windows. She was dark and had a round face, and wide blue eyes with thick dark lashes. She was wearing a wide skirt that was like the leaves of a melodeon, a white blouse and a black cardigan affair. I took all this in. I was going to make a snide remark, because I was angry at the fear in her face, but I didn't. I said: 'Sorry, miss,' and walked past her without another look and headed for the cliff. I was thinking: How quick people are to look at you and assess you, from your accent and your clothes and put you into a box marked Dangerous, or Inferior. Without even talking to you!

I was about five minutes getting to the top of the cliff, and I stretched myself there looking at the white clouds in the blue sky.

Maybe I just gave up and drifted off to sleep. Anyhow I heard a scream. At first I thought it was a sea bird since sometimes they can cry like children. Then I sat up and turned my head and looked down at the strand. This girl was sitting down, holding her foot,

and even from here I could see the scarlet of blood against the white sand. So she cut her foot, I thought. That's fine, and I went to lay back again, but she was looking straight up at me, and I couldn't do it. I got up and ran down the cliff, leaped the fence at the end and jumped down on the sand.

Her face was white. She was holding the bloody sole of her foot with small hands, and her fingers were scarlet.

I got on my knees and took the foot in my hand. It was badly gashed. I squeezed the edges of it and closed the wound. 'What happened?' I asked.

'I stood on a broken bottle,' she said. 'Isn't it very bad?'

She was afraid now all right, but it was different fear from the other. It would take three stitches to close it, I thought.

'It's not too bad,' I said. 'It looks worse than it is. One stitch should close it.'

'Will I bleed to death?' she asked.

I felt like patting her head. 'No, no,' I said. 'No fear of that. Let me lift you down to the water and we'll wash it.'

I put my arms under her. She wasn't very heavy. She made no protest. I carried her to the water's edge. We left a trail of blood on the sand.

I put her down there and took a clean handkerchief, and, finding sand-free water, I washed out the wound. It was a jagged gash and it was bleeding freely, which was good. I gave her the wet handkerchief.

'Wash the blood off your hands with this,' I said. She did so. She was still very pale, and she was trembling. 'Have you never been cut before?' I asked.

'Oh, no,' she said. 'Just thorn cuts.'

'It's not as bad as you think it is,' I said. 'But we'll have to get up to the main road and try and get a lift to the hospital.'

'You are awful kind,' she said.

I took the handkerchief and washed it in the sea, and then I tied

it very tightly around her foot. I hurt her, because she gasped, but it had to be tight. 'Where are your shoes and things?' I asked.

'Behind that rock,' she said, pointing. I left her and went over there. Small shoes with the stockings rolled and pushed into them. I took those and put them, one each, in my coat pocket and went back to her.

'I will have to carry you now,' I said.

Amn't I very heavy?' she asked.

I lifted her easily. 'Hold on to my neck,' I said. She put her arms around my neck and it eased the burden. 'I'll tell you the story of the King,' I said. You know this story about a King who was a great hunter and wanted to be praised, but a female of the court said that anyone could do anything with a lot of practice. So he was annoyed and ordered the forester to kill her. The forester didn't kill her, but kept her in his house in the woods. There was an outside staircase and each day she would take a small calf, put him on her shoulders and carry him up and down these stairs. He became bigger and bigger until the calf was a great big bullock, but by dint of practice she could carry the huge beast up and down the stairs. One day the King came and saw this and learned his lesson.

'What? Am I a cow?' she asked. I laughed. Some of the paleness was leaving her face.

'No,' I said. 'It just shows you.'

'Are you often carrying girls like this?' she asked.

'Not often,' I said. 'You are the first.'

'You are not afraid of blood and cuts?' she asked.

'I got fourteen stitches in my right leg,' I said.

'How?' she asked.

'A machine that went wrong,' I said. 'But that's nothing. I know a man in our street with forty-eight stitches.'

'Forty-eight!' she exclaimed.

I didn't say that he got the stitches as the result of a sort of bottle party, a broken-bottle party.

146

'That's right,' I said. 'So one stitch in the sole of your foot won't seem too bad.'

'Oh, no,' she said. 'I was afraid I was going to die. Isn't that silly? Wasn't I lucky you were there?'

Listen, I want to tell you something. This was the best time of my life since the day I was born. I made her laugh. I made her forget her cut, which must be paining now. I told her funny things about my young sister and my brothers, the things they got up to. She had no sisters or brothers and I felt one with her. I was carrying her in my arms. I could feel all the softness of her, her breath on the side of my cheek, her soft hair brushing against my forehead; it wasn't those things, it was just that the two of us were one person, like, going up that road. It was like the fulfilment of a daydream, if you know what I mean. She liked me, I was just me and she was just a part of me like an arm or a leg or a heart. Do you know what I mean? I thought that all things are destined, marked out to happen just like the rising and the setting of the sun. Now I could see a reason for why I was sacked, and why I walked the lonely places looking for something, searching. And I had found it. I felt that I was walking a foot above the ground. How many times in life has that happened to you?

It stayed with me. We got a lift in the first car that passed, an oldish man with a black moustache and a bald head. She was a pretty girl, of course. I would have been waiting by the side of the road for a lift until I grew whiskers, or a tinker's van would pass by. All this didn't matter. She wanted me with her, see. She got comfort for my presence. She held on to my hand and I rested her foot on my knee.

Even at the hospital she wouldn't let me go. I had to go in with her to the room where they fix up people. I knew it well, since I was a boy. It was practically a second home for us with cuts and bruises and fellows swallowing spoons and bones and things.

I held her hand while they gave her this tetanus injection and

while they stitched the cut and bandaged it. Then I said, 'You wait here now until I arrange for a hackney to take you home.'

'Don't be long,' she said. 'Please come back.'

She did. She said this.

I went outside the place. Turk was just swinging away having dropped a client, so I whistled him and he came back when he heard the beryl.

'What's up, Schol?' he asked. 'What's the game? I'd know your whistle a mile away.'

'No back-chat, cabby,' I said. 'Just stick around. I'm bringing out a client.'

'Yeah,' he said, 'and who pays? Any client of yours is a free ride.'

I went down to him. I had a fistful of coins.

'Take you filthy lucre out of that, Scrooge,' I said.

He looked at the money. 'So you can pay,' he said. 'All right. I'll trust you.'

I went back then again to her.

Now I didn't have to carry her. She was wearing one shoe on her good foot and they had a wheel chair to bring her along the corridor and out to the steps. But I carried her from there to the hackney. Turk was so surprised that he even got his great bulk out of the car and opened the back door. I put her in the seat and got in beside her. She kept holding my hand.

'Where to, Miss?' Turk asked her. I was glad to see that he could see that she was a lady and treated her with respect. Otherwise he would have said something coarse. She told him where to go.

She was looking at me.

'It's all over now,' I said. 'It wasn't too bad, eh?'

'No,' she said. 'How will I ever thank you for all you have done for me?'

I didn't know how to answer that. I just swallowed my adam's apple. I don't do that often. You see, ever since it had happened, all that time she was so close to me, I had felt no evil in me. Do you

148

know what I mean? It was all part of the clean and beautiful things of life. I know this sounds odd, blood and gaping cuts and hospitals and disinfectant, but it was so. And it wasn't just a dream, either. It was as real as life.

It seemed to me a very short time before the car went in through open iron gates and up a short winding drive. There was a house with steps leading up to it, a fine big house with lots of windows. I took her out of the car and carried her up the steps to the door. And this burst open and a very well dressed white-haired woman came out and a maid with a black dress and a small white apron.

And the woman said: 'My God! What happened? What in the name of God happened to you?'

And the girl said: 'I was on the beach and I cut my foot on a bottle and he was marvellous to me. He got me to the hospital and brought me home.'

'My dear! My dear!' said her mother, taking and embracing her, and then looking at me over her shoulder. Looking at me up and down and she said: 'We are very grateful to you. Julia, go in and bring out my purse.'

The girl said in horror: 'Mother!' but it was too late, see, the bubble was burst.

I still had her other shoe and stocking in my pocket. I took it out and put it in the mother's hand, and then I turned and went down the steps and into the car beside Turk, and shouted at him: 'Get out of here!' and he shifted gears and left.

I could hear voices saying: 'No! No! Come back! Please come back!' but what was the use? The blindfold was down. I saw myself in her mother's eyes. Reach for the purse. A cobweb can be shattered by a stick, a big one, totally destroyed, and the spider can come along afterwards and fix it. But we are not spiders. We may be very dumb but we can see a thing when it is in front of our nose. I felt as if I had suffered a bad beating. I had been beaten before in fights, but never knocked out. I was like that now, as if I was knocked out, see.

I don't remember much after that.

We were in a pub. It was late, I think. Other men were there and Turk. And I heard Turk talking. He was saying about Schol having a doll down on the beach, a real doll, Turk's coll doll, a real smashing doll, and what he wanted to know was had Schol tumbled her on the sand.

So I hit him. And Turk hit me, and somebody else hit me, and I hit him. And later the blues were there and I hit them and they hit me with a truncheon. I fought and struck out.

Now I know I am in the lazer in the back of the police place. I am not drunk. I am sick. But I am not sick in the way that they think. I am heart sick, heart sick. So I take this stool and I start banging the door with it, so that maybe they will have to come and quieten me some more. This is what I want. Because I can tell nobody, see. It will be with me for ever. It could never be, unless I was born different and she was born different. But I can't forget, and I feel a fire eating away at my chest. And there is nobody I can tell. Nobody at all. Nobody in the wide world. Who would understand? Who would know? Who would believe?

The Kiss

I
T WAS A most beautiful morning. The white clouds, above this
part of the Irish coast, seemed playful and benign. The waters
of the river went over the weir like a flow of silk and emptied
placidly, a short distance farther on, into the sea. The flowers on
the far bank of the river were white and purple. Many small,
brightly coloured pleasure boats were tied up along the near bank,
waiting for the tourists to get out of their beds.

The boy paid not the least attention to those real boats. Standing
on a ramp leading into the river, he sailed his own boat. It was a
short piece of rough timber, the front of which he had shaped very
crudely into a sort of bow. He had put a nail in the bow and tied a
long string to it. He would push his boat out into the water, and it
would wobble its way towards where there was a slight pull from
the current, and as it set off towards the weir he would pull the
string and the boat would turn reluctantly, half drowned, back
towards him. He was about nine years old, with brown, curly hair.
He wore a shirt, short trousers, and sandals; the sandals were wet,
and one of them had a broken strap.

Sometimes his boat was a great battleship. He would purse his
lips and make big-gun sounds. Sometimes it was an ocean liner, tall
and majestic, and he would make a deep siren sound from his chest.
It was also a fussy tug, a river boat. It was anything he wanted it to
be, and he thought it was wonderful.

Then this girl came along by the riverside. She was six or so. She had fair hair and a short dress that showed her well-browned limbs, which were in the pudgy stage. She had blue eyes and fat wrists, and she was still inclined to bite one finger. She was pulling a wooden horse by a string over the uneven ground. It was on wobbly wheels, this horse, and was painted white, with red trimmings. When it toppled, she would stop and put it upright and go on again. She came to the ramp and stood there and watched the boy playing with the boat. 'Hello, Jimmy,' she said.

Jimmy gave her one glance over his shoulder. He wished her to go away. She knew this, but it didn't embarrass her. She just squatted down and watched him — boat in, boat out. Like Jimmy, she thought it was a beautiful boat.

'Nice boat,' she said.

He raised one eyebrow to look at her. He didn't smile, but he was pleased that she knew a beautiful thing when she saw it. 'Huh,' he said.

'Could you carry my horse across the river?' she asked. She asked that as if it were an impossible thing.

Jimmy considered it. He knew she thought that he couldn't possibly do such a thing, so he said, with scorn, 'Of course! Bring the horse down to the dock.'

She rose from her squatting, and very carefully pulled the horse to the edge of the ramp. She wished to show him that she could handle a horse well. As the boat was then in midstream, he had to turn it with finesse. He used the string gently, so that when the boat turned it didn't even go under the water. Like a master mariner, he brought it safely to port.

'You will have to back the horse on to the ship,' he said. 'Careful. You might swamp the boat and there is no insurance on her.'

'I'll be careful,' she said. She put her small red tongue between her teeth and held it there as she started backing the horse on board. The horse would take up a lot of room — nearly the whole

width and length of the boat. She was conscious of a critical eye watching her and when finally the horse stood on the boat she clapped her hands and said: 'Now!'

'That was easy,' the boy said. 'Now it is hard.'

The weight of the horse was almost submerging the vessel, so he was very cautious. He gently eased the boat and its burden out into the water with his little finger, and as the flow of the stream caught the boat he loosed the guiding string with extreme care. They held their breath. The boat went out the full length of the string. It wobbled a bit. The girl bit at her finger.

'Crossing the rapids is the worst part,' the boy said as he delicately began turning the boat and its burden around. Slowly it came around, little by little, and then, after a few terrible moments of anxiety, it started to come back to them. They were standing by, tense, as he brought it in. Finally, it scraped against the ramp. He bent down, pulled the horse on to the ramp, and then, standing up, he said, 'Now you will have to pay!'

To his astonishment, the little girl clapped her hands and said, 'Oh, Jimmy!' and stood on her toes and kissed him.

It was this sight the priest saw as he glanced up from his breviary. He thought it was a most wonderful sight. He was pleased with the morning, the summer sun, the flowers, and the green leaves. The psalms of his office were in praise of the material works of God, and this sight to him was the climax of the morning. He was pleased he had come to the riverside.

Jimmy was about to wipe his mouth with the back of his hand where she had kissed him, when this tall figure of a priest dressed in black loomed over them. He was smiling. 'Oh, this won't do,' the priest said. 'I saw you kissing Jimmy, Cecily. Now you will have to be married. You know that.' He was marking his place in the breviary with the index finger of his right hand. He put his hand on Jimmy's head and his free hand on Cecily's head. 'Now,' he said, laughing, 'you are married.'

He was very pleased with his joke. He looked at their innocence and smiled, and then walked on, chuckling. It was a little time before he could erase the picture they made and get on with his office.

Jimmy was glaring at the little girl. His fists were clenched. 'Now see what you have done,' he said.

'What?' she asked.

'Everything! Everything!' he shouted. 'You have ruined everything!'

He saw her face starting to crumble. He bent down, took his boat, string and all, and fired it out into the river. He watched it as it went under the water and then popped up again and settled. It was near the weir. It went around and around and then it was gone. He felt sad. He felt it was the total end of a way of life.

'Come on!' he said roughly to the girl. She was biting her finger now. He snatched this hand from her mouth and took it in his own. Her finger was wet. He bent over and took the horse in his other hand. 'Come on!' he said again, and walked off with her. She had to run to keep up with him.

He walked her from the riverside, up one street and into another street. He knew her house well. It was only a few doors from his own. The door of her house was open to the sun. The red tiles of the front step were polished. 'Go in, now,' he said, 'and don't stir out again.' She went in and stood, looking back at him. There were tears in her eyes. 'And don't be biting your finger. You are not a cannibal,' he added, and left her. She watched him go. Then she came out and sat on the step. She reached for the horse he had set down there, and cuddled it in her arms. She was bewildered.

Jimmy wondered where he would go first. Somewhere away from home he would have to go. It wouldn't do near home. Everyone left home when a thing like this happened. He thought of places he had been with his father. They might know him, those shopkeepers. He

headed for the shops. It was quite a walk. He had to stop now and again to pull the sandal with the broken strap up on his heel. Down into town and along the main street and across the bridge and down another few streets. He saw this shop where his father often took him. He went in. He liked the smell of it. Raisins and spices and fruit and at the back a closed-off place where his father would drink a glass of stout and Jimmy would have fizzy lemonade and a biscuit with currants in it; he would pull out the currants and eat them before he threw away the biscuit.

'Mr Moran,' he said to the shopkeeper.

Moran had to bend over the counter to see where the voice came from. 'Ah, hello Jimmy,' he said. 'Do you want a pint?'

'No, sir,' said Jimmy. 'I want a job.'

'Oh! Ah!' exclaimed Mr Moran and roared with laughter. 'Hey, Dominic,' he called to a man in a white apron. 'Here's a fella after your job.'

'Don't be laughing, Mr Moran,' said Jimmy, desperately.

'What do you want me to do?' Moran asked. 'Now, look at the size of you. You couldn't reach the bottom shelf. God — you're a comic, Jimmy. Come back when you've grown four feet.'

But Jimmy was gone. His face was red. He was digging his nails into his palms. Why wouldn't they understand? They shouldn't laugh.

The man in the hotel laughed. He called a lot of people to look at Jimmy and tell them what Jimmy had said. The man in the fun palace laughed. His laughter and the laughter of his clients followed Jimmy as he ran towards the sea.

There he sat on the rocks. The tide was coming in, and he flung round stones at the sea. He felt really desperate. He understood, now, all the hardships of being grown up.

Jimmy's father's heart didn't return to its proper position until he saw the lonely figure on the stony beach. He left his bicycle on the

promenade and walked down to him. He's alive, he was thinking. Imagine, he's alive! When Jimmy hadn't come home for lunch, he had begun searching for him; that was two hours ago. He had been thinking of getting the river dragged, thinking of small bodies caught at the weir.

'Hello, Jimmy,' he said, sitting beside him. Jimmy looked at him. His father's face was serious. This pleased Jimmy. 'You didn't come home for your grub,' his father said. 'I was looking all over the place for you.' He had heard about Jimmy's looking for a job. 'Did something happen?'

'Yes,' said Jimmy. 'It was that silly Cecily. We're married.'

'Oh,' said his father. But he didn't laugh. Jimmy noticed that and put his hand on his father's knee, and after a pause, Jimmy's father put his own hand on the small one. 'Married?' he said. 'I see.'

Jimmy told him about the priest. 'So I had to go looking for a job,' he said, 'and go away from home.'

'I see,' said his father. 'I see.' But, again, he didn't laugh. 'That's serious, right enough. It's a tough life.'

'What am I going to do now?' Jimmy asked. 'Nobody wants a boy to work for them. I'm too small.'

'The best thing we can do is to go and see that priest,' said Jimmy's father.

'Will that do any good?' Jimmy asked.

'You never know,' said his father. 'Come on.'

He put him on the bar of the bicycle, and they went into town and over to the house of the priest. I hope, Jimmy's father was thinking, that he will understand the feelings of a small boy.

'Will he be able to do anything?' Jimmy asked, as they stood at the front door.

'They have great power,' said Jimmy's father, ringing the bell.

The priest's housekeeper showed them into a room lined with books. Jimmy was very nervous. The priest came in. He smiled when he saw Jimmy. 'Ah, Jimmy,' he said. 'Hello, Joe, what ails you?'

'I believe,' Joe said slowly, 'that you married my son to Cecily this morning.' Don't laugh now, Father, he thought, because you are the one that started it.

Jimmy was watching the priest closely. The priest didn't laugh. He nodded, and sat down in a leather-covered chair. Joining his fingers together to cover his mouth, he said, 'Ah!'

'So Jimmy did the right thing,' said his father. 'He went looking everywhere for a job to support Cecily.'

'Hmm,' said the priest. 'Cecily would be an expensive wife.'

'You should see her eating ice cream,' said Jimmy.

'I see,' said the priest. 'Tell me, did you go into her house at all since you were married?'

'I did not,' said Jimmy.

'You mean you didn't go into her house and have a meal or anything?'

'I did not,' said Jimmy scornfully.

'Ah, then it's all off,' said the priest.

'It is?' said Jimmy.

'Certainly,' said the priest. 'If you don't go and live in the same house as Cecily, it's all off.'

'I'll never go near her again as long as I live,' said Jimmy.

'That's a pity,' said the priest. 'I thought you were a nice couple.'

'She's a silly girl,' said Jimmy.

'Incompatibility,' said the priest. 'So you are as free as a bird again, Jimmy.'

'I'm glad! I'm glad! I'm glad!' said Jimmy.

The priest and his father wondered at the fervent way he spoke.

'Thank you, Father,' said Joe. 'You are very kind.'

'No,' said the priest. 'I'm very silly.' Jimmy was running into the hall towards the door. 'They were such a pretty picture. I meant no harm. That silly joke, and it gives a boy many hours of worry. Who would think it?'

He watched father and son go out the door. Jimmy was a different

boy from the one who had stood in the room with the books. He was chattering now, joggling about on the bar of the bicycle. Joe waved at the priest, and then they were gone.

Joe thought how relieved his wife would be to see Jimmy. He thought of the change that had come over his son. He wondered if he would remember this when he was grown up. He himself would never forget it. He wondered if, somehow, it was his fault. He wondered if he was responsible for something buried deep in the mind of his son that had caused this simple joke of the priest to bring such terror. He wondered if his son would ever understand what had happened.

Jimmy was honking from his chest as if he were the horn of a motorcar.

Characters in Order of Appearance

MICHAEL ONE

YES I AM Mick Owen. How do I know why they call me Michael One? Just because my grandfather and his father were called Thady, I suppose, and if people minded their own business and worked hard they wouldn't have time to be going around naming other people.

I know I have a cut on my forehead. It took three stitches. I could show you the rest of my body and there isn't a mark on it, because I am a quiet man, that's why, because I never had a row with a neighbour all my whole life. I like peace and quiet. I prefer to turn my back on another man's anger and shake his hand when his blood is cool.

I have lived in Bealnahowen all my life. We have been here in the memory of four generations that I know. I have sixty acres; about forty of them are rock with a few stubs of grass in the cracks. If you know anyone who wants to buy rocks you could make me a rich man.

The rest of the land is good. It keeps us comfortable. I sell about ten store cattle every year, a few calves. I don't make what you call a comfortable living. Where's the comfort in having to work as hard as I have? We won't starve and there'll be a bit in the bank when I go. No, I don't want anything else out of life but what I have. I am

a countryman. I am uneasy in towns. I go when I have to go but I always like to come home.

How can I account for the upheaval? It wasn't my choosing, I can tell you that. I'd run a mile to get away from a rooteach like that, even though I'm fifty now and not as supple as I used to be.

Will I talk about my son? All right, I'll talk about my son, not that he isn't right and ready to talk about himself. He got this gift from his mother's people. If they talked less and worked harder they wouldn't be scattered all over the world now coming home every ten years or so throwing dollar bills around like they were chaff off the oats.

No man likes to fault his own son, and I am not faulting him. He was our only child. I could have done with a few more but you have to take what God sends, and I often wished that He had sent me a few that would keep their mouths shut and be able to handle a plough, along with him of course. No, even if you could send them back after a trial period, I wouldn't be without him.

Look, if you are a man like me, who works hard in the fields and the bogs and the haggard outside, you need help. So you have a son and all your life you watch him grow up and you think one day, that fella will be a great help to me, when I'm slowing down.

Not that he didn't try. And not that he couldn't do it if he set his mind to it. You know him yourself. He is a fine strong young lad. He could wrestle with a three-year-old bullock.

I'm a simple man. You know that now. I got past the sixth book and even if I had a chance to go further, I wouldn't want to. I can read and write and add up sums to beat the band, and that was enough for me. Maybe I don't understand him. Tell me what father understands his sons and somebody will give you a medal.

I see life one way and he sees it another way. It's as easy as that. It's a puzzle, but if you don't get to grips with it and understand you'll never keep the bile out of your mouth.

He was always airy even when he was small, with you and not

with you if you know what I mean. Now Ceolaun Maloney is airy, but he's an eejit. My son is not like that. Dreamy sort of. Fine for him, but what about me?

You can't dig spuds if you stand half the day looking at the sky and your leg wrapped around the handle of the spade.

You can't cut turf on the bog if you are watching the skylark and studying the habits of the grouse and looking at old trees that have been in the bog for a thousand years. How are you going to keep warm in the winter?

It's no use scratching behind a cow's ears when her udders are bursting to be relieved and she is lowing with the pain.

If you put in cabbage plants in the garden it's no use putting them in upside down. As true as God didn't I see fifty of them with the roots up and the heads down? What's going to feed the pigs?

I like little mice as well as the next one, but I don't want to spend half the day looking at their nest in a field.

If I cut the meadow hay why do I have to leave half the field because there's the cursed nest of a corncrake somewhere in there? A corncrake? That's the fellow with the rasp of a voice that often got me up at night to throw rocks into the field and ruining my scythe blade after.

You see, that boy spent more time lying down than standing up. Not sleeping, mark you. There would be some sense in that, but with his eyes open.

Of course he was willing, when you got his attention, and he would do more in half a day if he set his mind to it than another fellow would do in two, but you had to keep after him so you became weary and you would go ahead and do it yourself in the end.

He wasn't lazy. No matter what they say about him. It was just that he wasn't putting his mind to things. That boy never stayed in bed late in the mornings. I often saw him at dawn, out on one of the big rocks looking at the sun rising. There's nothing mad about that. I don't mind looking at the sun rising myself when I am going

to the fair so that I can stop the devil of cattle from running down the bye-roads.

I'll say no more about him. That's all now. I'll say no more about my neighbours. Nothing good ever came from talking about your neighbours. All I want is peace to come down on this place again after the upheaval.

I'll say no more about the trouble we had. I'll have a sore head and a scar to remind me of it any time I want to think about it, and that won't be often.

The sooner they take away their interest in Bealnahowen, the sooner I'll be pleased. It's our own business.

All I had to do with it is that I was the father of the boy, and he's a good boy when his mind is on it and I don't believe he ever meant to hurt anyone. He got the gift of words from his mother's people like I said, and if you want to talk to her about him, there is no harm in it. She's there, she'll give you tea from the pot and a brown egg if you want it, and now I myself must go and milk the cows.

Who else will do it?

MICHAEL ONE'S MARY

Don't mind Mick. He's like a jennet with a harness sore. He doesn't understand our Michael. How can he, a man like that who always keeps his eyes on the ground? The only time he looks at the sky is to see if it's going to rain. But he's a good man, as kind as a saint, just that he grumbles away like a disturbed stomach.

Isn't it only a mother that understands her own son? Like two heartbeats. Here, I'll get you a few of his pictures out of the drawer. No, it's no trouble, and how will you understand the man if you don't know the boy?

There, look at him, isn't he beautiful? With the curly hair and the sturdy limbs? Haven't times changed? He was a baby when that picture was taken, and when some of the old ones saw him pictured with no clothes on they used to bless themselves like you would passing a graveyard at night.

This is one when he was dressed up for his First Communion. Isn't he handsome? I know he didn't get on well at school, that there was some trouble with the schoolmaster and the boys, but do you know why? *He* should have been the teacher. Even that young he was full of brains. He could have blinded them with knowledge. From the first minute he learned to read he was stuck in the books. I'll show you his room in there if you like. Well, it's like a shop that sells books. So what is he *did* correct the schoolmaster on a few things? He was always a truthful boy. 'Truth and beauty, mother,' he would say to me, 'they are the only things men should die for.' I remember well. He would come out with things like that when I would be chopping cabbage for the pigs, and I would have to stop and cry into my apron, and he would comfort me.

He always confided in me. The schoolmaster was cruel to him. He used to wallop him with a sally rod. There'd be blisters on his backside as big as sea-rods. Do you think Mick'd go down and speak up to that man? Another father'd half-killed him. But not my Mick. More power to his arm, would be all he would say, not understanding how sensitive his son was. So I had to go down and read him myself, but little good it did. He was a sour little man with a tongue on him like a razor, God be good to him. He's dead now and I hope he's in the right place.

Oh, yes, about the present. Well a mother's heart wanders. What else has she over the years but the tender memories of the long ago?

I knew he would be a writing man some day. He'd scribble away in there for hours, night and day. Before we got the electricity his father would go around shouting: 'Who's eating candles? What

d'you want another packet for?' Imagine! And that wax nurturing the mind of a genius. Oh, yes, I'm not putting a tooth in it. My son Michael is a genius. I told him so often, and I think he agrees with me now. You saw that play yourself didn't you? The one that caused all the trouble? Well why would it have caused all the trouble if it wasn't a great thing?

No matter. You haven't heard him reading some of the things he has above there in the chest. He would prance around the kitchen here reading them out to me, his mother, and if I didn't understand some of them, me heart would be bursting with pride and I'd be weeping buckets of tears. It used to do him good to see me crying. 'I have moved you, mother,' he would cry. 'One day I will move the world.'

How could you expect a man like that to be bothered with all the little things? I knew they were complaining about him. Did they expect him to have his nose stuck in the muck of the fields when his eyes were always on the stars? They expect everyone to be like themselves. Aren't some of them filled with envy, God forgive them, and they barely able to write their own names on their dole cards?

I didn't see the play. Why would I see the play? Didn't he read the whole lot to me here, all over? No I didn't see anything in it about real people. About the neighbours? No, sure they weren't people but characters like in a story. How do I know why they all thought they were in it? Listen, they weren't *important* enough to be in the lines written by my son. I wouldn't go near it. I'd be ashamed. What do I know about the big city? Wouldn't I be like a duck out of water? The excitement would kill me. But my Michael was well able to handle himself. Hasn't he a silver tongue? Wouldn't he charm the crows? If they had just listened to him on the night of the ructions there would have been no ructions.

It was all them Valley people, I tell you, coming over for the fair, and what happened to Sarah, but that was an accident.

I know he called them the people of Bally in the play and said that a thousand years ago the pigs of Bally were turned into people and they were still there. But that was a joke. Couldn't they laugh at a joke? And how do they know that he meant them at all? He wouldn't be bothered with them, a bunch of rowdy luderamauns like them, wild bogmen that never saw a play in their life and wouldn't know what it was if they saw it.

No, I didn't pour boiling water over some people deliberately. It all started when I was in the kitchen and I was taking the kettle off the crook to make a sup of tea when it started. That was how I had the kettle in me hand. I wouldn't hurt a fly. I have too much dignity. Didn't the kettle fly out of me hand?

Ah, it's a pity you have to go, and I hardly started on telling you about my son Michael. A better boy was never born. If he got some of the gift of the words from me, amn't I the proud mother?

The things they did to him and the things they said! Won't they be sorry one day, when we're all gone and they'll be putting flowers before his statue out there near the weighing scale. You mark my words. He'll be famous, and Bealnahowen will be famous because of him. My mother's heart tells me this.

When you meet him you'll know what I mean. Look at his eyes. Through you he'll be looking, reading you down to the soles of your boots. He'll know more about you than your own mother.

And you'll see the fire in him, banked like a turf fire at night in the hearth and ready to burst into flame in the morning at a blow from the mouth.

Come back again and I'll tell you more, since you have to hurry away now. I have lots to tell you, and who better to tell you than his own mother, who bore him and fed him from her own body and watched over him like a head of celery that's hard to grow in the thin ground?

I'm proud of my son Michael and I don't care who hears me.

Here I am shouting at the door with you gone, and I don't care

who hears me. I can hear me own voice coming back from the hills and going out over the sea, and back in over the heads of an ungrateful people!

MISTER FINE DAY McGRATH

Ah, is that so? Come on in.

We'll go in out of the shop. It has too many ears. Here, Joe, bring a bottle and a few glasses into the parlour.

Indeed it is good. I only stock the best not like some other places I could mention where it's half potheen and three-quarters water.

If you want to know about me, I'll tell you about me in all honesty. The fact of the matter is that I am the father of this village. I know more about them than the priest above in the chapel, and why? Because they are all into me for money, that's why, and debts bare a person's soul. If I could collect all the money that's owed to me you could walk around the whole of Ireland on a path of pound notes.

I'm a just man and a patient man but sometimes I do be tempted to drown the lot of them in civil bills, and then where would they be?

Ah, now, Michael Owen, the fella that wrote the play?

If you asked me a week ago you would be in danger of being thrown out on your head, so you would. But look at me now, as calm as a bishop and not a tremble in me hand. I have a forgiving nature. Everyone knows that about me or I'd have the whole of that Owen family nailed to the wall.

Well, I've known him all his life and people will tell you that I'm the most observant man in the place. He was nothing but a lazy scut from the day he was born. This is not a lack of charity now, it's just facts, plain facts, and facts cannot be outfaced.

His mother Mary is an oinseach. She hasn't a brain in her head and a tongue as long as an electric cable and enough venom in it to electrocute a saint.

Mick Owen is all right. He pays his bills in due time and works hard and keeps his tongue in his mouth and the only thing you can fault him for is that he fathered that son and didn't belt hell out of him at the proper time. But then Mary was a tartar. He gave up the fight there too soon once she got him to the altar.

No, I didn't see this play. I wouldn't be seen dead looking at this play. I haven't seen a lot of plays, just the ones that come now and again to the village in a tent. Good for business afterwards, but they put on this little play; and songs and dances and a raffle as well. That's the kind of a play I like.

No, but respectable people who saw it told me about it, and if I wasn't a man of peace and loaded with charity, I'd have that fella up in court for slander and ruin him, but what could I do when he hasn't even a penny to bless himself with, and besides I'm above that sort of scabby action, even if my name is important to me.

How do I know? He writes in the play about this village. There's a merchant in it, and nobody since God created Adam ever heard of such a scoundrel. And since there's only one merchant in the village, who do people think it is? Me, of course. He even has the actor in the play, I hear, *looking* like me. I know I couldn't be like this fellow in the play who is a grasping-poisoned-tongued monster, a gombeen man of the first water. Everyone knows my character. Only God knows of my charity to the poor people of the world. Am I expected to trumpet my goodness all over the place, when your left hand isn't supposed to know what your right hand is up to?

Well, I don't mind that. Great men have been slandered before this. Let him call me mean, a profiteer, taking advantage of people's needs, even, may God forgive him, pressing little farmers to take over their places and graze it with my bullocks, which is a lie,

because at this moment there are men and families all over the United States *prospering* because I was there to help them in their need, when they might be here at home now scratching the stony soil in poverty and starvation.

I forgive all that. How is the poor amadaun to know about me and the things I have done for the village? Who is to tell them, when the lips are sealed with gratitude?

No, it's the other thing!

You saw that girl Julie out there now. Did you ever see a prettier girl? She is a good girl, decent and obedient and grateful. She is an orphan of course, and what does he say? That I am her secret father! Who could forgive a thing like that?

I know I am a good-looking man, but can you see any resemblance at all between the two of us? Can any man alive? What about the effect on the mind of that poor girl, raising false hopes in her heart? What about the feelings of my poor wife, a meek gentle woman? Will she cast the eyes of suspicion on me? That is what galls me that people will think I'm as randy as a puck goat when I'm a pure man that wouldn't give a double look at Venus herself if she was cavorting stark naked down on that strand!

Where did you hear a terrible thing like that? I know, but it was nearly forty years ago. It was all a mistake. There was an affiliation order, and my father paid, but nobody told you the whole story. I was young and I was led up the garden, but it wasn't really me. I couldn't say at the time and I won't say now, who was to blame, but may the Lord God forgive them and commend me for keeping my mouth shut all those years. Would you ever think there are so many wicked people in the world telling you a thing like that? Every day I am shocked to me soul with the perfidy of those people I am like a father to.

Ah, well, for some special people, this world is a life of pain. That is the way it is meant to be. You have to keep thinking of the reward afterwards.

168

No, sir, I had no hand act or part in the trouble afterwards. I was indignant, but I am a just man. You have spoken to me now. You can see that, without me telling you.

And what he did to poor Sarah Maloney! The poor creature. You wouldn't do it to an animal unless you were born with a stone for a heart. I kept my own injury in my bosom, but Sarah moved me. I must say that. I spoke, maybe a little over much, about the torture that fella put her through. Somebody has to speak up for the helpless and the weak. And who would speak if I didn't! That man down in the church should have been raving about it from the altar, if right was right.

And what about the people of Valley? They are friends of mine too. There's no shop over there so they come to me for their simple provisions. They are good people, nice people, the salt of the earth, and what does he call them but reincarnated pigs?

Would you like to be called that? Would you like to be told that your father was a pig and your mother was a sow?

No man would. No man with red blood in his veins. Is it any wonder they were blinded with anger? Righteous with rage? What could you expect of them? I tried to calm them. Everybody knows that, but they got out of hand a bit. It is a damn lie to say that I incited them. They needed no inciting, and if in their terrible anger they took the law into their own hands, can you blame them?

I can't find it in my heart to blame them even if a lot of bottles and glasses were destroyed on me and I'm not even claiming compensation, even if I could get it put on the rates. That'll show you what kind of a decent man I am.

You saw this play, eh, and what did you think of it?

Funny, eh? To you maybe. But you don't know.

Was it good then? Hard to say, eh? Maybe only one shot out of a single barrelled gun, eh? It would be terrible if that fella ended up as something. Not me, sir, you'll get me doing no back pedalling. Even if he'll know himself in the future how good I was to his peo-

ple, how I kept them all from starvation in the lean times. He'll remember that all right, I'm sure.

But for the present as far as I'm concerned he's nothing but a bad apple, a blighted potato, and the sooner we get him out of the community the better we all will be.

Here now, have another glass.

I'm glad you called on me.

Now you have a clear picture and people will know the facts.

Your good health or as we say health and life to you and a thousand a year to you.

MISTER SAILOR MURPHY AND MISS SARAH MALONEY

If I'm a hard man to catch it's case equal.

I haven't the gift of talk.

Running away from nobody, just fishing.

Leave all those things alone. Nobody's business.

Yes, out in the open now.

About myself. What importance? Just work and tobacco and the pint of an evening in the pub.

It's true, long ago in foreign parts. Ten years. Why they call me Sailor. No. Always wanted to come home. This is home, the boat and the house.

You make me talk about the other things I get a pain in my stomach.

I know everybody knows, but does it make it easy?

Michael Two's play. No. No hurt. Only about Sarah and Julie.

Haven't seen Julie since. Run a mile. Wouldn't you?

Why, well, dammit, you know all about it.

I know she is a good girl and a nice one, but all the same.

Of course we were friends before, but now that it's out in the open, can't face her. What I done to her!

Not important? What I done to her? Cheeeee, man!

Sarah young was like a fair fish you see in the hot waters of the sea. Yes. Still is just seen through a mist. All my fault. Persuader in those days. Her father and mother against. Why not? No good, that young Murphy. Those days. Wouldn't let my own daughter walk out with him.

Went away. Didn't know about Julie.

Can't you leave me alone?

Well, all right. Married a woman in foreign parts. When I come home after ten years, heard about Julie. McGraths took her in. Foreign wife still alive. Then she dies, but what can I do? Hah? Can you solve it? Too ashamed see. And to have to tell Julie. She's all right. Good girl. Settled in with Fine Day and his missis.

Sure, all my fault. Not bold. No guts. Afraid of what people will say. Plague of the world that. Not able for it. Prefer to face gale nine in the sea.

That's all now.

No, no more. Have to get away. Tide is in.

Maybe Michael Two did good with that play when all is said.

No. Can't say any more.

See someone else.

See Sarah maybe. She is better now.

No! No! You talk to Sarah. See my sweat. Goodbye.

Mister Murphy told you to call did he? I suppose he ran away in the boat. He's a very shy man now. Some people don't like to be looked at or talked about.

No, I don't, but after the first shock you accept it. Yes, I make things for the women, skirts and blouses and dresses. No, I like needlework. My eyes are good. It helped me over the years to be busy.

Hate Michael Two? God bless you, I do not. What's the use of hating anyone. It only makes you bitter.

Only about Julie I am sad. I should have kept her myself, but these times people were very righteous. Maybe they were right too. Sort of having a bad example in the village. Say: Look at Sarah Maloney! The brass of her! And she got away with it. She flaunts it! Things like that I think.

No, Mrs McGrath was very kind. She had no children of her own. They reared her well. You see the nice girl she is now.

No, the accident that happened to me was used by people to pound Michael Two.

You know the river outside the wall there with the wooden footbridge over it. You see the river is calm now. But that evening there had been a lot of rain and it had poured down from the hills. The rushing water was touching the wood of the bridge when I was coming home. I slipped and fell in. Of course! The wood was slippery from the rain. I know they won't believe me. I doubt if they will ever quite believe me. Why should they? Isn't it more dramatic to think that in a burst of despair I threw myself into the river? What pish! I'm not a girl any longer. I have lived with this thing since I was seventeen. Why should I up and kill myself at this late stage?

Mister Murphy was down farther. He was coming home from his fishing. It was very simple. He had a net with him, as he saw me tumbling over and over in the river, he just threw the net and hauled me in like a fish. Wasn't it a good thing that nobody saw? Why wouldn't I be laughing? It's very amusing. No I wasn't even unconscious. I wasn't in the river long and I didn't panic. I kept my mouth shut and held my nose and each time I came clear I took a breath of air.

I'm laughing because Mister Murphy had a hard job untangling me from the net. He is a man of few words as you now know. But he was using a lot of them at this time. Quite another person, in fact. The kind of person I always knew him to be.

Other people came when he freed me. They insisted on carrying me home. I didn't want to be carried home. I could have walked. But they insisted. People become very officious at times of

crisis. Not that there was any crisis. I was quite happy to be rescued by Mister Murphy. It was like old times, and they spoilt it.

Mister Murphy feels loaded down with guilt. That was his trouble. I know it was silly of us not to *do* something about it all those years, but if you can't understand why by your own instinct you will never know.

Yes, we are going to be married now. This will give people a great occasion for talk, but what harm? It will be worth it all no matter how long it has been delayed. No, it will take place right here in the village church.

Yes, Julie. We have met and talked. She is a kind girl. But she is very bewildered. Wouldn't you be? I don't know how long it will take her to adjust herself to the new circumstances, but I know she will do the right thing. Do I sound prim? I don't mean to be.

Michael Two did good by doing bad. After the first shock, I saw that. Otherwise it would never have come into the open.

It's all so silly isn't it? It's so hard for sophisticated people to understand? I can't make you understand. Oh, yes, I suppose I speak well. I was four years in a secondary school, a boarding school run by the Sisters. I think that was why my parents objected to my falling in love with Mister Murphy. They didn't think he was *good enough* for me. I suppose they thought he was a poor reward for their investment in my education.

Parents can sometimes be very foolish.

I say that and I ask: Am I any better as a parent?

The answer is no, I am not. I was worse.

So life is a cycle, you see. You worry at it like a dog at a bone, and then like the dog you bury it, instead of leaving it in the open so that the eyes of people become accustomed to it, and one day they won't see it at all.

I'm only sorry that they used me to ignite their own passions. I don't like being used as a Cause.

I am pleased. Thank you. May God go with you.

Turloc O'Connor

Yes, I am Turloc O'Connor. I am a hard man to find because I am not always at home. When there are fish I go to catch them in the river and lakes, and when there is game I go and shoot them. I also have sheep on the commonage, and way back in the hills. Here I have a piece of tillage and two cows, so I am kept busy. I don't have much time to be home in the house.

You think it is tidy? Well, I like things to be tidy. I have had plenty of practice. My parents died of the flu some years ago. Brothers and sisters yes, scattered over the world, mainly in America.

Resentful at being left at home? Yerra, have sense! I like it at home. I make a living. I have enough to eat. I live a good life.

No, I don't mind talking about my neighbours. There is no people nearer to a man than his neighbours, that's why there are quarrels, like a family.

Mick Owen is a good man. He worries too much, that's his main problem. His wife talks enough for two, but there is little harm in her. He will always be puzzled by his son, like a duck that hatches out a goose from an egg instead of another mallard. Always looking at him. Saying: Could that ever be mine? He'll go down to his grave wondering. Fine Day McGrath is as he is. He hates to see another person making a shilling if he can't make it first. He is like he is. Who can change him? You have to take people as you find them.

He was decent enough to Julie. She doesn't live in luxury and never did, but she gets enough to eat and clothes to keep her looking respectable. He gets cheap labour from her, but after all he took her in in the first place didn't he? He deserves credit for that.

When you ask me to talk about Michael Two we come to quaky ground. We were at school together. We didn't get on much. I'm very big as you see and he was small, strong and healthy but butty. Small men are always agin big men, and big men can't hit small men. It's as easy as that.

He was always a terrible one for righting. He would right your talk and your speech and your opinions. He was always like a little bantam cock. But he wasn't always right in his righting. He read a lot all the time, but I think he only took out of his reading what agreed with his own opinions, and didn't digest anything else.

Then his people sent him off to school. He was away for five years and this sort of separated him from the rest of us. I think young men should grow up in their own places. If I had a son I don't think I'd send him off like that. I don't know how I would get him educated, somehow, but not send him off like that. They come home at holiday time. If they are not stable they are inclined to look down on the rest of us, sort of doing us a favour when they play with us or dance with us, or sing with us or drink with us or talk with us.

But Michael Two was a special case. There are not many like him.

I don't sound as if I liked him much, I know. Let me think of it. No, I don't think I like him, but I have a sort of affection for him. I know one thing contradicts the other, but I can't get any closer than that. It's like having a tame rat in the house. No, I don't mean to call him a rat, that way. He is not of course. It's just he's odd, say.

Right, we come to the play. Do I feel resentful about it? No, indeed. I slipped up to see it.

Why should that surprise you? I often slip away to see things for a night or two, a play or an opera or these dancing things, ballet is it? Lots of people do, you know. We are not all yobs.

It isn't much of a play. It's thin enough, but it's good gas. There's laughs in it. Yes I saw the character what did he call him, Burly Bonner? That's supposed to be me. No I only laughed at it. The idea of me poaching salmon with dynamite and that poison, that's all cod. There are easier ways of catching them than that, and I wouldn't slaughter fish. I have too much sense. Why would you slaughter them like that, when in a few years they would be all wiped out?

175

I'll tell you some of the lines in the play are vicious, but they are only vicious if you are us and see that he was making caricatures of us. Michael Two doesn't like me, I know. This and that. He has the odd idea that Julie likes me, and he has been very keen on Julie. Have you met her? Well she is a very intelligent girl. She walked a lot with him and listened a lot to him. She is a very good-looking girl too, and she would make a good wife for him. He is afraid that she would like me, but this is stupid because she thinks of me like a brother, because she never had a brother, and I look on her as a sister. I kind of keep an eye on her you understand, and we get on well, like brothers and sister do when they are young, we laugh a lot, and she has a nice laugh like a bell, and when you hear her laughing at one of your poor jokes it makes you feel bigger than you are. Do you understand this? It's important to understand it, because there was no need for him to have a bash at me on that account. Our relationship is pure friendly. Companions. You understand this?

Well, when that's out of the way, what have you? I think his mind is shallow, and that his words have no deeps in them. He just skims life, not even the top of the milk, just skim milk. Like he spends hours looking at the sky and the stars and the moon and the sun and the hills and the green grass and the heather, but that is all he sees, I think, the things. He doesn't see the unity of them, or what's behind them, or the purpose of them, so how can he see the purpose of people, even little people like us? Sure most of the world is made up of little people, and it is their unity and purpose and dreams that make up the reason for the universe at all. You see what I mean? Hold a mirror up to life, they say, and show us life, but all he does is hold up the mirror and show us his own face and his own thoughts.

I may be all wrong, but this is the way I see it.

And you are not permitted to hurt people, I don't think. Sure, we all knew about Julie and Sarah and the Sailor. But it had gone on

so long that we had sort of forgotten. But nobody would talk in their sleep about it if you know what I mean. It was a stupid situation, but it was also sad. It went on too long for anybody to do anything about it, and by then it was too late.

And this is what curdled my stomach. Knowing about Julie and then making the merchant her father in the play. This was not good. Fine Day is a person too. He had a few weaknesses in his youth, but that's long ago and you see the cunning of it. How could he defend the present when he was a defaulter in the past? You see. It was no wonder he was enraged even if it was only on hearsay evidence.

I don't think that was right, to strike out at people for the sake of a few laughs. Of course nobody would ever know he was mixing up real people with shadows only the people themselves, and Fine Day should have kept his mouth shut. Even the people of Valley wouldn't have lost their tempers, if it wasn't a fair day and they had drink taken and Fine Day sort of rubbed salt in their wounds. There was no need for it all. It would have died if they had left it alone and in a few months' time it wouldn't even be remembered. It wouldn't even then if there hadn't been a fellow from a newspaper passing through and picked up the story. Yes, it was a good story, with Michael Two there to make a drama of it. He didn't do himself any harm out of the publicity, a sort of proto martyr, assaulted and rejected by his own people.

Man, he can live on that for the rest of his life.

Why did I fight for him if I feel this way about him?

That's a hard one.

Let me think about it.

Well, I suppose because he was one of our own, and when the flags go up you have to take sides. We wouldn't mind beating him ourselves, but we'll be damned if we'll let strangers beat him. That sort of a way, eh?

It wouldn't have mattered a damn only for Julie and Sarah. Julie is such a grand girl. And she was shocked. Like digging a knife into

her. And Sarah like a mouse under a big light. And poor inarticulate Sailor. You see what I mean. Fine Day wouldn't mind in the end. He would probably put up a banner saying: Come and drink in the pub of the villain of the play. Eh? You see what I mean. These fellas can look after themselves. But it's the little people who have to carry the wounds.

Yes, you go and see Julie. If only to see her and talk to her. Not about this even I mean, just to see one of the nicest girls in the world.

MISTER CEOLAUN MAHONEY

Hah?

Oh.

Ah! Yes. Me. Have you a fag?

Wha'? Oh, tha'! Yeh. Hah? The play. Wha' play? Oh, tha' play. Yeh. Do hah? Oh, yeh, Drive a taxi? Wha' tha' No, a motorcar.

Oh, yeh, jany I go to the big place. Fellas missed train. Say you take us, Ceolaun. Long way, hah?

Wha' happened? Met your man, Michael Two. Gas. You come, he sez, have seat for you.

Man, laugh. There, posh people. Nah, never saw a play. Oney this one. Lights go out. Curtain thing goes up. Who do you think is there, hah? Laugh. Janey, tha's Fine Day. I say. Loud. People say shish. Laugh. All the people. Gas. Just like at home see.

I know them, I say to fella. You stop puckin' me in the ribs this fella says or I get you put out. He said tha'. No friends there, hah?

It goes on. I have to laugh. Out loud. Can't help it. There they all are, way they talk and everythin'. Let a few shouts out. Full of gas, eh. Then thin lady comes and says Would you mind leavin'? Didn't mind. Saw enough.

Comin' home I stop in Valley, and have a talk. Ye'er famoust, I say. Michael Two has ye in a play. The pigs of Bally ye are, I sez. Wait'll ye see. Then I come and tell Fine Day how he is in the play. And Julie and Sarah and Turloc. Laugh, I sez, ye'll break yeer hearts laughin', I sez. Tould them all about it. I was the oney one then, see.

Wha' you say? Cata what? Catalyst? Like catapult? I didn't do nothin' and they all shout at me. Wha'd I do, tell me? Oney wanted them to laugh same as I laughed. Tha's all.

Don't know why the big row. Maybe everybody drunk is why, hah? See wha' happened me. Somebody hits me on the skull with a two-gallon petrol tin. Yeh! Me own, too. Took it out of the car as well. Turned the car over on its side. Was that a nice thing to do? Would you do that to a Turk even?

No, I done nothin'.

I do know wha' it's all about.

Wha's wrong with them all, eh?

I do know wha' happened to them all.

Oney wanted to make them laugh see, like in the play. Laugh with the belly an' all.

People's quare.

Tha's all.

JULIE

All right. Do you mind if we walk down to the pier? The sun is shining and we can get away from the pub.

Do you like the smell of porter?

I don't. You'd think one would get used to it.

Maybe some people would get used to it, but I won't. I would like to be somewhere I would never see the black colour of it again.

I'm chattering. I suppose it's because I'm embarrassed.

One day it will all fade away. Age brings wisdom and forgetfulness. So the old people say.

I'm twenty. When you are that age, things seem more pointed maybe. No, not hurt. You get well used to that, early.

I don't like to be talking about myself. It's easy enough to say fill in the picture. It's a queer picture. For me anyhow.

No, I like Mister McGrath. He has one interest in life, the pursuit of money and what power can be got in a small area. When you understand that, you don't feel afflicted by him. He is never consciously cruel to anyone. It's just that when your mind is set on one or two things only, you kind of don't look to the left or the right, and if you hurt people you don't even know it.

Yes, he has been good to me, and Mrs McGrath has been good to me. No, I don't think the amount of work I do will ever repay them for their kindness. I never once heard an insulting word from them, or a whisper of who I really was.

No, nobody at all. It seems ridiculous in such a small community, I know, but that's the truth of it.

Of course I often wondered. You do, you know. They told me I was an orphan, that they took me from an orphanage. That was all I knew.

I filled in the rest with dreams. I wouldn't like to tell you those dreams. They were too romantic, about who I was and who my mother and father might have been.

I never dreamed that they were here under my nose all the time.

Now, see, look at him.

Sailor: he saw us coming and he's scuttling into the boat and hoisting the sail and in a few minutes he'll be out on the sea, in case I would catch up with him. Isn't he funny? I always liked him. I would go and sit on a bollard while he mended his nets and talk to him. I did most of the talking, but looking back, I noticed he regarded me in an odd way. I would see him looking at me, oddly,

like an affectionate dog you would catch taking a chicken from an open cupboard door.

Well, there he is now, a speck in the ocean, so we can sit here for a little while. Never mind Sailor. One day I will catch up with him and talk sense to him.

Oh, Sarah is different.

It was very awkward.

You can't bridge a thing like that in a day or two days. I don't know how long it will take.

It is only now that it is beginning to dawn on me that I have a real father and mother. After the first hearing it is like as if you were numbed. But now the feeling is coming back, and sometimes I get an excited feeling in my stomach.

It is a pity it's so late for me. Now is the time that ordinary children are leaving home to get married or to go to jobs, and I'm only after finding one.

About the play?

Well, I wasn't surprised. I know Michael. Too well. We walked a lot together and talked a lot. At least he did most of the talking, because he is like that. If flows out of him like a river. He is good company. He is colourful.

No I wasn't surprised that he did this to me, I mean not hurt. Because that is what he is like. He would be horrified to hear this, but he and Mister McGrath are very alike in that: the pursuit of a single objective. He wants to talk about people or write about people. He can't help it. Why he even has his own mother in the play, garrulous, flapping, fussy. So Turloc tells me.

Turloc? Oh, Turloc is all right. He has his feet on the ground and although he'd die before he would admit it, he has his head in the clouds. Michael Two sees all the wonders of the world all around him, and examines them closely. But Turloc sees them and loves them, that's the difference.

Indeed Michael Two has a great personality. He can capture you

while you are there, feverishly throwing pictures at you, condensing people in a few sentences. He is a good mimic too. You would swear that the actual person is there talking to you.

Am I fond of him? Of course I am fond of him. Does he want me to marry him? He does. More so now than ever, because he feels that he may perhaps have injured me. Partly that, and also he sees himself as a knight on a charger rushing to save the damsel in distress.

This is the part that makes me laugh.

Because I don't feel in the least distressed and besides I'm going to marry Turloc.

Of course, Turloc doesn't know. You spoke to him. I suppose he told you all about him being a big brother to me. Full of brotherly love? Well, his love for me is anything but brotherly. He keeps trying to tell himself that, because he doesn't think much of himself or the kind of life he leads, but it'll suit me fine.

I know it maddened him to see me so much with Michael Two in my free time, but girls have to use some wiles. Sometimes I used to see the sparks coming out of his eyes, but he has great control over his emotions or he would have half killed poor Michael Two.

Oh, yes, Michael Two probably knows this. His instinct would tell him and he would be enraged against Turloc, because he feels that I might have been using him a little to stir up Turloc. These people with objectives hate to think they have been used a little. It hurts their egos. They want to be the Number Ones in every situation. That was why he put Turloc in the play and made him do nasty things. He wouldn't guess that Turloc is too big to be hurt by pinpricks.

I'll have to be going back now, or Mister McGrath will be roaring for me.

Anyhow, if we stayed here any longer all I would be doing is talking about Turloc, since I think he's the living end.

There, what did I tell you? Hasn't Mister McGrath a powerful voice! Even down here we can hear him.

I must go.

MICHAEL TWO

Obviously an uncivilised community, only one or two steps removed from the stone age.

Look at it! What do I do? I bring honour to my people. All my life I have been trying to uplift them, to make them see the better things in life, and if this isn't proof of my failure, nothing is. Not my own failure but theirs, because it proved how little they had assimilated.

See it this way. Here I am. I have been in the city. I have been acclaimed by intelligent people.

I am aware that some of them were caustic, but when you decide to place your wares in the market place, you must expect to be pelted with garbage by the ignorant.

I decide to come home. I had a mild expectation that I would be greeted if not with flags and banners and the local fife and drum band, at least with some form of welcome for the attention I had brought to their little village. With my own eyes I have seen the bonfires on the hills when one of their young men becomes a priest and he is welcomed home after his ordination.

Well, priests you have always with you but a man like me only happens in several generations. There won't be one like me again in this place for hundreds of years, and maybe never if they continue in their ignorance. Isn't this a fact? It's nothing to do with egotism. The last one they had was over a hundred years ago, and he couldn't write his own name, just tell mouth stories in Irish. You see what I mean?

Well, I come home. I confess to a feeling of satisfaction, a sort of I told you so, because I knew they thought I was nothing but a lazy young man, constantly showing his belly to the sun or giving suck to the handle of a spade. How could they see that when I was doing nothing I was doing everything; that my mind was crowded with thoughts, that would one day cover reams of white paper, of which they might all be justly proud?

There was a fair on, as you know, and the green was crowded with people and animals, and when I stepped from the car and they shouted: 'There he is! There he is!' I thought they were intent on a welcome for me, but instead there were shouts of anger, the waving of sticks, and the shouting of words you only see on the walls of public conveniences in cities. I had never seen my village sink so low.

I could hardly believe it! I made my way to our home through a babel of noise and vituperation, which might have been mistaken by the ignorant for acclamation, and I find my home almost in a state of siege.

The kitchen is crowded. Of them all my mother was the only person who kept her head. She greeted me and kissed me and I felt very good. She knew! But the others.

I could hardly make out what they were shouting about.

This near moron Ceolaun Mahoney had apparently spread the most dire distortions about my play all over the place. Other people, too. I couldn't believe my ears. I had driven Sarah Maloney to suicide! Julie would undoubtedly take her own life as well. Turloc O'Connor was going to shoot me or blow me up with dynamite.

I said: 'What kind of stupid people are you? Do you think any of you are colourful enough to be put into a play? You are the most boring persons in the world. If I put any of you into a play it's the audience that would commit suicide from yawning.'

This is what galls me, that they would even think for a moment that the people of my play are not dream figures from my own bright brain, creatures of my own imagination. How would they dare even think that I would use their puny personalities in a play?

No, this is the only village I really know well. I admit there might be some similarities here and there, but that's utter coincidence, just because I held that famous mirror up to life.

No, they are not the people of Bealnahowen. They have nothing at all to do with the personalities of this place. They are people

forged from *within* me. I feel deeply insulted that they could even think for a moment that my imagination requires assistance from their dull minds.

I told all this to that merchant McGrath when he came in with foam at his mouth. I told him straight. 'Do you think for one minute, you little pot-bellied gombeen,' I said, 'that I would put you in a play? Look at yourself,' I told him. 'Can you even see yourself in a looking glass, you are so dim? How could I be expected to hold the attention of even lunatics by putting somebody like you in a play?'

I tried to open his eyes, but he was very annoyed. He went out in a rage and, I am told, addressed the drunken populace out there from a pedlar's stall. He was really at the back of all this. I am not surprised. He hasn't the intelligence of a tick. These Valley people were always violent dim-witted people. That might have been the only real thing I took from life, about the pigs of Bally.

The next thing we know there are stones falling on the house like hail. Would you believe that in this day and age? Can't you see how far we are from the cultured civilisation of a thousand years ago.

My people wanted to restrain me, but I wouldn't have it. 'I will go out and face them,' I said, 'and silence them with reason. They are only animals.' I insisted on this. They couldn't have kept me in that house unless they had tied me down with cart-ropes. What kind of a man did they think I was?

So I went out there in the midst of them. I faced them boldly. I walked through their ranks enveloped in the aroma of porter and whiskey from their foul breaths and I occupied the pedlar's stall so recently vacated by the merchant McGrath. He wasn't there of course. I had a glimpse of him behind his window peering out. A coward as well as an inciter.

'You are a stupid people,' I told them, 'you are no better than dumb animals being led astray by your own passions and by a bullock-

brained man called McGrath. Who is profiting from all this fracas but this same McGrath? How much silver have you put into his till this day? Are you human?' I asked them. 'Have you no brains at all to think with? Don't you know that I am your friend? That one day you will be boasting in your old age that you were born in the same area and the same age as Michael Owen?'

I had plenty more to say to them, but I didn't get a chance. They swarmed in on the stall with sticks flying and terrible language. I was enveloped in them.

But there was still no need for the others to come to my assistance. I could have fought this battle on my own. I would have *forced* them to listen to me by sheer will power. I know I could, but I didn't get a chance. The whole thing developed into a disgusting free for all. All I could do was to stand back there and watch them saying: Could these be my people? Are these the kind of people one can be proud of? Can one say with satisfaction: These are the people from whom I sprang?

It was a faction fight all over again. The people of Bealnahowen against the people of Valley. I saw my father fighting, and my mother pouring scalding water from a kettle, and that huge Turloc O'Connor firing people all over the place like sacks of potatoes.

You know something? I honestly believe that those people *enjoyed* fighting. They forgot why they were fighting, if they had a cause it was buried. It was an atavistic and disgraceful exhibition.

I left them to it and went into the hills to lie on the heather and think.

I did *not* have Sarah Maloney in my play. Of course I knew about Julie. Would you think for a minute that I would put the story of her tragedy in a play? Well, the story yes, why not? There are about two thousand illegitimate children born in this country every year. It provides legitimate material for an author. But as far as I'm concerned one bastard is just the same as another. It's only the *idea* that is important. Are you to say nothing at all, just in case you might

by accident hurt somebody else? Isn't it the duty of an author to explore all things in life, like a surgeon to open up and display something diseased and cure it?

Me having an interest in Julie? You mean a love interest? Nonsense. You know where I am going and how far. How could this girl keep up with me? I admit she is very good-looking and has a sharp intelligence, but my sole purpose in keeping company with her was to sharpen her mind, to *educate* her intelligence. I spent a lot of time on that girl. But latterly I could see that she was attracted by Turloc O'Connor. You see, this is interesting too. He is a big man. Some people might think he is handsome. But what else has he? Hair on his chest, I suppose. This is the terror of life the way pretty girls are attracted by ape-type men.

You think he has a fine mind? Turloc O'Connor? Well, at least I am glad to hear that he has a mind at all. It was something I wasn't aware of.

I have come to the end here. How could you expect someone like me to settle down here among people like that? Commonplace, ordinary as weeds.

Am I the first artist to be vomited out by a community? If they don't want me then they won't have me. It is their own loss.

They can bewail that loss over the years.

I have a little money now, from royalties. I can go where I like. And believe me, I am going. I have had appreciative letters from my mother's people in America. I will probably go over there. At least they understand the mind of the artist. They will appreciate talent, and what is more they will reward it.

Oh, indeed I have my bag packed. I fully intend to shake the dust of Bealnahowen off my shoes, and if you are going back, why can't I go with you? I see you have a car out there on the street. There is no time like the present.

I don't mind what divergencies you have to make, I will go with you. My mother? I suppose she is in the fields helping my father.

No, why should I wait? There would only be tears and lamentations. I will write to her. She will understand.

Why wouldn't she understand?

Isn't she my mother?

A Talk in the Dark

I T WAS A very dark night. The sky was lighted only by the stars. I sat in the nook on the top of the quarry. If I looked over the lip I knew that I would see the water, black and awesome, sixty feet below me, faintly reflecting the stars.

I knew this place well. When I was young, and unafraid, several of us had tied together a few old railway sleepers, and on this frail raft had ventured on the water in the quarry. We could not swim. We knew there was a great depth of water under us and if the raft toppled we would probably die. We thought that added spice to our daring.

I did not feel this way now.

My hand was up to my mouth and I smelled tobacco from my fingers and got a craving for a cigarette. Why I should crave for a cigarette at a time like this, I do not know. I felt in my pockets. I had a packet with me, a crushed packet but I opened it by touch. I held the one cigarette in my hand and threw the packet from me. I heard a slight rustle from it. I could see it in my mind, falling to the water and resting there, slowly becoming sodden.

I had a box of matches. I took one from the box and was about to strike it, when I heard the sounds. I listened. It was a very still night. There was no wind at all, not even a stray one. It was late September. It was not cold. I listened closely.

It was the feet of a person, I could swear. The land around the

quarry was rocky, naturally. But there were many tufts of grass amongst the rocks. I could trace this person coming as if it was broad daylight and I was up there watching. They weren't the sounds that would be made by the feet of a man. They were woman sounds. And not old, but the footsteps of a young one. You can tell these things, particularly now when my feelings were so sensitive.

I pulled well back into my nook below the top. I looked up at the star-lighted sky. This way I saw the figure of the girl. I was looking up, you see. She was looking down. I couldn't see her face, just the shape. I knew the hair was falling around her face as she looked down. I knew she was slim, and long-legged. Although this could have been a delusion on account of the way I was looking.

If I was deluded about that, there was one thing I was positive of: this girl was going to step off the top into the water of the quarry. I had no doubt about this.

I said: 'Don't do it.' Quietly I said this, just quietly, and I knew I was right when she didn't start or scream or show any movement whatsoever. You see, the mind of this girl was gone beyond fright.

I knew she had heard me. She was holding herself tensed. I thought maybe she thinks I am not real, that she just heard a voice in her head.

'I am here below you,' I said. 'You cannot see me. I am looking up at you. Don't do it.'

'Who sent you?' she asked. 'Somebody sent you. Did my parents send you?'

I tried to analyse her voice. I knew I had to be so careful. Her voice was young, but it was dead. She didn't care, you see. She had no interest in this strange happening.

I thought wildly that the chances of this meeting occurring like this would be millions and millions to one.

'No,' I said. 'Nobody sent me. I am just here. I do not know your voice, so how could I know your parents?'

'Somebody sent you,' she said, deadly, sullenly.

'Can you swim?' I asked.

'No,' she said.

'I can,' I said.

She thought over this. 'Oh,' she said then, and sat down on the ground. She didn't really sit down, she seemed to drop there.

'It is dark,' she said then, 'you might not see me down there.'

'I think I would,' I said.

'It will do again,' she said.

'Oh, no,' I said. 'Just persuade me.'

'What do you mean?' she asked. There was faint interest in her voice.

'Tell me why,' I said. 'If it is very valid, then I will let you go.'

'You mean this?' she asked.

'I swear, by God!' I said. I said it savagely. I saw her head turning in my direction, but she could not see me.

'My parents are very good people,' she said. 'There are no better parents in the world. I mean they are good. Good is good, you see, really, really good.'

She was silent. She was thinking over that.

'I am their only child,' she went on then. 'I am going to have a baby. I am seventeen.'

'They do not know?' I asked.

'They know,' she said. 'I told them. I have always told my parents everything.'

'And they said?'

'They said nothing,' she said. 'They said nothing. I see their faces. Their faces are full of love you see, but they said nothing. They just sit and they say nothing. There is nothing they can say. My father, he could beat me, but all he does is put his hand on my hair and he cries. My mother says nothing. She is good you see, really, really good.'

'And that is why?' I asked.

191

'Yes,' she said. 'I do them a good service. I kill me. Their faces will not change. They won't know a deeper sorrow. This is the way.'

'There is someone else,' I said.

'Who?' she asked.

'There is the father of the child,' I said.

She laughed. I didn't like this laugh.

'I don't know him,' she said. 'I am good, you see. I break away from my parents who are really, really good. Some few times. We play away in this game, on Sundays, and we dance after the game and we drink, and I'm not used to drink, and we put out the lights and we kiss, and we wander on the beach, away from the bonfire and the bottles and I don't remember. I don't even know. I just think I have a sick stomach afterwards. You see. Like you take stomach powders to settle a pain.'

'You will kill the child too,' I said.

She was silent.

I struck the match on the box.

'Look at me,' I said. I knew she would. My eyes were blinded by the light. I put the cigarette in my mouth and lighted it. The match went out. 'You have seen me?' I asked.

'I have seen you,' she said.

'Do you know me?' I asked.

'Yes,' she said. I was hoping she would. After all, it was a small town.

'I don't know you,' I said. 'If you know me, you know who I am, and what I am. You know that I am married for about ten years and that we have no children.

'I think I know this,' she said.

'I want a child,' I said. 'Give me your child. Don't kill it.'

I heard her drawing in her breath.

I talked on. 'You and my wife can go away together, anywhere,' I said. 'I am a moneyed man as you know, and when you come back my wife will have the child. Don't kill this child.'

'You are mad,' she said.

'I know,' I said. 'Why do you think I am here?'

She was silent. I let the thought sink in to her brain.

'It cannot be,' she said. 'It would be too strange.'

'Truth is very strange,' I said.

'Why?' she asked.

'Because I killed a child,' I said.

'You are trying to confuse me!' She almost shouted this.

'No,' I said. 'Read the papers six months back. Only a small account. A four-year-old child rushes into the road, right in the path of a car. The child died. That was me.'

'Oh, no,' she said.

'Yes,' I said. 'The poor father. He carried her in his arms and she had fair curly hair and blue eyes and there was blood coming out of her nostrils. I knew from the way her head dangled that she was dead. Not my fault, they said. That poor father nearly apologised for his child running in front of my car. They nearly gave me a medal for killing this child. And it was my fault. I could have saved that child. I know I could have saved that child. Every minute of every night I see this child. She is my constant companion. I could have saved her. They exonerate me. They blame the child's death on herself. This is an outrage. I killed this child.'

'What about your wife?' she asked.

'Ah,' I said.

'Do you love her?' she asked.

'Yes,' I said. 'But she is good. She is really, really good.'

I heard her sucking in her breath.

The night was silent then. The cigarette was burning my fingers. I flicked it away. It sparked a bit as it described an arc. I could feel we both waited for the sound of it hitting the water. How could we hear a sound like this? We heard nothing.

The girl stood up. She stood up straight.

'Well,' she said, 'you killed a child; you have saved a child.'

I waited.

'You hear this?' she asked.

'Yes,' I said.

'I will carry my own cross,' she said.

'You have taken the weight from mine,' I said.

She didn't say goodbye. She just turned and left.

I heard her crossing the field. All the way. I heard the sound of her heels clearly on the tarmac of the road. I couldn't mistake this.

I took up the small .38 pistol. I had a licence for this. I kept it to protect my money. I never used it. Once or twice for target practice; once aiming it and firing at flying wild geese on the lake.

It made a loud splash as it hit the water. You see, I swim well and that was why I needed it.

I got out of the nook and I stood on the bank. All at once I was as cold as death. All my limbs started to tremble. Now I was deeply afraid that I might fall from the top into the waters of the quarry. I was filled with panic. I got to my knees and hands and I crawled away from there like a sick dog. I was shaking like the leaf of a silver birch, but I got to my feet and I tottered towards the road, and all I could think then was: not who sent me, girl, but who sent you? Just tell me that! Who sent you?

My Neighbour

I SAW HER first in early April. She was riding a bicycle. She was thin, her hair was pure white and she wore one of those knitted suits, light brown, and big beads around her neck.

I was at the front door of the new house. It was a sunny day. I was sitting on a stool smoking a pipe after the meal. I was going back into the fields shortly. I was planting spuds.

This new house was on a hill. Then below was the road, and on the other side was the old thatched house that had been there longer than the memory of any living person around, which was why we had left it and built this new cottage on the hill. Even from where I sat you could see over the roof of the old house, and survey the great waters beyond.

She passed on the road and went out of my sight. I wondered a little about her. You don't often see ancient ladies riding bicycles, not around here anyhow, since most of the foreign settlers have motorcars.

I was about to knock out the pipe and go back to the fields, when she came back. She got off the bicycle, leaned it against the wall, and then fumbling at the wooden gate, she opened it and went into the place. I couldn't see much of her after that, because the house was surrounded with thick fuchsia hedges that were coming green. I didn't move. Five or ten minutes later she came out of the gate and closed it after her. Then she went to the bicycle, looked around

her, hesitated, finally looked in my direction, left the bicycle and came to the gate below.

'I beg your pardon,' she said. You could tell she was English. She had a hooked nose and deep-set eyes, and a long face. I said nothing.

'Could you please tell me who owns the vacant cottage?' she asked.

I thought over this. It is not our custom to give information to strangers without thinking over it.

'Well, it could be me,' I said.

She waited for more. She didn't get it.

'Well, is it or isn't it yours?' she asked a little impatiently. It was easy to see she didn't know our ways. She should have talked about anything but the house for a while, the weather and how we were and were cattle sales good this year, things like that, and then just bring the house in much later as a sort of afterthought.

'Well,' I said, 'I lived in it and my father died in it and my mother and their people as long as memory goes back, so I suppose it must be mine.'

She thought over this. She then tried to smile. It came hard on her. Somehow, even then, her face seemed sad to me.

'Ah, I see,' she said. 'It's your sense of humour. I wondered very much if I could see the inside of the house.'

I was going to put her off. It was all too abrupt. Say, which was true that I had to go back to the fields, and to come back later, but she looked frail, and it would mean a long cycle for her again, so I rose up and said: 'I'll get you the key.'

'You will,' she said. 'How kind of you!'

What kindness was in that, I ask you?

My woman was at the new steel sink washing the dishes. She was proud of this and the flowing water from taps. Still new to her you see. 'There's a lady wants to look at the old house,' I said.

'She's welcome,' she said. 'Anyone can look at it as long as I don't have to look at it.'

I took the key and went out to her.

'The weather is soft and beautiful,' she said. 'Are the winters hard?'

'Sometimes,' I said.

I unlocked the front door of the old house. It needed paint. So did the windows. They were dusty and spider-webbed. I opened the door. It was clean enough. There was dust on the floor flags, some green stain on the walls from the leaking thatch. The walls could be whitewashed. The big open fireplace smelt of soot washed down by the rain. There hadn't been a fire in it for months. I showed her the bedroom above the fireplace and the room at the other side. I thought she was one of these ladies who go around seeing how people lived years ago.

So she surprised me.

'Would you rent this little house to me?' she asked.

I goggled at her.

'Ma'am,' I said, 'you have no notion of what you are asking. Do you want it for somebody to live in it?'

'I want to live in it myself,' she said.

I said: 'But there is no water, it has to be hauled from below. There is no whatyoumaycallit, toilet. The house is damp, it would need great fires. Do you know what you want?'

'I am quite willing to accept the inconveniences,' she said.

'I had no notion of renting it,' I said. 'I intended to turn it into a stable or tear it down altogether. It is only fit for cattle now or a few pigs.' I meant this. She looked like a lady with delicate upbringing. The thought of her living here was funny.

'How much would you ask in rent for it?' she persisted.

I thought over it.

'Would ten shillings a week be too much, then?' I asked.

I could see her calculating. This meant that she was a rich woman who wanted to make a bargain, or she was tight of money and could not afford it.

'Would eight shillings be better?' she asked.

This came hard on her, this bargaining, I could see, so even if I was wrong I decided she hadn't much money.

'You are making a blunder,' I said, 'living in a place like this.'

'No,' she said. 'I think it is lovely.' She looked out the front door. The ground sloped to the water that was blue coloured now from the sky. You could see the clouds reflected in the water. There was no wind. 'It is like a place I have been looking for all my life. It is peaceful and lonely and tranquil.'

She didn't know how unpeaceful and violent it could be.

'All right,' I said.

She came every day after that on her bicycle. I found out she was living in a house in the village, not in a hotel. She had long thin hands, and she used them to whitewash the inside and outside of the old house. I watched her. And then one day the train van came with furniture. It was good furniture. It wasn't three-ply wood, but dark polished stuff. There wasn't a lot if it. It had come all the way from England.

It only took her about two weeks to get settled in there.

That was how I came to have Miss Blair Forsythe as my neighbour.

I know you are supposed, even commanded to love your neighbour, but mostly all your neighbour wants you to do is mind your own bloody business.

It was this way with Miss Blair Forsythe.

I don't know why she preyed on my mind like a bad summer. I never interfere with anybody. If people want help and I am asked, I will help, widows or orphans, sudden deaths, wakes, funerals or weddings. I keep my own nose clean.

My wife said: 'I've never seen you like this. You'd think Miss B.F. was your old mother. Leave her alone. She doesn't want you.'

'She wants somebody,' I said. 'You think of it. You are a widow or an orphan or you are out of work, somebody gives you a few bob, the State nowadays. But who gives this old one anything?'

I knew what she was getting. She got a letter once a month from a bank. I know that. The postman and myself examined it. I knew what she bought in the village once a week. She bought tea, sugar, butter, eggs and about a pound of meat. She bought flour so she baked her own cakes. I supplied her with a pint of milk, every TWO DAYS. I cheated there because I always slopped more than a pint into the jug she brought to the door. She paid for it every time she came from a little purse she had in one of her drooping pockets.

You take the winter. It was a right dirty one. It was cold and wet and windy. The east winds that blew in over the water would cripple you. Yet she had no fuel for her fire. I know. What did she do? There was a stand of scrub to the left of the old house and she went in there and she cut branches. Not with a bush saw. She hadn't one of these. She had one of those squat saws that butchers use to cut meat. I would go down there and observe her hacking away with this useless implement for hours in order to make a thin smoke appear out of the chimney.

So I did something. I cut down several willow trees in my own woods, cut them to manageable size and I went and dumped them inside her gate, at night when it was windy and she wouldn't hear.

She was up at the door the next morning.

'Somebody left wood inside my gate,' she said.

'I know,' I said. "I had a few fallen willows that I cut up and I thought you would have more use for them than me. They were rotting away in the wood.'

'I am very grateful to you,' she said, reaching for that horrible little purse. 'So grateful, and I insist on paying you for the wood.'

'I don't want payment,' I shouted at her. 'You will be doing me a favour by burning the cursed stuff.'

'You are very kind,' she said in a determined voice, 'but I will take nothing without paying for it. Will five shillings cover the cost?'

'I don't want payment,' I said. 'You are doing me a favour.'

'No,' she said. 'I insist. Please take the five shillings.'

She made me take the two half-crowns. She had a strong jaw.

'I'm so grateful to you,' she said and went away with her bent back. You should have seen how the long thin hands had changed. They were hard and cracked and wrinkled.

When she was out of sight, I flung the two half-crowns from me as far as I could. They sailed away into the bushes.

'Some day,' said my wife, 'you will be down on your knees searching for them with a torch.'

'She gives me those,' I said savagely, 'she has to go short on food. Do you know that?'

'It's her own life,' said my wife. 'She wants to be independent.'

'She can kill herself with independence like that,' I shouted.

'That's her privilege,' said my wife.

'Well, she's not going to,' I shouted at her.

I got the minister to call on her. That was no good. He didn't belong to her church or something. But she gave him scones and some of her precious butter. Other people called on her with baskets of fruit and things like they do, calling gifts. She called right back on them with calling gifts too, and probably had to deprive herself in order to do so. You see. So they stopped calling out of charity.

What are you going to do with a woman like that?

And then the letters from the bank stopped coming.

I knew she was in serious trouble. I even went to our own priest. He had a little fund that helps out with people like her. He called on her. He got nowhere. She wouldn't be helped, you understand.

I left a basket of groceries outside her door. It contained everything she would need for two weeks.

Right? Like the firewood, she called with the basket in her hand. She could hardly carry it. She was furious.

'Who is doing things like this?' she asked. 'Do they think that I am a subject for charity?'

'Maybe it was the fairies,' I said.

'Was it you?' she asked.

'No,' I lied.

'Whoever it is I wish they would stop,' she said. Her face was gaunt now. She was thinner.

She got out the bicycle and tied the basket on the carrier and off with her to the priest.

This is what she said: 'I'm sure you have some poor people in your parish. I would be obliged if you would distribute this among them.'

People got fed up with me. Even in the pub when they would see me coming on a Saturday night, they would drink up and move away to another pub. They knew I couldn't stop talking about her.

'She'll end up in her grave,' I would shout at my wife.

'You'll end up there before her,' she said, 'if you don't stop tormenting yourself about her. Leave her alone.'

'Would you like to be left alone like that?' I asked.

'No,' she said. 'But she's different to me. If this is the way she wants it, this is the way it must be.'

'It is not! It won't happen! If I have to spoon feed her with soup, it won't happen. Isn't she my neighbour?'

But of course it happened. One day in April, there was no smoke at all from the chimney. And a second day. I left it no longer. I went to the house.

We have her now, I thought. She is sick, and there is nothing she can do about it. She will be taken to hospital and kept there and fed whether she likes it or not. I was even gleeful about it.

I knocked loudly on the door. There was no reply. I tried the latch. The door was bolted on the inside. I knocked again and again and listened for a feeble reply. I knew she would be in bed in the far room.

I waited no longer. I went to the village and I got the policeman and the doctor, and we went out there in the car.

I knew how to open the bolt from outside. I had done it often in the old days when I would be late out at a dance and the old man would bolt the door on me. He never knew how I got in through the bolted door. It perplexed him until he died.

She was lying back on the bed, composed, and she was dead.

There was hardly a wrinkle on the bedclothes. There wasn't much of her under them. Her nose jutted out proudly like the prow of a sailing vessel.

'She is dead,' the doctor said. 'We'll have an autopsy, but I can tell you now, she died of malnutrition.'

'She did not,' I said. 'She died of pride. You hear that, common or garden pride.'

'It isn't common or garden,' the doctor said, 'if she died from it.'

'Well, that's the way I see it,' I said.

'S-s-sh, for God's sake,' said the policeman. 'Let you respect the dead and not be shouting.'

They couldn't understand this.

Even my own wife.

'She died of pride,' I said.

'Who's pride?' she asked. 'Yours or hers?'

Isn't that stupid? Don't women say the most stupid things? Isn't it a pity we can't beat them?

Jane is a Girl

HE HASTILY GULPED the tea remaining in his cup, grabbed the piece of bread and jam from his plate, started to stuff it into his mouth as he rose from the chair, and was stopped by his mother's voice: 'Sit down! Where are you going?' and as he went to answer: 'Don't talk with your mouth full!'

Jude thought she was most unreasonable.

'Now?' she queried, when she saw he had swallowed the bite.

'Out,' he said.

'Mother,' she said automatically.

'Mother,' he said.

'Be in here at eight o'clock,' she said. 'Not a minute after. Don't have me chasing you or you'll feel the weight of my hand.'

'All right,' he said, moving.

'Mother,' she said.

'Mother,' he said.

'Will I ever put manners into you?' she asked the ceiling.

He was going to go out the back way into the yard from the kitchen when he stopped and thought. Then he turned and ran up the stairs. He went into a room there. His big brother was in front of the mirror brushing his hair.

'Give us a tanner, Joe,' he suggested.

'Get out of here,' said Joe. 'I want all my tanners.'

'Spending them on old girls,' said Jude.

203

He banged the door and ran. Joe didn't chase him. At the foot of the stairs he went into the other bedroom. His sister screamed. She wasn't half dressed.

'How dare you come into a lady's room without knocking,' she said, hurriedly covering herself.

All the stupid fuss what about, Jude thought. 'Give us a tanner, Nora?' he asked.

'What do you want sixpence for?' she asked. 'Don't use slang.'

'Sweets,' he said.

'I can only give you tuppence,' she said. 'It's all I can afford.' She reached for her handbag.

'Oh, all right,' he said, holding out his hand.

'Go and wash that dirty hand,' she said, putting the pennies into it.

'All right,' he said. 'You smell nice.' He just said this to please her. He didn't like all the scents. His brother used brilliantine on his hair too. That wasn't too bad.

'Close the door after you,' Nora said.

He did so, and went to the sink in the yard and washed his hands with the big bar of white soap. He didn't want to go back into the kitchen for the towel so he just went out the back way shaking his hands to dry them.

He went around the corner into the small market place. There was a shop here. It was a private house that they had turned into a shop. The small window was packed with fruit and sweets in glass jars and advertisements for tobacco. Jude looked in the window. He had to get up on his toes in order to examine them closely. The prices were marked on a piece of cardboard with a puce pencil. He decided on bull's-eyes which were eight a penny. Each one, uncrunched, lasted for five to ten minutes giving an overall life of 160 minutes. That meant nearly two hours of minty sweetness if you didn't give any away except four at the most.

He went in. There was nobody in the shop. He knew they could

see customers through the pane of glass in the door, but since he was below vision, he coughed so they would know he was there. He liked the smells in the small shop; fresh bread and bags of meal.

The tall lady came out. He told her what he wanted. She counted them out, exactly, and put them in a small paper bag. She twisted the neck of this bag as she gave it to him, saying: 'Don't eat them all before you go to bed. They'll give you a pain in your stomach.'

He didn't answer her. She was trying to be funny. Funny idea of funny they have, he thought as he went out. She thought as she went back to the warm fire and the book she was reading that children nowadays didn't seem to have any sense of humour.

Jude took one from the bag and put it under his tongue. This was the best way to make it last. He went back to his street. It seemed empty, houses on one side facing houses on the other side, their front doors opening on to the pavements. The people were hidden behind lace curtains and geraniums in pots. It was a Sunday evening in March. There was quite a cold wind blowing up from the eastern end of the street, stirring cigarette packets in the gutters, and wisps of hay, sweet papers and orange peelings.

Jude hoisted himself on the wide window stool of one of the houses. He knew this was a house where they didn't mind you sitting on the window stool. Others did. They would roar at you, frightening the life out of you if you weren't anticipating it.

He now shifted the sweet from under his tongue to his cheek and made it bulge there. He knew this would attract custom, because although there didn't seem to be a living soul inhabiting these houses, there would be small eyes watching the street.

Sure enough, one by one the youngsters started to come out.

He needed four principals to use his sweets on. There were several games they could play. Caddy and marbles were not in season, so it would have to be rounders at the four corners where one street bisected the other, or maybe tig, or green gravel. On the whole he decided they would play hurling. It was more exciting and

205

would warm him up on a cold evening, so when Jane came out of the house, he took the bag of sweets out of his pocket and looked into it. That brought her. 'Have a sweet,' he said, handing her one. She took it, so he knew she was enrolled. Pat Fane, Jonjo, and Tip Heaney were the other three, so they leaned against the wall, sucking carefully at their sweets. Some of the smaller children also arrived, and sat on the kerb or stood with their hands behind their backs, looking, and their mouths watering. Jude knew this was slightly cruel, but how could he dish out sweets to all of them?

He got off the window stool, felt the sweet with his tongue, knew it was almost finished, so he crunched it to bits with his teeth and said: 'We will play hurling.'

They considered this for a moment, and then they ran. He ran himself down the street, around the backs of the houses, into his own yard where he picked up the hurley stick and the soft rubber ball. When he got back to the street, the others were scurrying about. His own hurling stick was in good shape. The boss had been broken but he had repaired it with the band of tin that came wrapped around fruit boxes. Jane had a good hurley stick too, better than his own. The others had makeshift hurleys, that were mostly bits of sticks with a crude curve at the end, but they were well used and as precious to them as if they were due to play in an all-Ireland hurling final.

He picked his team. He took Tip Heaney who was the biggest of them and a bit rough, while Jane had Pat Fane and Jonjo. They divided the small ones up between them then. The boys took off their coats and put them on the ground to act as goalposts. They sent two of the smallest to each end of the street to watch out for the police, because at this time some of the people took to talking in the Council about the way you couldn't walk the streets of the city without being belted with balls or knocked down with racing kids. Hadn't they homes to go to or the wide spaces of the municipal playing fields. All that stuff, so you had to post sentries.

Jane and himself put the ball in the middle of the street. Then they hit their hurleys on the ground, as they shouted ONE, clashed them three times and then scrambled for the ball. The game was on. It was vigorous. It was interrupted once or twice when irate mothers ran out to take their children's best Sunday clothes from the dusty road, brushing them angrily, and shaking their fists before departing. They replaced the lost goalposts with rocks. Once the ball hit a window and all of them stood like statues waiting for the result, ready to run if the reaction was hostile. Nothing happened so they continued with the game.

Jude's side was being defeated. The combination of Jane, Pat Fane and Jonjo was too powerful. Jude himself was fast and slick, but Tip was too slow and heavy, and even the little tricks he used like putting the hurley between his opponent's legs to trip him were unavailing in the end.

So they had to take to argument. It was a goal! It wasn't a goal! It went outside the stone. Didn't it? Yes it did! No it didn't. You stupid idiot, are you blind? The veins on their necks standing out as they tried to outshout one another.

This led to a lot of heat and a lot of vigour. It developed into a furious struggle between Jude and Jane. Each time the ball came to them, they slashed and heaved and threw their bodies at one another until one got the victory and belted the ball away. Sometimes Jane won these struggles and sometimes Jude won them and they glared at one another like animals. Now! See! I told you! Jude had cuts on his knees and Jane's stockings were torn. They were egged on by the others. The street was a canon of shrill screams and shouts being deflected into the sky.

This last time, the ball was in the air, and they were pressing together looking up, watching its descent. They raised their hurleys to catch it. It came down between them, their legs interlocked, the ball escaped and Jude fell on top of her.

Now as he fell, shouting, he put out his free hand to save himself

and pressed down on her breast. His forehead was practically touching hers. He could see her wide eyes and the bead of sweat between her eyebrows and her white teeth snarling at him from drawn back red lips.

Something happened between them. He saw her face changing as she looked up at him, the excitement dying out of her eyes. He was conscious of feeling different inside himself. This game he had engineered no longer mattered. He was suddenly very conscious of his hand on her breast and that the shape of her was different from his own.

This is when it came into his mind: Why, Jane is a girl! Jane is a girl! He was suddenly embarrassed. Her face was red from exertion before. Now it seemed to him to get redder. He took away his hand from her as if it was scorched and got to his feet. She got up too. She avoided his eyes, brushing down her dress, fiddling at the tears in her stocking.

Jude couldn't stand this any longer. He turned and walked away from the field. They were stunned. They called after him: 'Hey, Jude! Jude! What's up! Where are you going? Hey, Jude!'

He was in an agony of embarrassment. He was upset. He wanted to run, but this would look bad. Instead he took the bag of sweets from his pockets, looked at it, and threw it towards them. The bag burst and the sweets flew all over the place. They stopped calling then and scrambled for the sweets, laughing. Jane didn't. She had gone to the path and stood there with her back turned. Did she feel the same, he wondered? Did she say: Why, Jude is a boy!

He went in the back way to his house. He put his hands under the tap. He filled his palms and sloshed the cold water on his face. His face was hot. Under his short pants he had many small cuts from the gravel of the road. He washed the blood from the knee cuts so that his mother wouldn't be fighting about them. Then he went into the kitchen. There was nobody there. He sat on the wooden stool in front of the fire, rested his elbows on his knees, his

chin in his hands, and he thought. Why should it be different he wondered? What difference does it make? Now he could see that she had long hair, that she wore dresses, that she was good-looking, but she was a Girl. Wasn't she always one? What was the difference now? Now that he came to think of it Pat Fane was also a girl, and she had fair hair.

'Are you sick, or something, Jude?' his mother asked. 'Sitting there gazing into the fire. Why aren't you out playing?'

'No, why?' he said.

'Mother,' she said.

'Mother,' he said.

'There must be something wrong with you, when you are that quiet,' she said. He thought he might tell her. But then he didn't. She was always very busy. She mightn't have time to think of it, how important it was. She sat sewing, quite content at that and listening to the wireless. There was a knock at the front door and she put down the sewing and she went to answer it.

His sister came down to the kitchen now, ready to go out. She was all dolled up.

She looked at the silent boy.

'What's wrong, Jude?' she asked.

'Jane is a girl,' said Jude, thinking, she will understand.

'Say that again,' she said.

'Jane is a girl,' he said.

'Well, what did you think she was, a rhinoceros?' she asked.

Oh, God, Jude thought, I made a mistake telling her.

'Hey, Joe, Joe!' she was calling, 'come here until I tell you!'

'No, no!' pleaded Jude.

'Hey, Joe!' she called. Then she was laughing.

Joe came down the stairs, fixing his tie.

'Guess what?' she asked. 'Jude has just discovered that Jane is a girl.'

'What? At his age? Not even twelve,' said Joe.

'Say it for him, Jude,' said Nora. 'Jane is a girl he told me.' She laughed, Joe laughed.

Then she was calling his mother.

'Mother, come here until we tell you what Jude said.'

Jude fled, his face flaming, out the passage, into the yard, out the back across the street and up the lane, a narrow one, that led away, towards a green field, as if he was being pursued. Up this and over the low wall and he threw himself on the grass. Nobody could find him. He turned on his back and looked at the sky. It was darkening already. There were colours around its edges.

They don't understand, he raged, gripping the grass with his fingers. Why wouldn't they understand? How could you make them understand and not to be laughing? He remembered going into his sister's room for the pennies. She had covered herself up. Now he turned on his face and pressed it into the grass. She was a girl too, see. Before it had made no difference. Now things were changed. They would never be the same. Never again.

The Dreamer

EVERY COMMUNITY HAS a quota of queer citizens. The most
peculiar person we had living in our street was Joe the Gent.
I don't know what definition 'gentleman' is given in dictio-
naries, but down where we lived a gentleman was somebody who
didn't work for a living like the rest of us, and Joe was certainly
that. He lived on his mother at No. 47 St Coleman's Terrace. She
kept three lodgers and Joe. His father was a stoker on a ship that
was blown up on a mine in some war or other, and I don't think it
was true, as some people asserted, that Joe's father was living with
coloured ladies on some Pacific Island, because he was horrified at
having sired Joe and fled when he got the chance. This couldn't be
true because Joe's mother is a very nice lady, clean, hard-working
and the only blind spot she has is Joe. She would move the stars for
him. Night, noon and morning she worked to clothe Joe, and to
send him to school and afterwards to the secondary school and she
would have sent him on to University but by that time Joe thought
he knew more than anybody in the world and it would be a waste
of a great brain to have a bunch of morons trying to teach him
things that he knew better than they.

It was very galling for us to rise every morning at seven, gulp
down our breakfast, rush into the bleak winter winds, smoking a
cigarette, and nipping it as we went to our work at hewing wood
or emptying coal boats or building houses or mixing mortar or dri-

ving dust carts, or mending shoes or driving nails, and to know that when you had half a day's work done at twelve, Joe was at home in his bed, stretching himself. His mother brought him his breakfast in bed at eleven; at twelve he stretched himself, as I said, rose and shaved carefully, put on his shirt with the freshly pressed collar, paused to decide which of the two suits he would wear, dressed himself and came down and spent another half an hour doing his nails. This is as true as God. Then when the unfortunate lodgers were due home at one for their dinner, Joe would amble out into the street and walk down by the Docks maybe or out by the sea, until the poor slaves were finished and gone back to work. It distressed him, Joe said, to see them feeding like animals, without delicacy. Joe had a good stroke himself, but naturally not as good an appetite as he would have if he was doing anything.

Afterwards he would draw the blinds halfway on the front windows and sit at the table composing poetry. All the street then knew from the blinds drawn down in the middle of the day, that Joe was at work; the great brain was ticking over. It was very funny. His mother thought Joe was a genius of course and if any neighbour called at the house during the time of gestation, to borrow the loan of an eggcup of tea or an egg or a grain of sugar that they had run short of, Joe's mother would shush them and make them talk in whispers as if somebody in the house was dying from a disease. I tell you that Joe wasn't very popular in our street, but everybody was polite because they liked his mother and didn't wish to hurt her feelings by telling the truth.

And another thing! People didn't know but Joe might be a bloody genius instead of the lazy fool he was and they wanted to play safe. Also Joe was very good at spreading little ballads about that could shame better men than himself, like the time he wrote the one about the Duck. There were umpteen bad verses, but this one will show you:

'Quack-quack,' said the Duck, 'I see a sight

A hairy man like a water sprite
Come swim to waters better suited,
For the water here is now polluted.'

and all this because one night I was coming home having had one or two drinks and on a bet I tried to walk along the railing of the canal and it was icy and I slipped and fell in, and then at the time, I used to wear a small thin moustache, that I thought looked all right, it went with my face sort of, but I had to get rid of it when they started to call me Hairy. I knew damn well they were calling me that behind my back and who had started it and all because I wasn't in the least bit in awe of Joe the Gent and told him that to his face not like others.

Anyhow.

I want to tell you about Mary Clancy. She had hair that wasn't red and it wasn't brown, and it was curly and short on her head and she had a square chin and we all thought she was very good-looking, but she had a very sort of determined mind of her own. You always seemed to see her standing with her legs spread and her hands on her hips. Very nice hips, and she was tall and straight. I'm over six foot and when I am standing near her I could just kiss her forehead, if I had the nerve, but I wouldn't because I'd immediately, I am sure, get a puck in the belly. When we were all young she was a real tomboy. She was up to everything. No feminine fripperies about her I can tell you. In fact I often thought that she was exasperated because feminine appendages had been bestowed on her. They only seemed to get in her way, like. Anyhow one day we all look and she has grown up and there you are. She is very beautiful in our eyes, and one or two of the boys tell her so and rush it a bit. It became a cant in our street, if you saw one of the fellows with a black eye or a swollen nose you would say: Oh, I see you were out with Mary Clancy last night.

So you see she could now get most things she wanted just by realising that she was a beautiful girl, where before she got it by force.

Still she wasn't lazy. She worked hard at her job in the town, and she kept her father and mother and her brothers and sisters up to scratch. That poor old man! There was no chance of him slipping into a pub on pay night and using it all up on the demon rum. The one time he did it, he was hauled out neck and crop and the innocent pub keeper got a bottle broken over his head for perverting the common man. I don't believe there was any truth in the story that the whole family were making novenas that Mary be taken away from them mainly by matrimony, but if necessary by an act of God.

You may think I'm bitter, a little, about Mary, but I'm not. I'm only sort of reporting this business. I admit I was cracked about Mary Clancy. I would have given everything I possessed at the time to have her marry me.

You see I always had a suspicion that Mary Clancy had cast her eye on Joe the Gent and found him good. You know why? Because the fellow hadn't an idea that she existed. All of us made a pass at Mary, but not Joe. Because Joe was a dreamer. Joe always dreamt dreams. You know this business about Dante and Beatrice. Dante was a poet too, Joe told us, but the inference was that he was only in the amateur class. But he was sound on Beatrice. Only true poets can love passionately without possession. And Joe had his Beatrice. In fact he had a succession of them since the age of ten. They always seemed unattainable. Their fathers were invariably rich men and lived in big houses up on the hill above the sea and they did no work and spent their time driving around in cars and dancing and party-going and things like that. The fathers, if they knew that a person like Joe the Gent was even dreaming about their daughters, would have called the police. But Joe didn't go near these girls. He just watched them from a distance. He sat on walls near their houses and watched them come and go, and languished in dreams about them. How do I know? Because Joe would compose poems about them and insist on reading them to us under the light of the street lamp on a Sunday night. I'll tell you this, there was no doubt that

Joe could put words together about these girls. Even though you didn't want to listen you would have to listen, and you'd be sort of panting about them, the way Joe could work on words. Often and often I would see Mary Clancy hovering on the funnel of the street light, just outside, listening.

She tried to be friendly with Joe. It was sad to see. She, so determined became sort of awkward. What would Joe do? He'd start correcting her speech. This is true. Why on earth don't you girls get rid of that frightful accent, he would say. Get the sod of turf out of your mouths he would say, and for the love of God articulate. Cover up your origins, he would say. You better be dumb than be mutilator. Get a bit of dignity. You, he said to Mary, are you a man or a woman. Keep your feet together. You might as well wear trousers. Don't stride like a cart horse. Walk daintily for God's sake. Look at the racehorse. Go and look at them. See the delicate way they move; the way they test the ground under their legs.

Wouldn't you think what I told you of Mary Clancy that she would have clocked him at this point. She did not.

Well, I finally got friendly with Mary. I worked hard at it. I avoided all the pitfalls. She let me take her to the pictures once or twice and I held her hand. She had long fingers. I kissed her cheek. Her skin was lovely and soft. I started to save some of my wages.

Then one day I asked her would we go for a picnic. I didn't know what a picnic was, except that you read about them, but I thought if we got out into a lot of fresh air away from the atmosphere of the streets that my cause would be more acceptable. She agreed, so I bought a lot of stuff, things, tins of stuff and such, sweets and things like that and I put them into a bag and I met her after last Mass. I met her away out of our street so that nobody would hear about this. It would look queer because I had a reputation of being a bit rough and that, because I was big and had been in a few rows with fellows and things like that and it would look queer for me to be seen going on a picnic with a little bag.

Anyhow, it was a nice sunny day and we set out. Tell the truth I felt a bit lost once we cleared the last of the houses. Lots of fields and trees and things like that. Like the jungle, it seemed to me. I never feel safe away from a lot of houses. I don't know how these farmer fellows live in such horrible surroundings, flies and things, all that and getting muck on your shoes, a waste of good shoe polish, I think. Anyhow, we seemed to be walking for miles and my feet were hurting and we came to this bridge over a stream with sort of trees, woods I suppose each side and I said: Here's here. This will do fine! and we clambered over the wall and into a sort of glade affair, grass and things and I emptied the bag and Mary set to, sort of fixing the stuff. Of course I had forgotten things like tea and such, but there was milk and a few bottles of stout for me and meat and cakes, and anyhow it tasted all right to me. Chocolate and porter goes well I think, and we lay back on the grass and I thought maybe this is all right, water over stones and sort of breeze in the trees and birds, lots of birds and I wondered how on earth the birds out here managed to live without the scraps from dustbins, but I supposed that farmers had dustbins too, and that was how they lived, and my hand met Mary's hand and I held it, and then I don't know what came over me, the strange surroundings or what but I turned over and practically pinned her to the ground with my body and I kissed her. Boy, I even remember that kiss now, and I could feel the length of her under me and I nearly went mad.

And then of course she blew everything up. She started to scream, and I tried to quieten her, but her hands were waving and I had to hold her hands in case I would get a puck in the gob, and I was saying, 'shush, for God's sake shush,' and she was screaming as if the Black and Tans were pulling out her fingernails with pliers and it's the most awful confusion and what do I see next but Joe the Gent coming over the wall and making for me. His face is full of dreams. I think, this scene is made to measure for Joe. He has been in action before. He has rescued damsels from distress before. He

has swum in shark-infested waters; floated on the sea in the rubber dinghies of crashed planes; climbed cliffs with bloody fingers, carrying the girl strapped to his back.

'You dirty bastard,' Joe is saying to me. 'You carnal monstrosity! If you had to pick on a girl to rape, why don't you pick on some of the idle rich, instead of a nice decent common girl like Mary Clancy!'

That's where the script went wrong. It was beginning to dawn on me that it was a script and that I was Joe Soap.

'Who are you calling common, you dirty little word-wagger?' Mary is asking him. 'How dare you come interfering with your betters, you lazy scut?'

It was the first time I had ever seen Joe the Gent with his mouth hanging open.

'What's wrong?' he asked. 'Wasn't that dirty devil trying to interfere with you?'

'That's his privilege,' she shouted. 'At least he works for a living,' she went on, 'not like you, lying on your fanny all day doing nothing so that you are beginning to look like a bag of tripe.'

I could see the back of her neck was red. And all because the poor dope called her common. He meant it different, I suppose.

'If I knew,' he said coldly, 'that I was interfering; that I had merely mistaken a cry of distress, for the love squeals of a slut; I would have stayed where I was.'

That did it.

She flew at him. He got a left uppercut and a right cross. It was like slow motion. First he was falling right and then he fell left, and his head hit a rock and while we watched, he slid over the bank and went into the river. It was a shallow river. The river accepted him just like any obstacle. It gurgled all around him. She screamed again. Then she ran into the stream and started tugging at him. He was out cold. She looked back and up at me beseechingly. What was I doing? I was laughing my sides out. Oh, it was lovely, lovely.

'Please, please,' she is saying, 'come and help me. Please come and help me, Hairy.'

'He's all yours, Mary Clancy,' I said. Oh the cute way she had fixed a picnic. The cute way we had arrived at the spot where Joe the Gent (on the other side of the bridge) usually communed with Nature every Sunday. Everybody knew the place. He told us often enough; the wood and the bridge and the stream and the green places. But not me. I was never good at geography. And then; I am made to hold her hand, and the indication of a hand can be made to incite, and there you are. I'm all set up to be a target for a dreamer, only the script went wrong. I laughed my way home. I enjoyed it so much that I never felt my feet scalding me from the country roads. And I left them there as I saw them last.

Sure, she married him. What do you think! When they really make up their minds that's that. What chance have you? Sure, he still writes poetry. Sure, he is still a gentleman. Sure he still gets up at twelve o'clock in the day while honest men have half a day's work done. She just carries on where his mother left off. And is she happy? Sure, she is happy. She even works for the fellow, and in my humble opinion his poetry is lousy no matter what everybody else says, and all I can say is that she deserves him.

Mary Clancy had her choice. She could have picked an honest, hardworking man. But she didn't, and that's that!

Three Witnesses

WITNESS 1 THE GIRL

THERE IS NO river that is not broken and tormented, somewhere in its length, before it meets the sea.

Indeed, the rivers around us, are only peaceful in pools since they come down from the hills and are always falling and whipped white with the hard rocks.

We don't regard those signs enough I suppose because they are always under our eyes.

I have only thought of them lately.

Our living was like the flow of a smooth river without waterfalls.

I have never wanted anything else but what I have. I was born here, just nineteen years ago. My mother died shortly afterwards. I do not even have a reflection of her in my memory. I see the old photograph of her in the long dress and the old-fashioned hair arrangement. She is smiling, but it means nothing at all to me, this yellowed print. My father does. I look at the photograph and think how little he has changed. He is a big tall man with the same curly hair and the fine white teeth. He points out to me the grey coming in his hair but I will not listen to him as I do not want him to grow old.

I have no brothers or sisters. I do not feel the loss of them. My father has always seemed like a brother and sister to me as long as I can remember.

I can never remember him in a temper. He has always been kind and gentle. He is just twenty years older than me because he married young, and we have nearly grown up together, you could say.

People have often mistaken us for brother and sister and this has always pleased him. I cannot remember a time when he was not near. When I would cycle home from school, which is six Irish miles from the village, he would be always waiting at the end of the small road for me and we would laugh together about the happenings in the school that day.

Later when I grew older and started going to dances, he would often be at these dances himself. He looked as young as anyone there, and he was a fine dancer. I often feared that a young woman would make him fall in love with her, and that he would take her into our house and spoil everything we had.

Once after a dance I had to wait for him while he walked home one of these young women. He had seemed taken with her. She was a good-looking girl with fair hair. I don't know why I should have felt strongly about this. If I loved my father well enough I should have been glad for a young woman to make him fall in love with her, and make him happy. I thought he was happy as he was. He saw I was upset as we went home that evening. He was laughing a lot and his eyes were bright. He knew I was upset. We had a sort of sensitive understanding with each other and before I went to my room, he put his hands on my shoulders and looked into my eyes.

'Do not worry,' he said, 'my dear Mary Ann. I believe that a person can only love once in their lives, and I have loved. Love is a thing that is as eternal as a soul. It is for ever and beyond for ever. You understand?'

'I think I do,' I said.

'You'll find out,' he said. 'Some day, but not yet, eh? Not yet?

We are having too much fun.'

I was happy again and laughing. 'That's right, father,' I said. 'We have more fun than anyone in the world.'

2

It was usual for us in the summer months to have one or two people staying in the house. We were a bit back from the sea in the hills, but they didn't mind that. Our cottage was small, just the kitchen and a small parlour room, with a bedroom near that, and on the other side two small bedrooms each side of the fireplace where my father and I slept. We would keep a married couple in the spare room or two ladies, or a single lady. They were city people and they always loved it because it was so different to what they had at home.

This year we had a letter asking if we could accommodate a person for two months which was a long time, and it was signed *Hilary Mallowe*. We were pleased, and we wrote back to Miss Hilary Mallowe telling her we did keep guests and she would be welcome for the months of July, August and September. My father and I had agreed that it would never do to keep a single young man in the house because it might give rise to a sort of scandal. I didn't see how this could happen but my father wanted this and it was a sort of rule with us. Sometimes I thought it would be nice to have a young man staying with us instead of all the spinster ladies and the married couples, but it wasn't important, really.

I remember this July day well. It was a fine day. The sun was shining. We got a lot of rain early on, and the fine spell started to come in about then. I was out in the back of the place throwing branmash to the chickens. That was why I didn't see the bicycle coming up the road. I thought I heard a knocking on the front door, but I wasn't sure. Then it came louder so I was sure, and I threw the rest of the mash to them and went into the house taking time to wipe my hands on my apron, and I opened the door and there was this young man standing there holding a bicycle. The carrier of

the bicycle was loaded with two heavy canvas rucksacks like you would see with soldiers. He was a tall slender young man. He was wearing thick horn-rimmed spectacles. He was fair and his skin was very clear, I noticed, and he smiled and he had quite a nice smile, so I smiled at him. I had to crinkle up my eyes and shade them with my hand because the sun was shining straight on top of us.

'Hello,' I said. 'Can I do anything for you?'

'I am Hilary Mallowe,' he said.

'Oh, no,' I said. 'You couldn't be. She's a woman.'

'Well,' he said, 'I am Hilary Mallowe, and if you regard me closely you will see that I am a member of the male sex. Even casual observation will assure you of the fact.'

'But,' I said, 'I wrote to Miss Hilary Mallowe.'

'Yes,' he said. 'I know. It will take a hell of a long time for me to live it down with the postman.'

'But, your name,' I said.

'Always masculine,' he said. 'Going back for many centuries. It is only recently that the name has been purloined by females.'

I had to laugh. It was really very funny.

'I was sure you were a Miss,' I said. 'I never thought. Forgive me. Won't you come in?'

He left his bicycle against the window and came in. He had to bend his head, like my father. He looked around the kitchen. Fortunately it was clean.

'This is nice,' he said. 'A real country house. Are you married?'

'Oh, no,' I said.

'Do you object to men or what?'

'Oh, no,' I said. 'It's just that only elderly people or spinsters stay with us in the summer.'

'Well, I'm not elderly,' he said. 'But I'm a male spinster. So what's wrong with that?'

He had long thin hands, and he fingered his glasses a lot. Now he took them off and polished the lenses with a handkerchief. He had

222

blue eyes. It was amazing what a change it made in his face to be without the glasses. His face looked strong and better shaped somehow. I saw he was smiling at my scrutiny.

'Will I pass?' he asked.

This confused me. I had to drop my head. I blush too easily.

'It's my father,' I said. 'He will have to pass you.'

'Are you serious?' he asked.

'Oh, yes,' I said.

'But we have a contract,' he said.

'Have we?' I asked.

'Oh, yes,' he said. 'Written and binding.'

'But that was for a Miss,' I said.

'If you like I will go,' he said. 'I'm sure I'd find digs in the village near the sea.'

'You'd have a job,' I said. 'They are all filled up this time of the year. Please wait. I will call my father.'

I went out the back way which was open. I searched the hill behind with my eyes and spotted him far up with the dog, so I put my fingers in my mouth and whistled. I waited for the sound to reach him, saw that it did and waved. Come down! Come down! He waved back at me. Then I went back to the young man.

'Did you whistle like that?' he asked.

'Yes,' I said.

'Did you never hear the proverb: a whistling woman or a crowing hen would drive the devil out of his den? Did you never hear that?'

'Often,' I said. 'But when you have a dog and sheep and a wide hill you have to be able to whistle.'

'How do you do it?' he asked. He came close to me. He was interested.

I showed him how you do it. You sort of double back your tongue and put your joined forefinger and thumb on top of the doubled tongue and blow.

'That looks extraordinarily easy,' he tried. He tried it. All he did was to hiss. He tried it again and again. He got quite annoyed with his failure. I couldn't help it. I had to laugh. He looked at me with his eyes affronted but he kept trying. Then he gave it up.

Somehow I felt very warm to him. I hoped my father would let him stay.

'If a girl can do it, why can't I?' he asked. 'The mechanics of the thing are obviously very simple. Show me once more how you do it.'

I showed him. It was silly really. I had to show him how to double the tongue and where to place the finger and thumb. He was close to me, genuinely trying to find out how to do it, and I didn't mind. You see what I am trying to say? I felt as if I had known him for a long time. We seemed to become friends as if I had known him for a long time. All in five minutes you might say.

I knew my father was coming when the collie ran in with his tongue hanging, wagging his heavy tail, and jumped up on me. I greeted him. I waited to see how he would react to the young man. He went over to him, slowly. The young man didn't move. He let the dog sniff at his shoes and his legs and then he put down a hand and the dog sniffed at that and then started to wag his tail so that I knew the young man was all right.

Then my father came in. I looked at him as he examined the young man. I was anxious for him to like the young man. I thought that it was the same as with the dog; he looked at him so cautiously.

'This is Hilary Mallowe, father,' I said.

'So he is not a Miss,' said my father.

'No,' I said, laughing. 'This is my father Murry Dempsey, Mr Mallowe.'

They approached and shook hands. They were of a height, but my father could make two of him. His sleeves were rolled and his arms were very brown and muscular.

'What brings you, then?' my father asked. 'Sit down.'

'Will I sit down if I am going to be thrown out?' he asked.

'Well,' said my father, 'we never throw anyone out of the house until they sit down first and have a cup of tea.'

'Oh,' said the young man, 'so I'll sit down.'

I got the teapot from the dresser; the kettle was nearly boiling on the crook.

'A friend of mine who stayed with you a couple of years ago, told me of you. She was a tall lady. You may remember her. She was a botanist.'

'Ah, the flower woman,' said Murry. 'Yes. She was nice. Are you in the flower business too?'

'No,' he said. 'I'm plants. I pick plants on the side of the hill and I analyse the soil at their roots, in order to find what might be in the ground hundreds of feet below them.'

'Oh,' said my father, 'you are a sort of minerologist.'

'Sort of,' said the young man.

'We have never kept young men here,' said my father.

'So Miss Dempsey told me,' he said. 'I didn't know. I'll go in to the village and look for digs.'

'Won't that put you a long way from the hills?' my father asked.

'It doesn't matter,' he said. 'I have my bicycle, and no spare flesh to carry.' He laughed. So did my father, because he was very thin all right. They would say around us that there was no hoult on him.

'Rules are made to be broken,' said my father. 'We invited you to come even if we were ignorant of your sex. We couldn't throw you out now. Come and I'll show you your room while Mary Ann is making the tea.'

'Thank you,' he said. He got up and followed my father into the room above the fireplace. It was nice and clean I knew, so I had no worry about its appearance.

I felt very pleased that my father had let him stay. I don't know why that should be. I had really expected my father to let him go. I don't know why I thought this either. I just thought he wouldn't let him stay. I thought how pleasant it would be to have this young

man under our roof. I put a clean cloth on the table and set out our best china.

My father came down from the room.

'You didn't mind my letting him stay?' he asked.

'No,' I said. 'I don't suppose he will be more troublesome than the ladies.'

'He looks like a fellow who could do with some feeding up,' he said. 'He's as thin as a rake.' He took me by the arm and walked me out the back door. 'Did you see him?' he asked laughing. 'He's like the picture you see of one of those secretary birds, a real skinama-link with the big glasses. It's a good job he has a career because he'll never get a wife. Be nice to the poor fellow, Mary Ann. He is most unattractive. I'll have to get back on the hill. We are missing four sheep.' He slapped his thigh with his hand and laughed. 'You know, if he wasn't wearing pants he could be one of those slack-breasted spinsters.' Then he whistled the dog and strode away.

I looked after him. I disagreed with him. My father was funny with people. He always made snap judgements of them, just as he would about the weather when he looked at the sky. He was often right. Now I wanted to call him back and say: But you are not right. He is a most attractive young man. He has a delightful sense of humour. I'm sure I'm going to get on very well with him.

But he was gone too far, so I shrugged and went back into the kitchen and the kettle was boiling so I made the tea and called the young man.

3

Hilary set up a sort of laboratory in the parlour. We rarely used it anyhow. Soon the sideboard and the table were covered with little bottles and jars with labels on them with a microscope into which he kept peering. There were chemicals too, with nasty smells off them. When they were too nasty he would take them out to the cowshed and do what he had to do there.

I became used to him. People are not things but he became like a thing that is part of a house and when it is broken or destroyed you feel like weeping.

It was different getting up in the morning, waking up and wondering why you felt happy. This went on with me for a time until I suddenly realised what had happened. I was quite sure that he felt nothing like this. He was so wrapped up in his tubes and his jars and his labels.

Every morning after his breakfast he would set off with his knapsack filled. I would make fried egg sandwiches for him or meat sandwiches and give him a flask of tea. He would be gone all the day, come home at dark in time for supper and we would be laughing away the three of us and then he and Murry, my father, would chat away about things sitting on the wooden chairs before the open fire, smoking.

We never had a chance to be alone. He didn't want it. I'm sure it never entered his head. Often I would wish that my father would go rambling to visit a neighbour's house of an evening, but he never did. I realised my feelings were serious when this thought started to come into my head. My father! I loved him very much and life had seemed always complete with him, and here now I was wishing he would go and leave us alone. At first I thought I was ailing with sickness, but then I woke up to the kind of sickness I was suffering from, and when I saw my father looking curiously at me once or twice, I had to set to and try to cure myself just as if I had a bad dose of the flu.

I told myself that Hilary and myself were so separated in intellect and education. I knew enough and I liked reading and I could talk humanities. I was uneasy with all this science of his, but I could grasp it when he explained it.

And it was a revelation to look into a microscope at a drop of water. You felt that you had moved into another world, just like when I swam in the sea and opened my eyes under the water and saw fish and waving weed in the great silence, but you couldn't look

at that for long whereas you could gaze into the world of the microscope for years.

This day then I knew that what I was suffering from was incurable. He had come home a little early and I had time on my hands for half an hour before I started getting the supper ready.

He called from the parlour: 'Mary Ann! Come and see this. Just come and see this.'

I went in. He came and took my arm and brought me over to it.

'Gaze at that,' he said.

I looked into it.

It was lovely. In the circle there were hundreds of little coloured things dancing, dancing and darting. 'Oh! Oh!' I said, 'all they want is an orchestra. Their movements are like music, joyful music.'

'It's funny you should say that,' he said. 'It's very funny. That was the very thought that was in my mind.'

He had eased me from the microscope with the pull of his hand. He held me close to him. I had to look up at him.

'Do you realise, Mary Ann,' he asked me, 'how closely we think about some things?'

He was looking into my eyes. Up to this, I had thought that it was only I myself who sensed what it was. But as I felt his nearness and saw the look in his eyes even behind those heavy glasses, I knew, and my heart pounded and my limbs shook, and I couldn't speak to him. This moment seemed to last so long that I still remember it, and then I saw the look in his eyes changing. They looked over my head, and I turned and saw my father standing at the parlour door and his face was tight. I didn't take any notice of it. I thought he might have been upset by something outside. I went over to him.

'Father,' I said, 'just come and look at the beautiful things that Hilary has captured. They're so beautiful.'

He didn't look at me, I remember. He kept looking at Hilary.

'Isn't it time you started getting the supper, Mary Ann?' he said.

I thought over this. It was a logical suggestion.

'All right, father,' I said. 'But go and look in the microscope at Hilary's dancers.'

Then I went down to the kitchen and started working, but I did all the things automatically. I didn't feel that my feet were touching the ground.

4

After that, nothing. I rarely saw Hilary. He never brought me close to him, so naturally, I thought that I had seen too much in too little, and I became cautious, afraid that I had presumed. Of course I was sad, but then young girls always get moments of joy and sadness, naturally, and I thought this was just part of it. But I was sad.

One afternoon I was out in the little flower garden I kept in front of the house, when he suddenly came on me from the low road. He didn't see me. I was bending down behind the wall that sheltered the flower bed from the sea wind. He had his coat off and he was walking quietly towards the front door. I looked once and then twice and I stood up and said: 'Hilary! what happened to you?' He was wet, all the way through even though there was no rain. He looked sort of pathetic. I smiled. Like a wet hen, his hair flattened, his boots squashing as he walked.

'I thought you wouldn't see me,' he said. 'I was on the cliff. I fell into the sea.'

I stopped smiling. I went towards him. 'Oh, no, Hilary,' I said. 'I will boil water. I will get you some of Murry's clothes.'

'No,' he said. 'Leave me alone. I will be all right.' And he went into the house abruptly. He had looked first to the road from the mountain. My father was coming down this road with the dog. He was sauntering. I went out the gate and ran towards him.

'Father,' I said. 'Father. Hilary fell into the sea.'

My father laughed. This wasn't surprising. Hadn't I myself smiled?

'How did he do that?' he said. 'And him with four eyes.'

This was a peculiar remark to make. It made me feel cold. But it didn't seem so peculiar at the time.

One day Hilary came home. He was limping. One trouser leg was torn. Part of his shirt was torn. His hands were dirty. He had scratches on his face and one side of his jaw was scraped raw.

I didn't smile this time. I was afraid. I didn't know what it was all about. Just that he was vague in his ways, maybe, and that he was walking into accidents not looking where he was going.

I wished with all my heart that this was true. But I knew it wasn't. Something had happened to us. There was a dark cloud over our heads. I didn't want to pursue it, you see. Why should I when it would contain nothing but unmentionable unhappiness?

But then he came with the deep bleeding cut on his head. His handkerchief was soaked with blood, and the fingers holding the handkerchief.

He sat on the chair in the kitchen.

'Bind this, Mary Ann,' he said.

I was trembling badly. I got the basin and hot water and put disinfectant into the water and I got a clean sheet and tore it into strips and started to clean the cut.

'Have you many personal possessions, Mary Ann?' he asked.

'I have nothing I treasure above you,' I said. 'This cut will have to be stitched.'

'Gather your few possessions together and come with me now,' he said. 'There is no other way. I love you with all my heart. I would like to save you suffering but there is no other way.'

No other way? No other way?

It was a supreme moment, of nearly perfect happiness allied with deep despair, because I was looking up at the loft over the fireplace, and I saw the twin barrels of the shotgun and they were pointing at Hilary's back.

WITNESS 2 THE YOUNG MAN

My personal appearance would win no prizes. Even at the university, at all those parties one goes to where you sit on the floor sipping gin and feel very daring, I seemed always to end up with the girls with a passion for discussing Tacitus or Evolution. Evolution of course can be very sexy, but desperately practical and objective, hardly romantic.

Here was this cottage, of the real old type, thatched and whitewashed, set in against the side of the hill as if it had grown there. They are dying out, these cottages that seemed like a hallmark of the west of Ireland. I know they have to go, that people want tight-roofed cottages and bathrooms and toilets and modern conveniences, but it is an aesthetic pity, so I was charmed as I pushed my bicycle up the hill to see it lying in the sunshine. I knew from its outside appearance that it would be very well kept inside as well, but I was unprepared for this girl who came to greet me.

I think I had grown used to the idea of myself ending up a sort of scientific bachelor, half-shaved, rumpled clothes, bits of egg on the tie, rusty voice, reading papers to other fossils in scholarly circumstances. I was twenty-four. Somehow when I saw this girl, pretty, sort of old-fashioned. Not old-fashioned in her dress or her appearance, just to me attractively old-fashioned, going with the cottage, sort of. She had a nice smile and innocent eyes and inside a few minutes we were talking as if we had known one another for years, immediately I seemed to forget all about this bachelor business.

I cannot explain this. It is obviously not scientific. No rules. You cannot even draw a graph about it. In the circumstances, I say to hell with science and let the psychologists figure it out.

Inside, the cottage was as I had hoped. Large stone flags on the floor, a huge dresser containing a few perches of gleaming china, the ceiling boarded, and the great open fireplace with the kettle hanging from a swinging iron crook.

So I was upset when this business about my name came up. It seemed odd to me. What difference did the sex of the lodger make to anything? I couldn't understand it. It made me uneasy. So I offered to depart to the village, not wanting to, and I was pleased to see that the girl didn't want me to either.

Murry Dempsey is a sort of Adonis, an extraordinary man, as I saw when I met him and talked to him. He is beautifully built, handsome, strong, virile, almost muscularly pulsating. I was glad when he said I could stay, but I am not stupid. I knew he said I could stay because he thought of me as the complete opposite to himself, the Before part of these advertisements you see by the muscle-building chaps, thin scrawny hollow-chested, diffident, weak-sighted. I knew he was making a mistake about me, but for some odd reason, I was pleased that he had done so.

What was a man like this doing living on a small farm, with his only daughter, growing the things they eat, rearing sheep? From a different man you knew it was because this was the sort of rural life that suited him. But I found out after a few evening conversations with him Murry was there because he was arrogant.

He could trace his people back before the time of Cromwell when they owned great possessions over in Kildare. They had been driven into Connacht. So had many thousands of other people, who had just settled down and got on with it and forgot who they were or where they came from. But Murry wasn't like that. He was in the highest house on a hill and he felt this physically. He was well read. He had a sharp intelligent mind, and if he was opposed on a subject he was expounding on, he could turn like a hare in a defensive way to support a rocky theory.

You see I didn't like him, so I have to be careful of what I say.

He grated on my nerves, but I tried my hardest not to let him see this.

Normally I wouldn't do it. I would have pointed out where his thinking had gone wrong.

Why did I suppress myself with him?

On account of his daughter, I saw with surprise. She loved him. She thought the sun rose specially for him in the morning and went to bed at night so that he could sleep.

I couldn't understand this. I don't know that I tried to understand it. I just wondered how she could be so blind.

Which meant of course that I was in love with her, which was a terrible surprise to me, almost as surprising to me as Darwin was when he wandered off from H.M.S. *Beagle* and found evolution.

I had been commissioned by a certain firm to do a plant survey of this part of the mountains. It's simple; you just take certain plants and analyse the soil at their roots and when you have covered a wide area with this sort of analysis, the firm know whether it is worth while going ahead with expensive borings to probe further. I enjoyed this work. Before, it was uncomplicated, but now I found myself thinking as I sat on the rock and eat my lunch: Imagine, Mary Ann's hands made these sandwiches. Which shows you how silly you can get. Now and again as I was working I would halt to think: Why do I feel so happy? What's it all about? I would pause to analyse my feelings and the end result would be that I had this terribly pleasurable feeling of happiness because in the evening I would be going back and Mary Ann would be in this house. I tried to douse these feelings as being unstable and unscientific, saying: She is just a pretty girl in unusual surroundings and what would you talk about anyhow if you were married? chickens? cows? sheep? This was a sound way to work until I discovered, when I talked to her about my work and showed her things in the microscope, that she had a fast mind, an absorbent one, like a pretty little bucket waiting to be filled. Her memory was retentive, her intelligence fast to grasp things and to comment.

So I had to cut out that line of thought.

Then the afternoon I was home early working, and I saw this beautiful thing and Mary Ann came to look at it, and did, and then

233

looked at me, and I forgot all about it, looking at her, one of these moments remembered in eternity, and then her father was there and I looked up and it was like getting a blow in the heart to see the look in his eyes.

They were blazing hatred at me. I swear this. It was not a delusion.

I thought: Why, this is the same as if he were a rival for her affections. Not her affections, her love.

I thought: This thing is not natural. I just imagined it, as the smoothness came again to his face and he said something to her about going to get the supper.

He came over to the table then and looked idly at the microscope. He didn't look at me.

'Will it take you long to finish your work here?' he asked.

I knew what he meant. It was very clear. I felt a hardness rising in myself then to match his own.

'Oh, a month or more,' I said.

He turned then and looked at me. I could see the distaste in his eyes for me, also the way he despised me, almost pity. He gave a sort of short snort through his well-shaped lips.

'I don't think you will be here that long,' he said almost casually, and then he went out.

That's what you think, I said inside myself, that's what you think.

It was a challenge. I was taking it up, but I didn't know then what I was taking on.

2

This day was a very beautiful one.

I had decided to go down the Menaun cliffs to get some chippings.

They were not very high cliffs, about a hundred feet or so but the rock formation at the deepest part of them was interesting.

I brought a nylon rope with me.

There was a convenient twisted thorn tree about ten yards back from lip and I tied one end to the butt of this and then I sat with my back against the bole of the tree and ate my lunch. The sea was calm, the sky was blue; the waters of the sea were coloured that Italian sky blue which is really a delicate green. There were one or two sailing boats, and a few trawlers out there, many miles away. Some sheep cropped the coarse grass near me and paused now and again to look curiously at me. Some seagulls had spotted my food and were circling around me, calling shrilly. I couldn't afford anything for them. I was too hungry. You see? A calm beautiful day, peaceful.

Only the thought of Murry made me uneasy. We were no longer conversing in the evenings. I made work my excuse and went to my room or the parlour where all my specimens were. I could see the disappointment in the eyes of Mary Ann. I was afraid she might take it personally, hoped she wouldn't, but even if she did it would be better for her than knowing the truth.

I got up then, left my knapsack beside the tree, took only a chipping hammer with me and a pouch. I tied the end of the rope under my arms, tried the rope for strain and then started to walk down the cliff. Before my eyes were below the lip I look all around. Looked for Murry. I was nearly always looking over my shoulder for him now. This was probably what he wanted. The whole landscape was bare of people. You'd think no human foot had ever walked the fertile walled fields, or the bogs and heather plain behind sloping up to the far mountains.

Then I forgot all about people.

It was no problem walking down the cliff with the support of the rope. At the top part the rock formation was coarse. Lower down it was much smoothed by the action of the waves. There were many interesting plants in the crevices as well as the actual rock itself. I paused many times and took samples.

I suppose I was a little more than halfway down when the rope I was holding with my left hand came free and I started to fall.

Favourite nightmares always consist of falling over cliffs.

This was no nightmare. I was on my way down. I tried to scrabble at the rock with my right hand letting the hammer fall. I couldn't hold on even for two seconds. All I could do was kick with my boots at the rock where my soles were scraping just enough to give me a kick off.

You see, I didn't know what was the state of the tide. I didn't know if I was falling into water or if I was to break my back on the black rocks. There was literally no time to think. It doesn't take a person long to fall fifty feet. The only other thing I could think to do was to put my hand over my glasses. I remember this distinctly. And then I hit.

But I sank, so it was water. So the tide was in. I didn't go deep. I had fallen on my back. I could feel rocks under my back but I had floated to them. It was no problem to kick with my feet and come to the surface. I had only to swim two yards and I was able to walk.

I walked along by the cliff, breast-high in water only for about twenty yards to the place where the cliff died and the shore sloped and I got out of the water there and sat down for a moment.

I still had my glasses. The nylon rope went away from me like an umbilical cord. I pulled it towards me, remarking how weak I suddenly felt. It was a terrible labour to pull this rope towards me. I thought it might have come free from the knot I had tied at the bole of the tree. It hadn't. It was cut.

I remember the feeling of weak helplessness that came over me then. Who would do a thing like that? What defence did I have against ruthlessness? I didn't think of Murry. I just thought: Who could be so ruthless as to cut a rope in a situation like this?

I gathered the rope and rose and started to mount the fields to the top of the cliff again.

I was breathless when I got to the top. I saw that there were about three yards of the rope around the tree. It had sprung back on itself. It was easy to see that it had been cut.

I stood and looked around. Away on a far hill I saw Murry. He was silhouetted against the skyline. He was looking in my direction. The dog was beside him. This was arrogance. He was so far away how could you ever think that he could have done this thing and then got so far away? But he had time. I knew it was he. I knew it from the arrogant way he stood against the sky.

I found my limbs were shaking. This was such a terrible discovery. I always thought I was too harmless to have an enemy.

He meant is as a warning perhaps. But I could have been killed. Quite easily. What then? I knew he didn't care. He was dangerous. I should be afraid. I should be very much afraid. If I had any sense I would go to the house and pack my traps and leave this beautiful place and all that it meant to me.

But I knew I wouldn't, because I was not shaking with fear, but with anger. My jaws were hurting me, I found, on account of the way I was clenching my teeth. For the first time in my life I knew what red rage meant.

3

Is it possible to understand human nature? I don't suppose it is, since we find it such a difficult job to understand ourselves.

Murry was very nice to me.

All of a sudden he blossoms out into conversation. That evening he even twitted me about falling into the sea. He joked about my appearance. He was kind, thoughtful.

So was it any wonder I began to question my own conclusions? Maybe this rope wasn't cut by a knife. Maybe it was done by the teeth of a sheep. They have sharp teeth you know. See how closely they crop coarse grass. Would this be what happened? Was there a sharp stone at the place where the rope parted? Was I giving way to feverish imaginings?

You see?

Mary Ann was very pleased to see her father and myself again so

talkative. As if to say: Here are two people I love and isn't it grand to see them so friendly? Such good friends?

Maybe I was wrong. I had thought he looked at her, teased her, enveloped her as if she was actually his wife instead of his daughter. I don't mean in an evil way, or do I? I don't know. I had thought that his affection for her was greater than it should be. Mary Ann wouldn't know this. She wouldn't even suspect this.

I actually began to hate myself for these reflections. I thought there was much evil in me that I hadn't know. I was growing fond of this girl and I resented the love of her own father for her. I told myself this.

If you are a normal person, leading a normal existence, you pass through life without ever coming on violent events. I had never even looked at the corpse of a human being. I had never seen an accident or a fight in which blood was spilt.

Are people like that prone to nightmares or outrageous imaginings?

If you have nightmares, what are the ones you dislike the most? The dreaming of nightmares is wonderful for the part where you wake up and your returning senses tell you it was only a dream, it is all over; you are enveloped by the silky night of reality. I had often had nightmares of falling over cliffs, the terror of finding myself walking on air and falling towards unknown depths. Now that I had suffered the reality of it, I knew I would never dream about it again.

There was another nightmare.

I love this land of free mountain range with heather and sedge. I had learned to know the boggy places; how to avoid sinking into the morass, by the colour of the covering of the mosses. Sometimes I would walk freely across a deep bog half a mile in width, to come to an outcropping of rock. It was wonderful to feel the solidity of the rock under you after the quaking bog.

I had done this one day in order to examine a wide rocky place where the outcrop of rock was wide. It was on the top of the hill,

and it contained a medium-sized valley, the floor of which was littered with broken rocks, as if one time a giant with a great sledgehammer in a fit of rage had broken all the rocks in the valley to knee-high size.

I was here one day on my knees, carefully taking plants from the ground with their root soils and putting them into containers when I heard the hooves on the hard ground.

This is another nightmare. You are in a rough place all alone, and suddenly you are confronted by a wild animal, a lion, a tiger, a charging elephant. It can be any of them.

What I saw coming at me was a ram.

Sheep are harmless animals, aren't they? There are horned sheep. People are nervous of horned sheep in case they are rams.

I had time to see him, and to shout. I heard my shout coming back at me as he butted me in the side. It was like being hit by the piston of a railway engine. I tumbled over and over on the rocky ground. I managed to get to my knees when he tumbled me again.

I was frightened, I confess. I was sore. I was helpless. He turned and came again, as if he was determined to destroy me. I took a rock in my hand. I was sitting up. I aimed it. As he charged it hit him on the forehead. It stopped him dead. He lowered his head and shook it. I scrambled towards him, fast, fast as I was able. I caught his horns while he was wavering, sat under him and tried to topple him from his feet. He was very strong. My side was hurting me, but there was nothing else for me to do, so I shoved and I pulled and I got him on his side. I hooked my left knee around his horn, and freed my left hand. With this I loosened the belt holding my trousers. It had a metal slip buckle. I pulled this from my waist, wrapped it around his two front hooves, and roughly tied it.

Then I freed myself from him.

He was helpless that way.

I got to my feet. I felt very sore all over. He was trying frantically to free himself. My side was very sore. I had to hold it as I went

back to my knapsack. From this I got a length of rope and went back to him. I tied his back hooves together, recovered my belt and tied his front legs with rope.

He was a big fellow. His eyes were evil. He smelt.

I left him there.

Mary Ann didn't know that I went to the village doctor that night and had two ribs strapped up.

Murry said a thing at supper.

'A strange thing,' he said. 'Somebody tied up my ram today. He could have starved to death if I hadn't freed him. Who would do an inhuman thing like that to an animal?'

I began to wonder if he was not insane.

4

The climax had to come. I was very glad when it did come and that I happened to be alive to see it.

I was working in a gully. It wasn't a steep one, it sloped away over me.

I was concentrating on getting this stubborn plant free from a crevice in a rock. I heard a sound and moved. This big round stone was in the line of my sight for a second and then it hit me on the side of my head, glanced off my shoulder blade and knocked me.

I was lying there for a few seconds, stunned. I was trying to account for this. The things that were happening to me were all simple to explain. They were part of the surroundings, but why had they never happened to me before in all the places I had been? One of them happening in one place would leave you a memory for ever.

I got up and went to the stone. It was a big stone, about four pounds weight, a granite stone with quartz crystals glinting in the sunshine. It looked very innocuous, but there was a deep damp stain on its lower part which showed that it had been embedded before it fell. So it couldn't fall of its own accord. It had to be raised from its bed and allowed to fall.

240

I saw the blood dripping from my head to the ground then and knew that I was wounded. I got my handkerchief and held it to the wound. It was soaking blood fast.

I gathered my gear and climbed out of the gully.

I should have stopped at the edge and looked carefully around me. I knew I would see him, hundreds of yards away, perfectly innocent, an air about his arrogant stance.

But I didn't look. I didn't turn my head. I walked down the mountain side towards the little mountain road, a grey ribbon in the green-gold of the spaces. Normally I would have stopped and looked, because it was so good in the sunshine, the glinting sea and the villages and the tiny white cottages.

I just walked fast, conscious that he was behind me. My inclination if I stopped would be to have pitted myself against him in blind rage. Even rage would not have been sufficient to defeat him physically. I knew this, but I also knew that if I saw him I would try to hurt him. I got rid of the savage feelings in my breast with my imagination, my fingernails biting into my palms, my teeth clenched, making my wound ache more with the tightening of my jaws.

Futile you see, not trying to reason, no longer interested in seeking a cause. Because there has to be a cause for actions like those, but the one I chose to think of when I did, didn't bear reflection.

She was in the kitchen, dear Mary Ann, puzzled, horrified and great unhappiness behind her eyes, because by now she must have guessed a little.

'Bind this, Mary Ann,' I said as I sat on the chair.

I watched the shock in her face, in a detached sort of way. I saw her trembling, but then I saw her practicality asserting itself as I had expected; the gathering of the basin, the hot water, the disinfectant, the strips of sheeting. Her hands were gentle on my head. I thought I knew her. I thought I knew more about her than she did herself.

'Have you many personal possessions?' I asked her.

I knew what she would say. Even though our times together had been few, I knew what she would say.

First an admission of love and next an admission of concern.

So this was why I had to put the whole thing to the test, here and now. I saw no other way.

'Gather your possessions,' I said, 'and come with me now.' This meant leave your father's house and all that it has meant to you; leave your father and all he has meant to you. Come away with me, a comparative stranger to you, one whom you do not know, who might make you unhappy.

I saw this struggle in her face as she faced me, and then I saw her eyes raised to the loft.

I knew he was there.

I had heard the scuffling, and I knew something terrible might to about to happen, but I didn't care. I was looking at Mary Ann and feeling the gentle touch of her fingers on my head, and I just didn't care.

WITNESS 3 THE FATHER

Nobody understands.

This is the unbearable part of it. You are always hoping there is somebody who will. Look for one on the hills or on the bog or on the road of an evening. But you know they won't, for they didn't know her and the ones who knew her have *forgotten*.

She was beautiful all over, inside and outside. She had this sense of fun, that made everything about her seem like a pleasant joke.

I met her at a village dance right on the other side of the peninsula. The minute I saw her I knew. Her name was Ann. Just Ann. It still sounds to me like a song of a river, stilled now, stilled, far off, like the call of a mountain curlew.

I had rivals. She preferred none above the other. I fought for her. She didn't know that. It was after the dances, when we drank from the white bottle outside in the moonlight. They knew I was after her. We weren't supposed to be fighting about her; it was always something else, an imagined slight, a push in the back, but it was about her, and I always won. I was strong but some of them were strong too, but little use to them was their strength. I saw her and she was mine.

If she were anyone else she could never have resisted the flood of my passion and determination. But she did, for a long time.

Times were hard then. People lived in very crowded conditions. I solved that. I went up near the mountain and I built this cottage; saying now we are free. This is a house for us alone. I thought I had her then. She couldn't see it. A woman of a house then was one who weighted herself down with buckets from the well, hobnailed boots, chop, chop, chop, cabbage and potatoes and big-bellied pots for pigs.

She wanted life before that; to see abroad how things were in other places.

She went away.

I can't forget that. She didn't understand then the depths of me; the way I felt about her. I didn't understand the depths of it myself. So she was gone. Like a wake, the shed tears enough to flood a lake. I don't remember much about it. I remember tramping the mountains, baying like a wounded dog at the hunter's moon that seemed as big as the world. Scrabbling at the heather like a wounded animal.

I fought against them but they restrained me. I don't know how long. I just remember this day in this place. It was a small room with bars on the window. It was an iron bed with a white quilt.

This door opens, see, a heavy door, and it was the same as if they opened it to let in the sun, blinding sunshine, and there she was the heart of it. I can still see her. Why? I don't know. I saw nobody else. I was in there some time they said, but I don't remember. I don't

remember one of them, just this door opening and she like the heart of the sun, and she came over to me and she took my hand and she said: 'Come on home, Murry.' See, this is what I remember. Nothing else. She said this: 'Come on home, Murry.'

It wasn't pity. This is what you will say. It wasn't. She was too sensible a girl to make a sacrifice of herself for me. It was just as if a door in my brain had closed when she went away and when she came back and said: Come home, it opened again, wide and free.

We went home.

Home can be heaven. This was. Not pleasant memories of the past, bad things forgotten with the years. It wasn't. Whatever else I remember every second of our life.

I heard her calling me.

I knew I was three miles away and that the human voice cannot carry for three miles, but I heard her calling me. Even as I ran, her voice was an urgent shout in my ears, in my brain. Oh, Murry! Murry! she was calling. Come on home, Murry! Like before. Only this was different.

She hadn't called at all.

She was lying on her side on the floor, leaning on her elbow. Mary Ann who was only two then, was playing in front of the fire.

She raised her head to me when I got down beside her.

She could just raise her head, and she smiled at me. She was in my arms. She smiled at me, and she raised a hand to my cheek and she died.

See, this is what they will never understand.

You had nearly three years with her, they said, or God is good, and don't forget that you will see her in Heaven. Death is life, they said, she was a good girl. Too good for the world, they said, that was why she was took.

I knew why she wanted to get away, to see a little of the world, because she must have known deep down in her that she wasn't long for it.

Lots of things I knew, but what good were they? There was only one human being on the face of the earth I could talk to about her, and that was she herself and I couldn't talk to her any more. Because the others forgot. It only took days for them to forget. I remember this. I wanted to roar and shout, even kill them, for the shallow memories they had.

But this was no good.

I could talk to Mary Ann though.

I talked it all out to Mary Ann. On my knee she would be. In the middle of the night to save myself from a death of my own choosing, I would go and lift her from her cot and sit her on my knee and talk to her.

She always understood. I swear this. Her small pudgy hand would grip my thumb and she would look at me with sad eyes. She was like a miniature of her mother. She was more like Ann than me. I felt I could be talking to Ann. This dawned on me, that Ann was not dead at all, that here was Ann, a little girl growing up. So I didn't just have her for three years, but for a lifetime to come. You see — Ann wasn't dead at all.

This was a thought that grew on me. If it hadn't, I don't know what I might have done. I was afraid of what was in me.

But Mary Ann saved me.

Life went on you see, watching her grow, hearing her talk, teaching her lessons. It was wonderful. It was the same as if she was Ann.

Life became a dream. Just she and I. I worked for her, laughed with her, taught her.

She could have been Ann. This disposition. This aura of innocence, the bubbling laughter.

I liked her friends. Young men courted her. I didn't mind. I encouraged her. But she was Ann in this. She would make no choice. I knew why this was; that our life together was so free, so beautifully easy, that she had no choice.

Then this fellow Hilary.

I didn't like him, but I didn't fear him. Look at him for God's sake. He was ugly. He was everything that a man shouldn't be.

I let him stay in the house on that account, I tell you, because he was what he was and I was sorry for him because I despised him.

Until I saw him showing her the sights in his gadget, and I saw him looking at her and saw her looking at him.

The danger bells were loud in my head. I tried not to show it. But they were ringing, loud and clear.

I only intended to warn him.

I saw the rope and I cut it. I can still hear the sound of its parting. I walked away from him.

He should have taken that as a warning. He didn't. He was clever. He should have known. Didn't he know I would certainly kill him if he didn't go away?

The ram was a warning.

He didn't go away. Why didn't he go away? Did he want to die? Go! Go! Go! I shouted at him silently as I freed the rock.

I was surprised to see him stagger from the gully and head for the house below, but this time he would go, I knew. He was clever. He had read a lot of books. By now he must know how dangerous I was.

I followed him down, stalking him like a wild goose hunt, watching him. But I didn't trust him.

When he went in I got the ladder and put it against the gable and climbing up I freed the shutter to the loft. This was the place we used before to store potatoes and the thrashed oats, and I went in there and took the shotgun from the thatch and loaded it and edged forward where I could look down into the kitchen.

She was bathing his head. His face was bloody, his shirt and his jacket.

You know what he said to her. I couldn't believe my ears. All my limbs started to shake. I was wet with sweat.

She said this thing to him. Mary Ann! She said it. I heard it and she said it. I have nothing I treasure above you. And then she was

looking up at the loft and I knew she saw the gun, and I knew he was aware of it. My hands were wet with sweat. I had to free them and wipe them on my shirt.

'You go and collect the things of yours, Hilary,' she said.

He stood up. I would have shot him then, but before my hands were dry he was gone out of my sight.

She just stood there looking up at the loft. She couldn't see me. She knew I was there.

'I am not Ann, father,' she said. 'I am Mary Ann. Look at me, father, I am Mary Ann. I am you and her. I am not her. Do you hear me?'

How can you answer things like that?

I was sighting on her.

Of course she was not Ann. Would Ann do a thing like that to me? She was different. I went over her face with my eyes. Of course she was not Ann. How could she be? She never knew Ann. But she knew me and what she meant to me and she was doing this thing to me, tearing out my guts. I was blinded with torment.

He was back. She moved to him. She held his arm. She looked up into his eyes.

'I love you, Hilary,' she said, and then she walked beside him to the door, right close beside him. She didn't even take off her apron.

I cuddled the stock of the gun to my cheek. I can still feel the sweat of my face sticking to it.

I couldn't do it. I don't know if I could have done it even if she was not so close to him, that I would kill her too. I don't know.

The door closed behind them and the kitchen was empty.

It was empty. Like it was the time I ran home and she died. Just a little child playing by the fire.

Now it was empty. There was no child. There was nothing at all. The terrible emptiness of it drove me mad with fear.

I jumped from the loft to the floor and I ran for the door. It was open. I went into the garden.

There was no sign of them. They were gone.

I ran on to the road and I looked towards the sea, but the road dipped and wound out of sight and they were gone.

I was alone.

The gun was in my hands. It felt to me now like the slippery scum on the body of a live eel.

I raised it and I broke it on the rocks of the wall beside me.

Then I had nothing in my hands.

I wanted to call out! 'Come on home, Mary Ann! Come on home!' but I knew that nothing but the sound of my own voice would come back to me, I felt drained of life.

So I went back into the house and I looked at the empty kitchen.

Now, I thought I will have to see.

Ann is dead.

This is the truth that I have been avoiding for so long.

Now I have to face it on my own and facing it may help to rub out the scars of what I have done to Ann's daughter Mary.

It may. I don't know, but now I am trying to live with it. Who will help me? Who will understand?

I don't know, I really don't know.